Twentieth-Century Painting and Sculpture

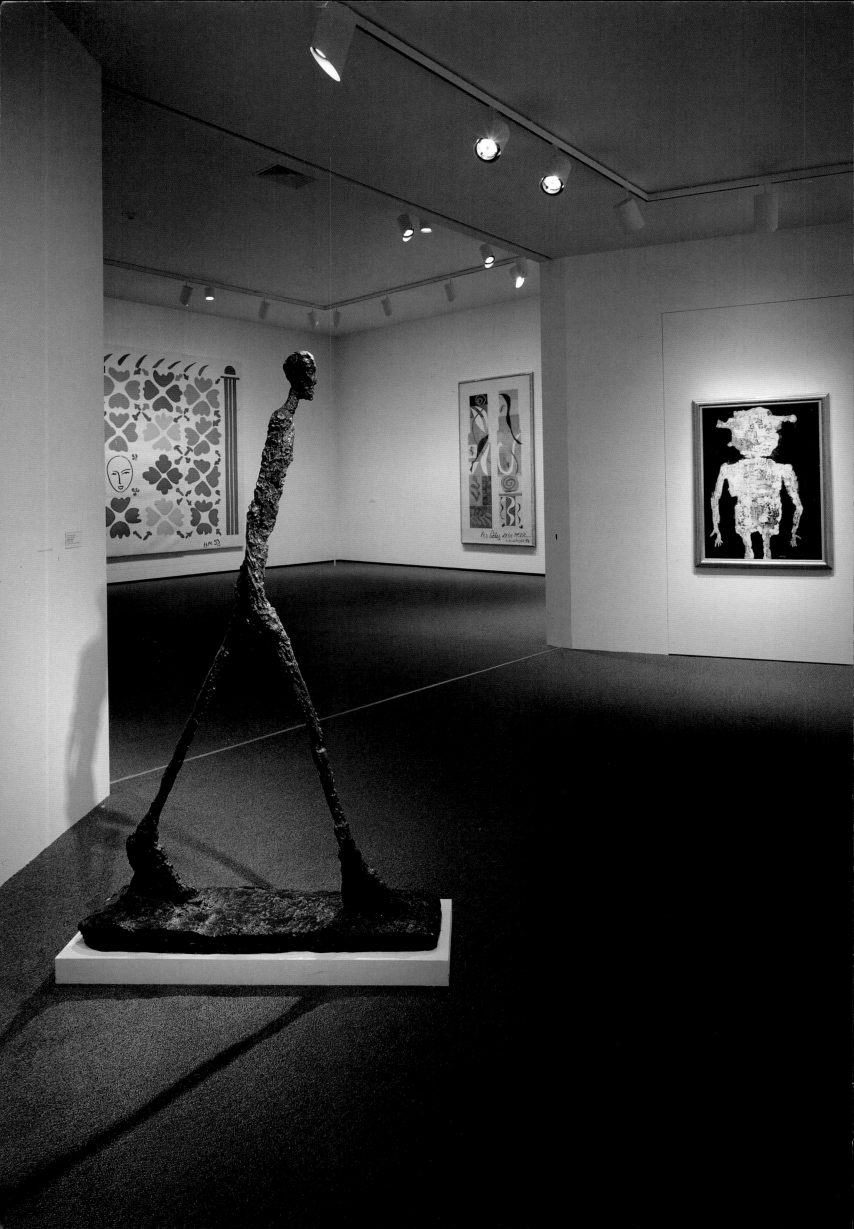

Twentieth-Century Painting and Sculpture

**Selections
for the
Tenth Anniversary
of the
East Building**

JEREMY STRICK

National
Gallery
of Art
Washington

The installation is made possible by a grant from American Express Company

This publication was produced by the Editors Office, National Gallery of Art, Washington
Edited by Tam Curry
Designed by Phyllis Hecht

The type is Optima, set by BG Composition, Inc., Baltimore, Md. Printed by Schneidereith & Sons, Baltimore, Md., on 80 lb Quintessence Dull text

Library of Congress Cataloging-in-Publication Data

National Gallery of Art (U.S.)
 Twentieth-century painting and sculpture: selections for the tenth anniversary of the East Building / Jeremy Strick
 Exhibition catalog
 Includes bibliographies and index
 ISBN 0-89468-125-7
 1. Art, Modern—20th century—Exhibitions. 2. National Gallery of Art—Exhibitions. I. Strick, Jeremy. II. Title.
 III. Title: 20th century painting and sculpture.
 N6487.W3N336 1989 88-38481
 709′.04′00740153—dc19 CIP

Cover: René Magritte, *The Human Condition (La condition humaine)*, 1933, National Gallery of Art, Washington, Gift of the Collectors Committee
Frontispiece: Installation on concourse level. Photograph by Kathleen Buckalew

CONTENTS

FOREWORD

In 1965 the Trustees of the National Gallery of Art changed the policy of the Gallery to permit the regular exhibition of works by living artists in the Gallery's collection. Chester Dale had died, and among the paintings in his bequest were major early works by Pablo Picasso. One can trace a direct line from that historic 1965 vote to the opening on 1 June 1978 of the East Building, constructed with the Gallery's burgeoning collection of twentieth-century art in mind. Since the opening of the East Building, this collection has continued to expand at a carefully directed and quite astonishing rate—more than doubling in the past ten years. There can be no more appropriate way to celebrate this tenth anniversary of the East Building, therefore, than with the current installation and exhibition of works of art from the twentieth century. By tripling the space normally devoted to that collection, this presentation allows us to assess the increased range and depth of the Gallery's commitment to the finest art of our time. By including important loans from private collections, we call attention to the continuing traditions of private interest, generosity, and support that have shaped the National Gallery.

Visitors will note that the institution's stance toward twentieth-century art is essentially retrospective; our central goal is to present the great European and American movements and masters of the century rather than to speculate on new trends. Our view is also ultimately monographic: we believe that the art of this century can be best understood when groups of works by a single artist are brought together. Wherever possible we have chosen to present concentrated overviews of the work of key masters. Always, however, it is the great masterpiece that stands out, and over the years we have sought to acquire works of pivotal aesthetic and art historical importance: works of art that define their times and their makers.

Credit for the tenth-anniversary celebration must go first to the many donors whose extraordinary vision and generosity is evident throughout the installation. This catalogue of selected paintings and sculptures acquired since the opening of the East Building provides much additional documentation of the role of numerous patrons. At the end of this book we have listed the names of all donors of twentieth-century painting and sculpture to the National Gallery throughout this institution's history. A special word should be said for our Collectors Committee, a group that was formed for the purpose of commissioning works of art for the East Building and that then extended its charge by annually funding gifts to the Gallery of one or more major works of twentieth-century art. These distinguished gifts are reproduced and discussed herein. Major acquisitions of twentieth-century prints and drawings, a range of which will be shown in temporary displays in the present installation, have been supported by many generous benefactors. Along with Collectors Committee commissions and special loan exhibitions, selected works on paper are addressed in the companion volume to this catalogue, *A Profile of the East Building*.

We would also like to thank the many private lenders and artists with whom we have had the great good fortune to work over the past two years. Lenders include Irving Blum, Jean-Christoph Castelli, Lois and Georges de Menil, Mrs. Robert B. Eichholz, Guido Goldman, Boris and Sophie Leavitt, Mr. and Mrs. Paul Mellon, Robert and Jane Meyerhoff, the Morton G. Neumann Family Collection, Candida and Rebecca Smith, David Whitney, and Richard S. Zeisler. Contemporary artists who have lent works to the Gallery for this special occasion include Helen Frankenthaler, Jasper Johns, Ellsworth Kelly, Roy Lichtenstein, and Robert Rauschenberg.

It is appropriate as well to recognize here the efforts of the Gallery's curators of twentieth-century art, who have helped guide and shape the building of this collection. They include the late Professor William Seitz, our first consultant for twentieth-century art, followed by E. A. Carmean, Jr., the founding curator of the Gallery's twentieth-century art department (now director of the Modern Art Museum of Fort Worth), as well as our current team of curators, Jack Cowart and Nan Rosenthal, and assistant curator Jeremy Strick. Throughout the planning, construction, and installation of this tenth-anniversary project, the curators have worked closely and creatively with Gaillard Ravenel and Mark Leithauser of our department of installation and design.

American Express Company, the exhibition's corporate sponsor, demonstrates a spirit of commitment and foresight in its decision to provide a generous grant for the new installations, publications, and related twentieth-century public programs. A special debt of gratitude is due James D. Robinson III, chairman and chief executive officer of American Express Company, with whom, and with whose able staff, it has been the very greatest pleasure to work.

J. Carter Brown
Director

PREFACE

Anniversaries provide occasions for celebration and for reflection, and this has certainly been the case with the East Building's tenth anniversary. Everyone involved with the project of installing 30,000 square feet of newly designed gallery space has had an opportunity to reassess the special relation of the East Building to twentieth-century art and to see in a fresh light the Gallery's twentieth-century collection. This book provides a further opportunity to reconsider that collection. A supplement rather than an exhibition catalogue, the volume documents a selection of the more than three hundred paintings and sculptures acquired since the opening of the East Building. As such, it reflects only in part the contents of the tenth-anniversary installation: several of the works discussed herein are not included in the exhibition, and the loans in the exhibition are not described in this book (they are included, however, in a checklist at the back of the book).

This volume offers brief, general introductions to individual works of art, and sources for information contained in each discussion may be found in accompanying bibliographies. The sequence of entries is organized chronologically by the date of the painting or sculpture. The publication anticipates the systematic catalogue of the Gallery's twentieth-century collection now in preparation. The systematic catalogue will contain in-depth technical and historical examinations of each object in the collection as well as the scholarly apparatus of provenance, exhibition histories, and complete bibliographies.

A great number of friends and colleagues have provided considerable assistance throughout the preparation of this book. I am grateful to Jack Cowart and Nan Rosenthal for their enthusiasm and support as well as their critical reading and editorial advice. Both shared their personal expertise in a number of areas, and Nan Rosenthal allowed me to read unpublished material from her forthcoming book on Robert Rauschenberg. Frances Smyth, the Gallery's editor-in-chief, has supported the project from its inception and has given the book its essential shape. Tam Curry has demonstrated extraordinary energy, patience, and care in her intelligent editing of the text, and Phyllis Hecht contributed a particularly striking design. Interns Cahssey Groos, Rachel Gerstenhaber, and Margaret Magner tirelessly provided critical research and contributed important ideas. Exhibition assistant Laura Coyle prepared checklist and donor list, assembled transparencies, and supplied crucial information and clarification of a number of points.

Ira Bartfield, Richard C. Amt, and their staffs provided photographs for this book, assisted by John Poliszuk and his staff, who took time from an extraordinarily pressing exhibition schedule to move and set up a number of paintings and sculptures.

Samuel H. Kress Postdoctoral Curatorial Fellow Elizabeth Brown read a number of entries and was a helpful catalyst in the development of ideas and interpretations. I am most grateful to Professor Yve-Alain Bois for his careful reading of the entire text and his many important suggestions. Eliza Rathbone graciously permitted me to read unpublished material of Arshile Gorky, and Paula Pelosi and Elizabeth Seacord contributed essential information pertaining to Frank Stella.

Thanks go finally to the members of my family, in particular to Joseph Strick for his sensitivity to Joycean reference and to Wendy M. Strick for numerous suggestions and unfailing encouragement.

Jeremy Strick
Assistant curator of
twentieth-century art

CATALOGUE

André Derain
French, 1880–1954
Mountains at Collioure, 1905
oil on canvas, 32 × 39½ (81.3 × 100.3)
John Hay Whitney Collection 1982.76.4

A series of close, intense, often brief collaborations have marked the course of twentieth-century art. One occurred in the summer of 1905 when André Derain and Henri Matisse worked together in Collioure, a French Mediterranean fishing port close by the Pyrénées. Painting side by side for much of the summer, the two artists advanced the style that would be dubbed "fauvism" at that year's Salon d'Automne.

The twenty-five-year-old Derain was Matisse's junior by eleven years, and his career as a painter had recently been interrupted by a three-year stint in the army. Nevertheless, each painter was eager to learn from the other, to experiment and to debate. Before the summer in Collioure both had been working with a variation of neo-impressionism in which the size of the characteristic pointillist dots was expanded so that they functioned as distinct and independent pictorial elements rather than blending together. Derain abandoned that style for a time, declaring in a letter to his friend and fellow artist Maurice de Vlaminck, ". . . I must eradicate everything involved with the division of tones." Divisionism, he continued, was ". . . logical enough in a luminous, harmonious picture. But it only injures things that owe their expression to deliberate disharmonies."

Instead Derain began to paint in a manner influenced by Van Gogh and to a lesser degree by Gauguin. The results can be seen in *Mountains at Collioure.* Rather than mixing or blending his colors, Derain here used short, choppy brushstrokes and contrasting areas of flat, even color. Between the short brushstrokes Derain allowed the white ground of the painting to show through, thereby filling the painting with a kind of interior light and air and energizing the picture surface.

Just as the insistent rhythm of Derain's brushwork in *Mountains at Collioure* recalls Van Gogh's St. Remy landscapes, his firmly outlined mountains and areas of flat color recall Gauguin. Unlike Gauguin, however, Derain has activated line here to an extraordinarily fevered pitch; lines cascade and swirl across the canvas. In *Mountains at Collioure* Derain has released the power of "deliberate disharmony," but that disharmony does not mean disunity. Through rhythmic color and interwoven line, Derain ties his painting together into a brilliant, luminous whole.

Bibliography

John Elderfield, *The "Wild Beasts": Fauvism and Its Affinities* [exh. cat., The Museum of Modern Art] (New York, 1976).

Ellen C. Oppler, *Fauvism Reexamined* (New York, 1976).

Denys Sutton, *André Derain* (New York, 1959).

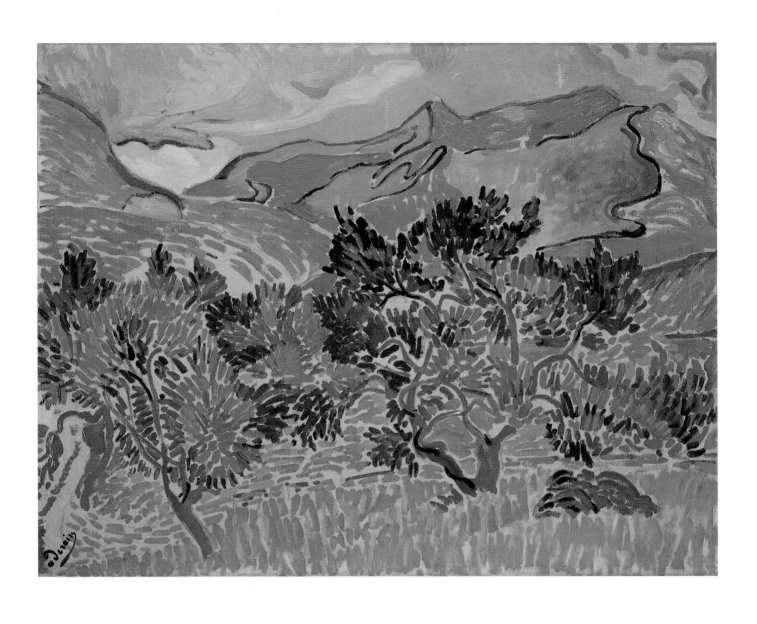

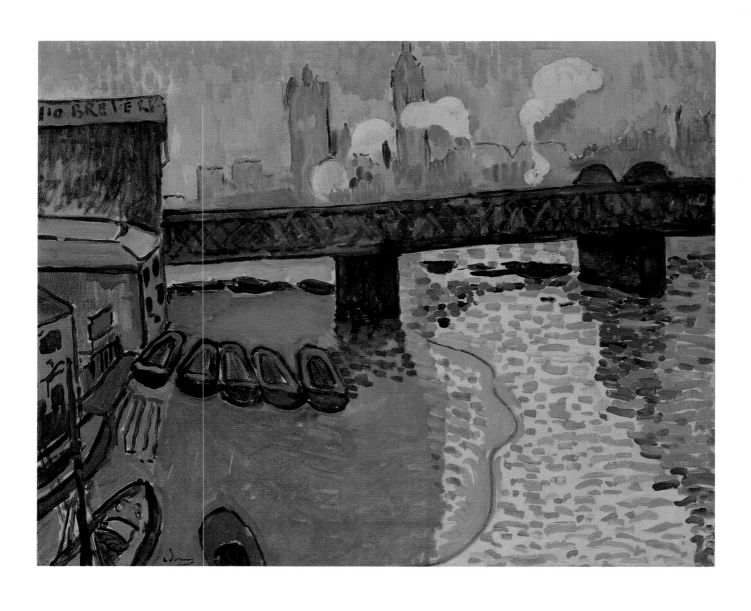

André Derain
French, 1880–1954
Charing Cross Bridge, London, 1906
oil on canvas, 31⅝ × 39½ (80.3 × 100.3)
John Hay Whitney Collection 1982.76.3

Derain made two trips to London: in 1905 and in 1906. The second trip (and possibly the first) was financed by Derain's dealer, Ambroise Vollard, who was inspired by the great success of his 1904 exhibition of Monet's views of the Thames and determined to repeat this success by commissioning paintings of the same subject by Derain.

The precise dates of Derain's trips to London are unknown, and because Derain's style before 1907 changed frequently, his fauve paintings are often difficult to date securely. Moreover, although the London paintings convey the impression of speed and spontaneity of execution, some of them were reworked when the artist returned to France. This further complicates their dating. Despite such difficulties, most sources agree in assigning *Charing Cross Bridge, London,* to Derain's second London trip, in the spring of 1906. The paintings of this second trip are often characterized by what one of the principal scholars of fauvism, John Elderfield, has termed "mixed-technique fauvism," in which pictures are composed both of separated, divisionist blocks of color and broad areas of a single color.

In *Charing Cross Bridge, London,* Derain limits his color blocks to the depiction of rippled water. The vibrant energy of these blocks is heightened by the contrast between their thick, highly colored brushstrokes and the ground (originally white, now off-white) that shows between them. Elsewhere, despite the strong colors, paint is handled quite thinly; each area is brushed in with loose washes. Impasto is used only as an occasional accent. Perhaps the most remarkable aspect of Derain's achievement here is that he conveys a powerful sense of an actual place even while employing colors that could at best have had a tenuous link with the view Derain observed.

Bibliography

John Elderfield, *The "Wild Beasts": Fauvism and Its Affinities* [exh. cat., The Museum of Modern Art] (New York, 1976).

Ellen C. Oppler, *Fauvism Reexamined* (New York, 1976).

Denys Sutton, *André Derain* (New York, 1959).

André Derain
French, 1880–1954
View of the Thames, 1906
oil on canvas, 28⅞ × 36⁵/₁₆ (73.3 × 92.2)
Collection of Mr. and Mrs. Paul Mellon
1985.64.12

Comparison of *View of the Thames* with *Charing Cross Bridge, London,* reveals that the paintings assigned to Derain's second London trip are quite varied in style. *View of the Thames* is the more radical work. In it Derain abandons the divisionist blocks of "mixed-technique fauvism" and fashions his composition entirely from loosely defined areas of color. The colors are not as bright nor as diverse as in *Charing Cross Bridge, London,* but the use of a single tone over so much of the canvas is startling.

In *View of the Thames* Derain forsakes a highly structured composition such as that which holds together *Charing Cross Bridge, London.* Indeed, *View of the Thames* is exceptional for its lack of traditional compositional devices, either for establishing depth or for ordering the surface of the picture. Vaguely sketched shorelines provide the only indication of recession. And this is contradicted by the empty area at the center of the canvas, which seems to project forward, as do the sky and the several plumes of smoke. The massing of buildings and boats at the lower left is balanced only by an arc of paint across the upper right corner, which serves no apparent representational function.

After Derain returned home to Paris, his art began to turn increasingly toward the examples first of Gauguin, then of Cézanne. Eventually fauve colors disappeared and his palette turned somber. *View of the Thames* shows Derain's fauve style at its most extreme, a state of compositional and coloristic liberty from which the artist would soon retreat.

Bibliography

John Elderfield, *The "Wild Beasts": Fauvism and Its Affinities* [exh. cat., The Museum of Modern Art] (New York, 1976).

Ellen C. Oppler, *Fauvism Reexamined* (New York, 1976).

Denys Sutton, *André Derain* (New York, 1959).

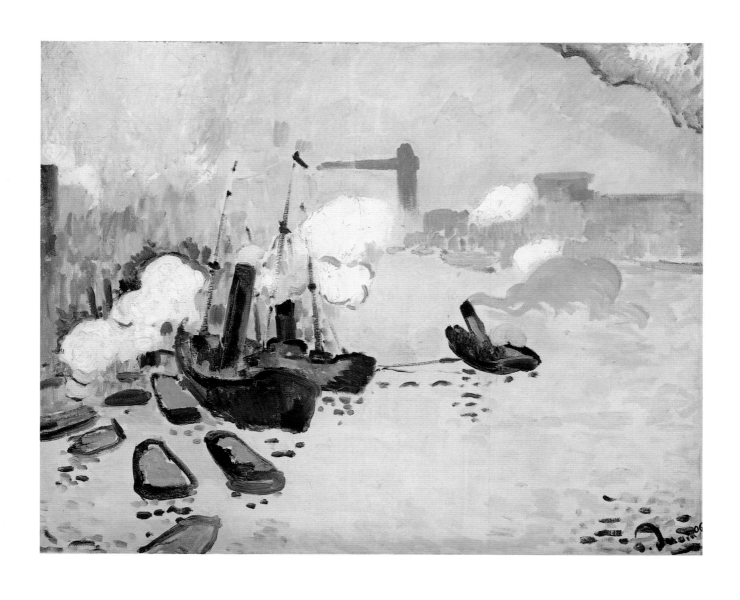

Maurice de Vlaminck
French, 1876–1958
Woman with a Hat, 1906
oil on canvas, 22¼ × 18¾ (56.5 × 47.6)
Gift (partial and promised) of Lili-Charlotte
Sarnoff in memory of Robert and Martha von
Hirsch 1981.84.1

Few twentieth-century artists prior to World War II
have worked harder to publicize their life and cre-
ate their own legend than Vlaminck. Author of no
less than five separate memoirs, Vlaminck claimed
for himself the invention of fauvism and the respon-
sibility for its demise as well as the discovery of
African art that, he claimed, led to cubism. Al-
though these claims can be dismissed, Vlaminck's
achievements as a fauve painter between 1905 and
1907 are nonetheless significant.

Vlaminck was influenced above all by Van Gogh.
He sought to match the emotional intensity of Van
Gogh's art by adopting the thick, heavily impastoed
brushwork, bright colors, and charged composi-
tions of the Dutch master. Vlaminck's *Woman with
a Hat* clearly displays this debt to Van Gogh, partic-
ularly in the way that Vlaminck enlivens the back-
ground surface with short, parallel brushstrokes.

Vlaminck's early paintings are difficult to date
with precision. It seems most probable, however,
that *Woman with a Hat* is one of several pictures of
dancers at the Parisian nightclub "Le Rat Mort,"
which Vlaminck painted in late 1906 when he was
working in Derain's studio. The motif may have
been inspired by Matisse's painting of the same title
of 1905. Matisse's *Woman with a Hat* was perhaps
the most controversial painting at the Salon
d'Automne of 1905, where the group of younger
painters that included Vlaminck, Derain, Henri
Manguin, Albert Marquet, and Jean Puy first exhib-
ited together and where the critic Louis Vauxcelles
was the first to call them *les fauves* (wild beasts).

Bibliography

John Elderfield, *The "Wild Beasts": Fauvism and Its
Affinities* [exh. cat., The Museum of Modern Art] (New
York, 1976).

Ellen C. Oppler, *Fauvism Reexamined* (New York, 1976).

Vlaminck: His Fauve Period [exh. cat., Perls Galleries]
(New York, 1968).

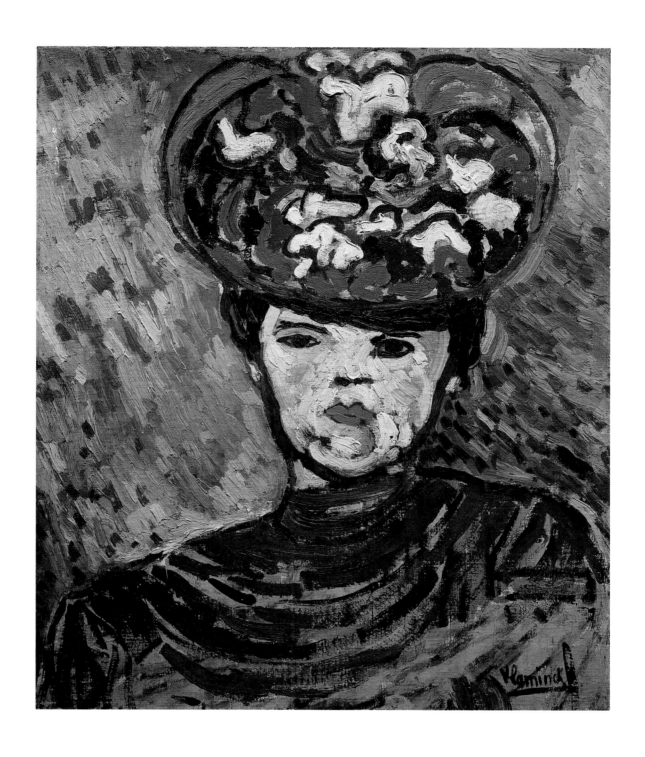

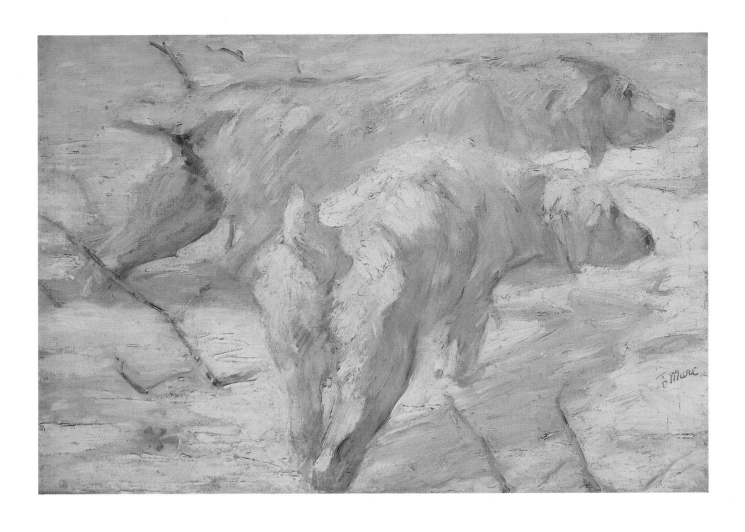

Franz Marc
German, 1880–1916
Siberian Dogs in the Snow, 1909–1911
oil on canvas, 31⅝ × 44⅞ (80.5 × 114.0)
Gift of Mr. and Mrs. Stephen M. Kellen
1983.97.1

Franz Marc's brief career was marked by a fascina-
tion with animals. Eventually the favored subject of
his painting became the horse, but he painted all
kinds of animals, wild and domestic. Animals rep-
resented for Marc a pure state of spiritual feeling.
He believed, paradoxically, that it was only by de-
picting animals that he could represent the finest of
human sentiments or the depth of human tragedy.
In *Siberian Dogs in the Snow,* Marc's subject is
especially personal: it is a portrait of his own sheep-
dog Russi, seen from two angles. According to Kan-
dinsky, Marc's relationship to his dog was particu-
larly close and empathetic; it typified the artist's
relationship to nature.

Siberian Dogs in the Snow precedes in date and
style the works of Marc's best-known period, a pe-
riod that begins with the founding, with Kandinsky,
of the Munich-based Blaue Reiter group of expres-
sionist painters in 1911 and closes with the artist's
military conscription in 1914. During those years
Marc began painting simplified forms in colors de-
termined not by natural appearance but by a
closely elaborated color symbolism. He progressed
to a futurist-influenced style in which forms are bro-
ken up into overlapping planes of color and tra-
versed by futurist "lines of force."

The earlier *Siberian Dogs in the Snow* neverthe-
less shows Marc concentrating upon two composi-
tional elements that would characterize his later
work: color and the repetition of form. Although his
palette is simplified, Marc is concerned here not
with color symbolism but rather with the interac-
tion of color and light. In a letter to his friend, the
painter August Macke, Marc described how the
painting resulted from an experiment in the use of
the prism to clarify tonal relationships.

Bibliography

Frederick S. Levine, *The Apocalyptic Vision: The Art of
Franz Marc as German Expressionism* (New York, 1979)

Mark Rosenthal, *Franz Marc: 1880–1916* [exh. cat.,
University Art Museum, University of California,
Berkeley] (Berkeley, 1979).

Félix Vallotton
Swiss, 1865–1925
The Wind, 1910
oil on canvas, 35⅛ × 45¾ (89.2 × 116.2)
Collection of Mr. and Mrs. Paul Mellon
1985.64.41

Vallotton is better known today as a printmaker than as a painter. He made etchings, engravings, and lithographs and was one of the pioneers of the late nineteenth-century revival of interest in the woodcut medium. Most of Vallotton's woodcuts were published between 1891 and 1901, the period of his association with the Nabis, a group of symbolist painters that also included Maurice Denis, Pierre Bonnard, and Edouard Vuillard. Vallotton's woodcuts are marked by a near-abandonment of modeling in favor of simplified patterns of black and white and a sophisticated use of line. Vallotton was an active social critic, and many of his prints were published in left-wing or anarchist journals.

Vallotton's paintings exhibit a curious combination of sharp, unsparing realism and chilled stylization. His favored subjects were landscape and the nude, but he also painted still lifes. Vallotton's best paintings, although more conservative in style than his prints or the paintings of his fellow Nabis, possess a disturbing intensity.

The Wind is an important example of Vallotton's distinctive achievement as a painter. Technically the painting appears somewhat anachronistic, for Vallotton has sought to reconcile the traditional academic interest in distinct outline with the impressionist concern for atmosphere at a time when neither concern was relevant to avant-garde painting. This quality is offset by the adoption (typical for Vallotton's landscapes) of an unusual viewpoint, here dividing the picture exclusively between tree-tops and sky. The lower half of the painting is all foliage, the top half sky, save for the silhouetted forms of trees bending in unison under a sudden gust of wind.

The sensibility of the painting is photographic: it calls to mind the "freeze-frame" effect in a photograph that captures an instant of violent motion. The analogy to photography can be extended further, for as in a photographic record of objects in motion, the speed of motion is not uniform. The tops of the pine trees are clearly caught against the sky, while some of the foliage below is a blur. The most surprising passage is the blur at lower left, so indistinct that it could be either rustling leaves, a cloud of dust, or both. The silver-gray color of the sky, and the limited range of dense, subtly interwoven tones in the foliage, also suggest the appearance of a photographic print.

Bibliography

Ashley St. James, "Vallotton as Printmaker," in *The Graphic Art of Félix Vallotton* [exh. cat., The Grunwald Graphic Arts Foundation, University of California, Los Angeles] (Los Angeles, 1972).

Maxine Vallotton and Charles Goerg, *Félix Vallotton: Catalogue raisonné de l'oeuvre grave / Catalogue Raisonné of the Printed Graphic Work* (Geneva, 1972).

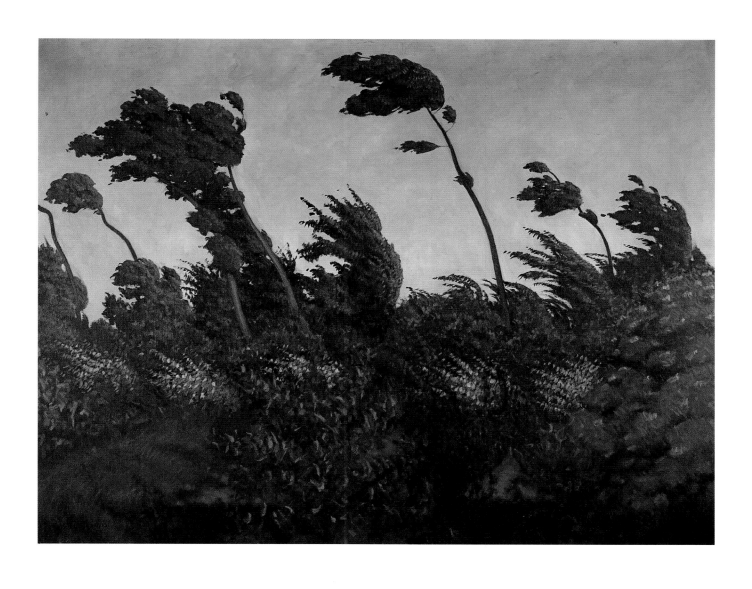

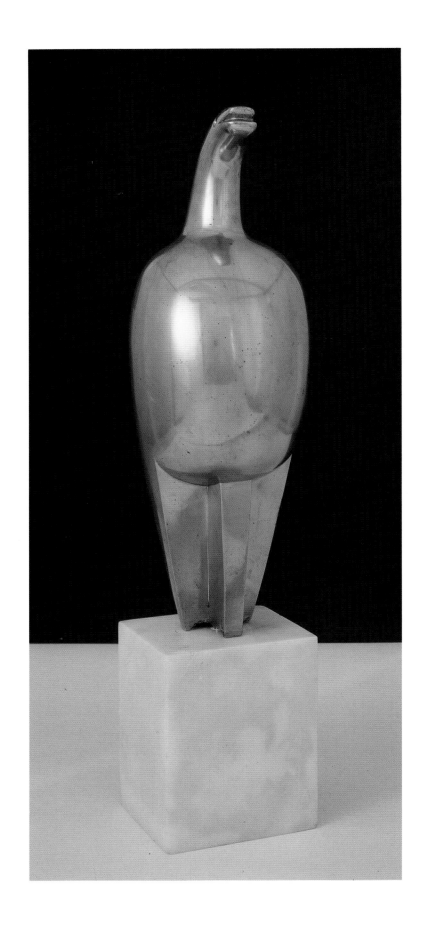

Constantin Brancusi

Romanian, 1876–1957
Maiastra, cast c. 1911
polished bronze, 22 × 7½ × 7⅜
(55.9 × 18.9 × 18.7)
Gift of Katharine Graham 1980.75.1

Maiastra represents a crucial moment in Brancusi's career and a key work in his oeuvre. The years 1907–1912 were transitional for the artist, as he moved from naturalism to forms highly abstracted from nature. *Maiastra*, or "master bird," stands at the midpoint in that process. Details of the bird's anatomy have been reduced to three areas: legs and tail, body, and neck and head. Seen from the front, these flow smoothly into one another, while from the side each is distinct. Throughout seven versions of *Maiastra*, one observes an increasing elongation of the figure, as the forms lose their discrete definition and become part of a single, swelling form.

The National Gallery *Maiastra* is one of four bronze casts. Although each of the bronzes derives from the original marble, which was probably begun in 1910 and is now in the Museum of Modern Art, New York, there are slight differences among them. Most sources agree that the National Gallery *Maiastra* is the second of the bronze casts. It was originally gilded, but the gilding was later removed. After completing the bronzes, Brancusi then carved two additional marble versions.

The title *Maiastra* refers to a magical bird well known in Romanian folklore who guides "Prince Charming" in his adventures. Much has been written about the relation of *Maiastra* to images of birds in African art and in Romanian folk art. In fact, Brancusi's synthesis of various styles and sources was so thorough that for *Maiastra*, as for most of his work, no convincing single source has been found. The *Maiastra* sculptures were the first in Brancusi's series of birds, a subject to which the artist returned throughout his career.

Bibliography

Barbu Brezianu, *Brancusi in Romania*, trans. Delia Razdolescu and Ilie Marcu (Bucharest, 1976).

Sidney Geist, *Brancusi: A Study of the Sculpture*, 2nd rev. ed. (New York, 1983).

Sidney Geist, "The Birds: A critique of the catalogue of a recent Brancusi monograph," *Artforum* 9 (November 1970), 74–83.

Pontus Hulten, Natalia Dumitresco, and Alexandre Istrati, *Brancusi* (New York, 1987).

Angelica Zander Rudenstine, *Peggy Guggenheim Collection, Venice* (New York, 1985).

Athena T. Spear, *Brancusi's Birds* (New York, 1969).

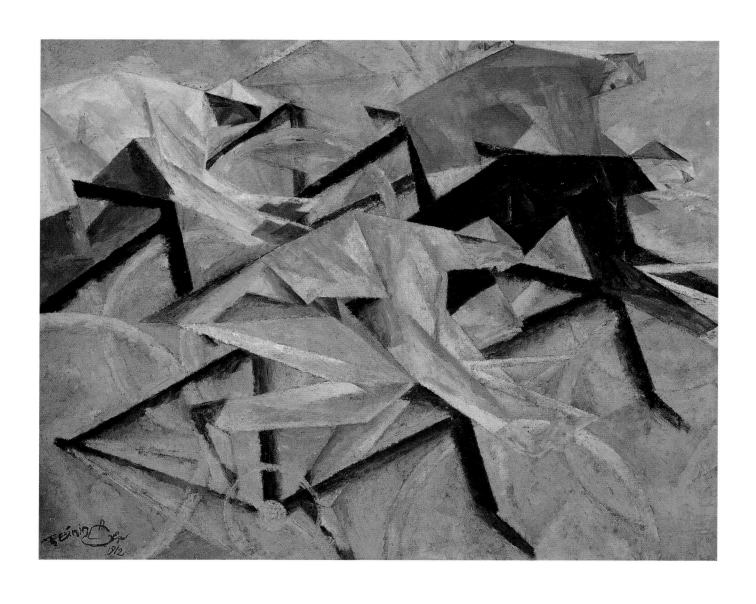

Lyonel Feininger
American, 1871–1956
The Bicycle Race, 1912
oil on canvas, 31⅝ × 39½ (80.3 × 100.3)
Collection of Mr. and Mrs. Paul Mellon
1985.64.17

Feininger, though an American, spent most of his career in Germany. Working first as a cartoonist and caricaturist, he began to paint in 1907, exhibited with the Blaue Reiter group in Munich in 1913, and joined the Bauhaus in 1919. Of decisive importance was a trip to Paris in 1911, when he exhibited six paintings at the Salon des Independants, the same salon in which a number of the cubists made their group debut in an official exhibition. Feininger wrote of his first encounter with cubism: "... I had gone to Paris for 2 weeks and found the art world agog with Cubism—a thing I had never heard even mentioned before, but which I had already, entirely intuitively, striven after *for years.*"

The division of forms into faceted planes in *The Bicycle Race* is evidence of Feininger's contact with cubism, but the painting also attests to the artist's unwillingness to sacrifice the legibility of forms by breaking apart their outlines. Feininger's experiences as a cartoonist may be suggested in his witty analogy between the heads of the bicyclists and their hats. In addition, *The Bicycle Race* may reflect Feininger's exposure to Italian futurism. The controversial futurist exhibition in Paris in early 1912 moved to Berlin in April of that year, where Feininger surely saw it. The depiction of spinning wheels and the organization of the composition through a series of forceful diagonals suggest familiarity with futurist concerns for the representation of energy and speed. Feininger's choice of subject here is also consonant with the futurist creed, although it should be noted that the subject of bicyclists had been treated by Feininger before, in a humorous painting of 1910 entitled *Velocipedists* and in cartoons.

Bibliography

Hans Hess, *Feininger* (New York, 1955).

June L. Ness, ed., *Lyonel Feininger* (New York, 1974).

Ernst Scheyer, *Lyonel Feininger: Caricature & Fantasy* (Detroit, 1964).

Henri Matisse
French, 1869–1954
Palm Leaf, Tangier, 1912
oil on canvas, 46¼ × 32¼ (117.5 × 81.9)
Chester Dale Fund 1978.73.1

Matisse made two trips to Morocco: one from January to mid-April 1912, and the other from October through February 1912–1913. By leaving Paris and immersing himself in a world of very different sensations (as he did repeatedly throughout his career), Matisse hoped to renew his contact with nature and expand the basis for his art. Certainly he was inspired by the traditional French fascination with North Africa. And for Matisse the sights of Morocco brought to life the North African paintings of Delacroix and his own recollections of the evocative nineteenth-century travel book by Pierre Loti, *Au Maroc.*

Toward the end of his first Moroccan trip Matisse began a painting in the large gardens of a private villa in Tangier. Initially dissatisfied with that picture, entitled *Park at Tangier,* Matisse determined to rework it upon his return in the fall. Yet when he returned, Matisse found the painting to his liking, and having promised his Russian patron Ivan Morosov a pair of Moroccan landscapes, he began two new paintings of the same garden in the same size and format. *Park at Tangier* and the two later works, *Moroccan Garden* and the National Gallery's *Palm Leaf, Tangier,* constitute an informal "triptych," united by subject and format but quite different in style.

Palm Leaf, Tangier, is the most freely painted of the three landscapes. Matisse later claimed that it was painted in a "burst of spontaneous creation—like a flame. . . ." The simile is apt, for the palm leaf—the central image in the painting—has the energy of a small explosion. The top half of the composition is carefully drawn and painted, while the bottom half is loosely blocked in with thin washes. At the center Matisse has left exposed a patch of light-colored ground, enhancing the effect of spontaneity and emphasizing the tonal contrast of the green brushstrokes of the palm leaf painted against it. The effect is completed by thin lines that further define the palm leaf, cut into wet paint with the butt-end of Matisse's brush.

Palm Leaf, Tangier, marks a high point in the artistic liberation Matisse sought in Morocco. Planes move back and forth and perspective shifts as Matisse pushes the very limits of representation.

Indeed the thinly painted, loosely brushed shapes and ambiguous forms of *Palm Leaf, Tangier,* remind one of nothing so much as the contemporary paintings of Kandinsky, one of the masters of early twentieth-century abstraction. Not until the end of his career would Matisse produce works so energetically abstract and so imbued with a sense of the paradisaical, the newfound Eden of the eye, mind, and spirit.

Prior to its acquisition by the National Gallery, *Palm Leaf, Tangier,* was in the collection of the great Matisse scholar and founding director of New York's Museum of Modern Art, Alfred H. Barr, Jr.

Bibliography

Alfred H. Barr, Jr., *Matisse: His Art and His Public* (New York, 1951).

Jack Flam, *Matisse: The Man and His Art* (Ithaca, 1986).

Pierre Schneider, *Matisse* (New York, 1984).

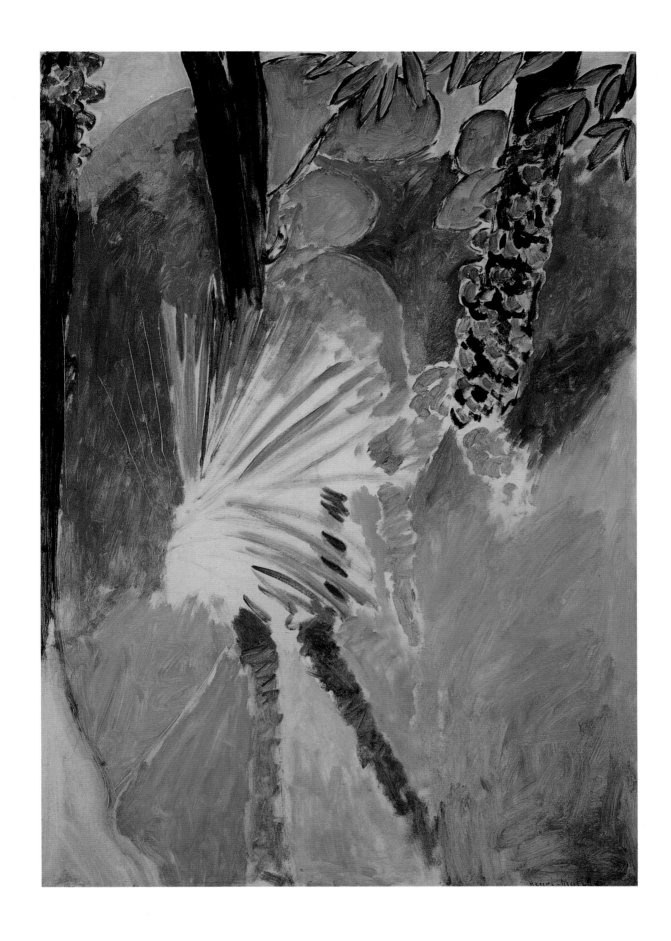

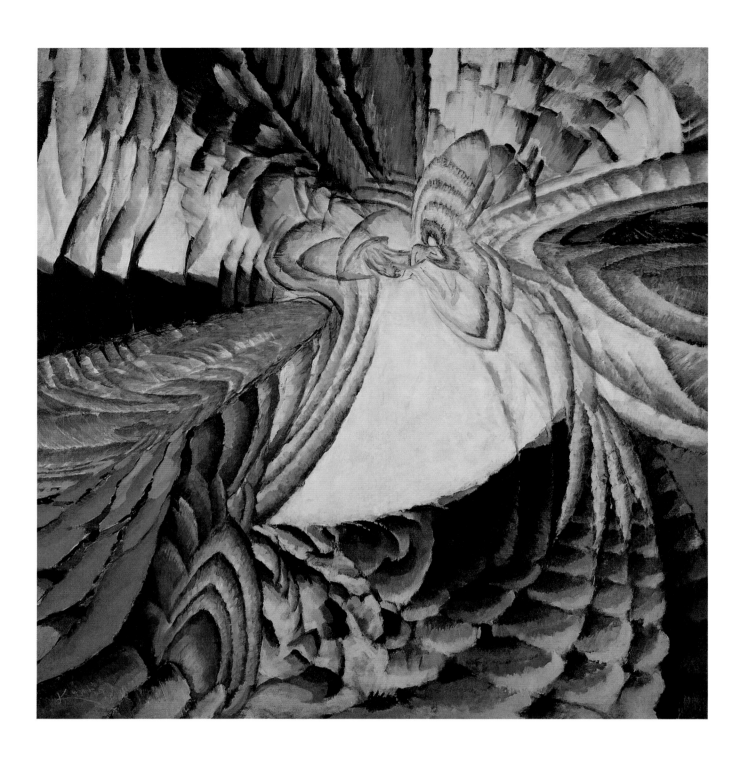

František Kupka
Czechoslovakian, 1871–1957
Organization of Graphic Motifs II, 1912–1913
oil on canvas, 78¾ × 76⅜ (200 × 194)
Ailsa Mellon Bruce Fund and Gift of Jan and
Meda Mladek 1984.51.1

After studying at the academies of Prague and Vienna, Kupka settled permanently in Paris in 1896. There his art evolved from the academic symbolism he had successfully practiced in Vienna toward a newer, abstract symbolism influenced by the color theories of neo-impressionism and fauvism and the poetics of Mallarmé. Kupka was also close to the cubist avant-garde of pre-war Paris. His neighbor and close friend in the Parisian suburb of Puteaux was Jacques Villon, and Kupka was well aware of the activities of the artists who lived in Puteaux. He was occasionally present at the meetings held in their studios attended by, among others, Villon, Raymond Duchamp-Villon, Marcel Duchamp, Fernand Léger, Albert Gleizes, Jean Metzinger, Francis Picabia, and the poet and influential critic Guillaume Apollinaire. Nevertheless, Kupka declared his separation from cubism and rejected many of its features, in particular its restricted palette and insistence on figuration. He developed an art that was in certain respects more radically abstract than that of any of his Parisian contemporaries.

Kupka's abstraction can be traced to his background in Eastern European spiritualism and mysticism. As a child in Czechoslovakia, he had been trained as a medium, and in Vienna he had been exposed to the theosophy of Madame Blavatsky and Rudolph Steiner. In his art he eventually sought to represent cosmic forces, aspects of a universal metaphysical order, rather than their material manifestations.

Organization of Graphic Motifs II reflects Kupka's spiritualism as well as his ideas about movement and color. An interest in the depiction of movement, common to a number of European artists at this time, was publicized in the Italian futurist painter F. T. Marinetti's *First Futurist Manifesto* of 1909. Kupka's independent interest in movement was stimulated by a fascination with cinematography and was certainly influenced by the motion studies of photographers such as Etienne-Jules Marey. The swirling lines and cascading sequences of colors in *Organization of Graphic Motifs II* result from Kupka's effort to produce an abstract representation of motion. The sequential or prismatic treat-ment of color also derives from Kupka's close study of nineteenth-century and contemporary theories of color, a subject about which Kupka himself wrote extensively.

Bibliography

Christopher Green, "Cubism and the Possibility of Abstract Art," in *Towards a New Art: Essays on the Background to Abstract Art 1910–20* (New York, 1980).

Meda Mladek and Margit Rowell, *František Kupka 1871–1957: A Retrospective* [exh. cat., Solomon R. Guggenheim Museum] (New York, 1975).

Wassily Kandinsky
Russian, 1866–1944
Improvisation 31 (Sea Battle), 1913
oil on linen, 53⅜ × 47⅛ (145.1 × 119.7)
Ailsa Mellon Bruce Fund 1978.48.1

Kandinsky gave the title "Improvisations" to a series of works painted between 1909 and 1913. That title distinguished these paintings from two other groups of works produced in the same years: the "Impressions," which were images painted after nature, and the "Compositions," more formal, conspicuously structured images. By contrast, the Improvisations were to appear, in Kandinsky's own words, "a largely unconscious, spontaneous expression of inner character, non-material nature." Loosely painted and seemingly abstract, the Improvisations look as if they were worked out directly on the canvas.

According to a number of scholars, however, the Improvisations are neither abstract nor entirely spontaneous. Kandinsky employed a consistent repertoire of veiled images and symbols throughout the series to represent his often biblical and apocalyptic subject matter. Moreover, he composed the Improvisations from preparatory drawings and watercolors, two of which survive for *Improvisation 31 (Sea Battle).* Kandinsky was not absolutely faithful to these preparatory studies: as he executed the final painting through a complex series of paint layers and washes, he would often make significant departures from his original design.

The central image of *Improvisation 31 (Sea Battle)* is a pair of sailing ships locked in combat. Cannons blast, and the ships are tossed by waves. Above and to the left the towers of a city tumble down. Kandinsky's subject, found in a number of the Improvisations, was probably inspired by the apocalyptic imagery of the Book of Revelations. Kandinsky denied that his interest in the symbolism of Armageddon in the years immediately preceding the First World War was a response to the talk of war prevalent at the time. Instead, he claimed that his concern was "a terrible struggle . . . going on in the spiritual atmosphere."

Bibliography

Vivian Endicott Barnett, *Kandinsky at the Guggenheim* [exh. cat., The Solomon R. Guggenheim Museum] (New York, 1983).

E. A. Carmean, Jr., *Kandinsky: The Improvisations* [exh. guide, National Gallery of Art] (Washington, 1981).

Will Grohmann, *Wassily Kandinsky: Life and Work* (New York, 1958).

Kandinsky in Munich [exh. cat., The Solomon R. Guggenheim Museum] (New York, 1982).

Hans K. Roethel with Jean K. Benjamin, *Kandinsky* (New York, 1979).

Rose-Carol Washton Long, *Kandinsky: The Development of an Abstract Style* (Oxford, 1980).

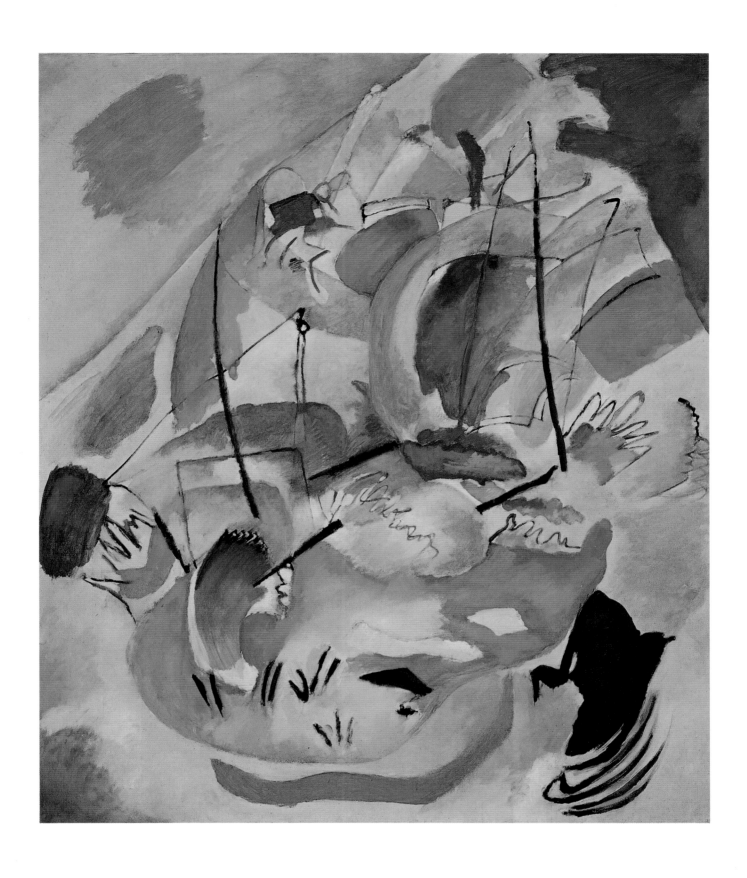

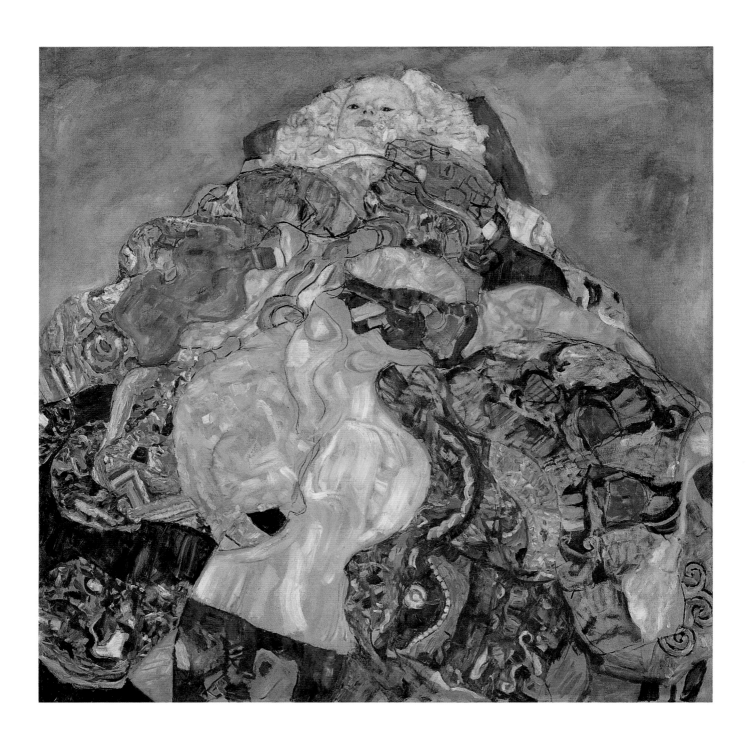

Gustav Klimt
Austrian, 1862–1918
Baby (Cradle), 1917–1918
oil on canvas, 43⅝ × 43½ (110.9 × 110.4)
Gift of Otto and Franziska Kallir with the help of
the Carol and Edwin Gaines Fullinwider Fund
1978.41.1

One of Klimt's last paintings, *Baby (Cradle)* typifies the artist's late style. The precise, finely detailed handling of surface characteristic of his earlier work has been displaced by broad, loose brushstrokes, and a renewed concern for pictorial structure is apparent in the sharply receding triangle that dominates the composition. The patterning so crucial to all of Klimt's painting has been retained, and that patterning, found in the quilt that covers the baby, virtually overwhelms the picture's subject.

Although Klimt made several drawings related to this painting, no other work in his painted oeuvre is devoted solely to the depiction of an infant. A baby appears prominently in a closely contemporary painting, *Death and Life* (1915), and in an earlier work, *Three Ages of Woman* (1905). In those paintings the infant stands in contrast to—or is overshadowed or threatened by—an image symbolic of aging or death. A similar juxtaposition of the themes of birth and death is also found in the disturbing *Hope I* (1903), in which Klimt places a group of grim heads and a skull directly above the figure of a young pregnant woman.

Baby (Cradle) was first exhibited in 1919 after Klimt's death, along with several other unfinished paintings from the artist's studio and a number of drawings. It remains unclear whether the composition should be seen as a simple affirmation of life and regeneration or whether it carries the more troubled meanings of works such as *Death and Life* and *Hope I*. Certainly Klimt had a penchant for ambiguity and mixed meanings.

Bibliography

Werner Hofmann, *Gustav Klimt* (Boston, 1977).

Jane Kallir, *Gustav Klimt, Egon Schiele.* [exh. cat., Galerie St. Etienne] (New York, 1980).

Fritz Novotnoy and Johannes Dobai, *Gustav Klimt* (New York, 1968).

Aleksandr Rodchenko

Russian, 1891–1956
Untitled, 1919
oil on wood, 15⅜ × 8⁵⁄₁₆ (39 × 21.1)
Gift of the Collectors Committee 1987.60.1

Rodchenko, one of the most important of the Russian constructivists, had a remarkably diverse career. His early paintings of 1912–1913 show the influence of symbolism and art nouveau. By 1915 he had turned to geometric abstractions drawn with the aid of ruler and compass. The lessons of cubist modeling and composition are evident in Rodchenko's paintings of 1918–1919, whereas in 1920 he painted severe compositions employing tiny points of color or straight, curved, or spiral lines that stand out against a monochrome ground. His constructed sculpture at this time elaborated upon principles established by Vladimir Tatlin: he used line and plane as opposed to mass to occupy and define space—drawing, in effect, in space. Rodchenko largely abandoned painting between 1921 and the mid-1930s. He turned to photography, becoming one of this century's masters, and he created theater sets and costume designs that employed a bright, geometric vocabulary. He also produced innovative graphic designs for books and posters in which line, image, and text are integrated into overall patterns of extraordinary dynamism.

In 1919, the year *Untitled* was painted, Rodchenko was working in many styles. *Untitled* is related to a group of works from 1918 and 1919 in which Rodchenko played bright circles off against broad diagonal lines. A complex and contradictory spatial structure was established by the overlapping of planes and by the extensive use of delicate modeling.

Untitled displays Rodchenko's continued loyalty at this date to the ideal of *factura*—the notion prevalent in Russian abstraction around 1915 that the ultimate concern of abstract art must be the truthful use and display of its materials. Rodchenko would soon reject *factura,* as would constructivist colleagues such as his wife, Varvara Stepanova, and Vladimir Tatlin (though not the suprematist Kasimir Malevich). But *Untitled,* with its cunning use of the wood grain of the panel and its subtle effects of shading, seems, if anything, an affirmation of that ideal.

Bibliography

David Elliott, ed., *Rodchenko and the Arts of Revolutionary Russia* (New York, 1979).

Camilla Gray, *The Russian Experiment in Art 1863–1922,* rev. ed. by Mariane Burleigh-Motley (London, 1986).

Selim O. Kahn-Magomedov, *Rodchenko: The Complete Work* (London, 1986).

German Karginov, *Rodchenko* (London, 1979).

Christina Loder, *Russian Constructivism* (New Haven and London, 1983).

Margit Rowell and Angelica Zander Rudenstine, *Art of the Avant-Garde in Russia: Selections from the George Costakis Collection* (New York, 1981).

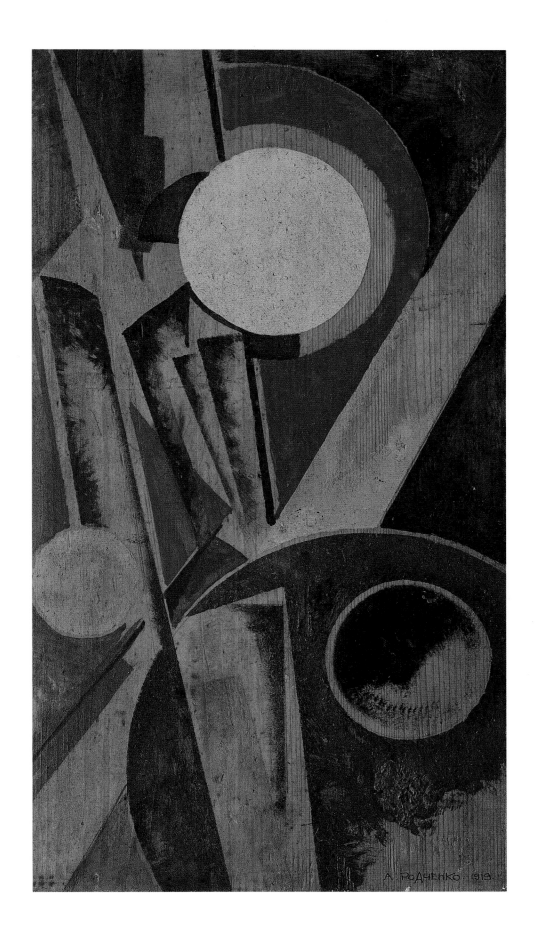

Joan Miró
Spanish, 1893–1983
The Farm, 1921–1922
oil on canvas, 48¾ × 55⅝ (123.8 × 141.3)
Gift of Mary Hemingway 1987.18.1

Miró decided to settle in Paris after visiting the French capital from his home in Barcelona in 1920. In Paris he tried to adapt the realist style he had practiced in Barcelona to the cubism still in favor among the Parisian avant-garde. Like many artists who emigrate from the provinces to an artistic center like Paris, Miró felt the need to assimilate the most advanced ideas of the capital while retaining his provincial identity. For Miró this meant associating not with the sophistication of Barcelona but with the primitive life of the Catalan countryside. Miró spent summers at his family's farm in the Catalan village of Montroig, and in 1921 he decided to make a painting of this farm, a painting that he came to regard as one of the key works in his career.

The Farm both looks back to Miró's realist painting and looks forward to the surrealism he would soon embrace. Less effort is made to accommodate cubism here than in the paintings that immediately preceded it, although there is still much tilting of planes and a tendency toward repeated geometric simplifications. Miró later claimed that his essential effort here was one of realism, that almost every detail was carefully observed and depicted precisely as seen. The focus on realistic detail, however, does not produce a realistic effect. Each object seems independently conceived and presented so that the painting has the quality of a catalogue of separate elements. The painting owes much of its extraordinary intensity to this quality. When in the mid-1920s Miró became part of the surrealist circle and abandoned realism in favor of automatism and abstraction, elements from *The Farm* would continue to appear in his paintings. The intensity of vision found in this work remained a standard for all of his later art.

Despite Miró's efforts, *The Farm* did not sell for several years after its completion. It was finally purchased from Miró by Ernest Hemingway.

Bibliography

Jacques Dupin, *Joan Miró: Life and Work* (New York, 1962).

Robert S. Lubar, "Miró Before *The Farm:* A Cultural Perspective," in *Joan Miró: A Retrospective* [exh. cat., The Solomon R. Guggenheim Museum] (New York, 1987), 10–13.

Margit Rowell, ed. *Joan Miró: Selected Writings and Interviews* (Boston, 1986).

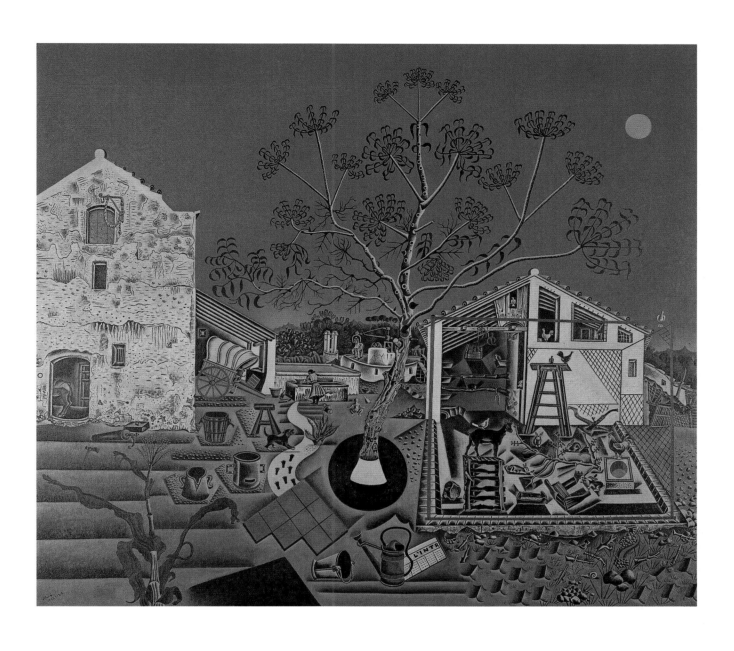

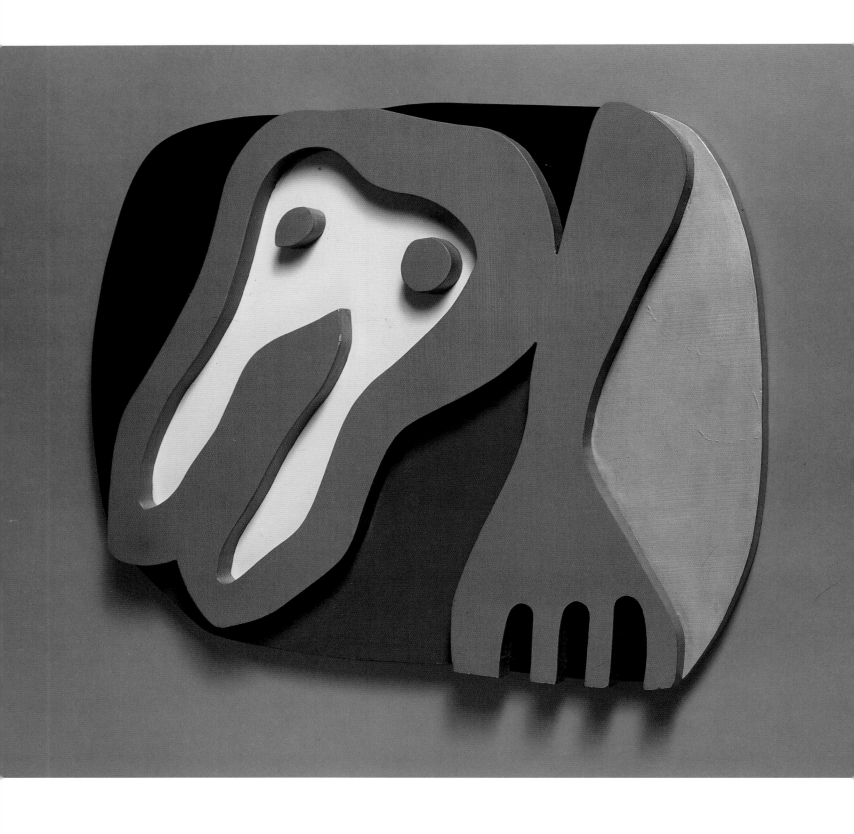

Jean Arp
French, 1887–1966
Shirt Front and Fork, 1922
painted wood, 23 × 27½ × 2⅜
(58.4 × 70 × 6.1)
Ailsa Mellon Bruce Fund 1983.3.1

Arp produced reliefs throughout his career, beginning in 1914 with the so-called Dada reliefs. These had their origin in drawings of abstract or biomorphic shapes that Arp gave to a carpenter to cut out of wood. Some of the reliefs may have been assembled from a collection of these cut-outs without reference to a prior plan or sketch. Others, like *Shirt Front and Fork,* were probably carefully composed before the individual shapes were given to the carpenter to cut. Most of the early reliefs were either painted, like *Shirt Front and Fork,* or polished, although in a few the wood was left partially or wholly untreated.

Shirt Front and Fork exemplifies Arp's gradual turning, in the early 1920s, from the aleatory aesthetic of Dada, where chance helped determine the choice and arrangement of subjects and forms, toward the more planned effects of ambiguity and bizarre juxtaposition that would come to characterize most surrealism. Arp not only brings two disparate objects together here but he reverses their normal scale, making the fork appear larger and more imposing than the shirt front. Moreover, the innocence of the juxtaposition of shirt front and fork is undercut by an alternate reading. Despite the title of the relief, the two objects can be seen equally well as a disembodied head and arm, placed down upon the flat ground.

Bibliography

E. A. Carmean, Jr., *Arp: The Dada Reliefs* [exh. brochure, National Gallery of Art] (Washington, 1983).

Robert Melville, "On Some of Arp's Reliefs," in *Arp* [exh. cat., The Museum of Modern Art] (New York, 1958), 27–33.

Bernd Rau, *Jean Arp–The Reliefs–Catalogue of the Complete Works* (New York, 1981).

Joan Miró
Spanish, 1893–1983
Head of a Catalan Peasant, 1924
oil on canvas, 57½ × 45 (146 × 114.2)
Gift of the Collectors Committee 1981.9.1

Between 1924 and 1925 Miró painted four versions of the *Head of a Catalan Peasant.* The National Gallery version is either the second or the third of these. All four have as their source a painting Miró produced in 1923, *Catalan Landscape (The Hunter),* which included a stick-figure peasant with a *barettina.* The *barettina* was a knit cap that served at the time as a highly charged symbol of Catalan nationalism. Miró adopted this figure as the central motif in the four paintings of the *Catalan Peasant.*

After completion of *The Farm* in 1922, Miró's style evolved with extraordinary rapidity. Many of the elements found in *The Farm* were transformed into pictographs or symbols in a group of transitional landscapes. Landscape itself, so carefully depicted in *The Farm,* is indicated by the simple expedient of a meandering horizon line in a painting such as *Catalan Landscape (The Hunter).* In the several progressively simplified versions of *Head of a Catalan Peasant* even that expedient is abandoned. The ground for these paintings is treated as a unified field of color. In the National Gallery version thin washes of yellow paint have been brushed unevenly across the canvas. This may show the influence of the surrealist theory of automatism wherein apparently accidental effects arrived at by painting or drawing without premeditation were seen as revelatory of unconscious thought processes.

In contrast to the "automatic" ground, the figure of the Catalan peasant derived from considerable planning and even preparatory studies. Details of the head are reduced to a minimum: a trailing beard at the bottom, two eyes, and the telltale hat. These features are united by three thin lines that form a kind of skeletal structure and define the figure against the ground. At the upper right a star and rainbow indicate that the figure is outdoors in a landscape.

Various readings unfold from this simple structure. The painting can be viewed according to its title as a depiction of a head. But one is tempted to see it also as a stick-figure, arms outstretched. The curving vertical lines of the beard recall similar lines indicating a plowed field in Miró's landscape *The Tilled Field* (1923–1924), making the horizontal line at which they meet a horizon line. What

had been part of a figure in a landscape is thus suddenly metamorphosed into an aspect of the landscape. All of these readings are made possible by the ambiguous and suggestive nature of the yellow ground. Miró's purpose here is not to present a mysterious image with a single hidden meaning, but to provide a scaffolding for multiple meanings.

Bibliography

Jacques Dupin, "The Birth of Signs," in *Joan Miró: A Retrospective* [exh. cat., The Solomon R. Guggenheim Museum] (New York, 1987).

Jacques Dupin, *Joan Miró: Life and Work* (New York, 1962).

Rosalind Krauss and Margit Rowell, *Joan Miró: Magnetic Fields* [exh. cat., The Solomon R. Guggenheim Museum] (New York, 1972).

Gaeton Picon, *Joan Miró: Catalan Notebooks* (New York, 1977).

Henri Matisse
French, 1869–1954
Pianist and Checker Players, 1924
oil on canvas, 29 × 36⅜ (73.7 × 92.4)
Collection of Mr. and Mrs. Paul Mellon
1985.64.25

In *Pianist and Checker Players* Matisse can be said to have painted a surrogate family portrait, a luxurious reprise of *The Painter's Family* (1911) painted thirteen years before. There Matisse depicted his wife and daughter with his two sons playing checkers. The family had gathered in the living room of their home at Issy-les-Moulineaux outside Paris.

Through the 1920s Matisse stayed in Nice from late fall to early spring of each year, while his wife and family remained in Issy. His favored model at the time was Henriette Darricarrère, and he made several drawings and paintings of her with her two brothers. *Pianist and Checker Players* is one of these. It is set in Matisse's Nice apartment and shows both boys in striped boating jackets. Henriette may be a stand-in for Matisse's daughter, and her brothers may represent his sons. But regardless of the relationship between the artist and his subjects, this is distinctively Matisse's world: near the empty armchair at the center of the painting his violins hang from the armoire and his drawings and paintings are tacked to the wall. On the bureau stands the reduced cast of Michelangelo's *Slave,* which appears in various of Matisse's paintings and drawings.

Whatever psychological complexities the painting may entail, these are more than matched by the complexities of its pictorial organization. Matisse is known as a master of pattern, but in few paintings does he manage to control such an extraordinary proliferation of pattern and ornamentation. To a degree Matisse painted what he saw: contemporary photographs record the arched screen and flowered wallpapers, striped tablecloth, diamond floor pattern, and oriental rug. Each element, however, is simplified and enhanced to create the most vivid effect. The extent of Matisse's decorative impulse is evident in the base of the *Slave.* Instead of painting what he saw here—a white base—Matisse added colored dots.

Matisse brings together not only a profusion of patterns in *Pianist and Checker Players* but also a number of viewpoints. Piano, chairs, floor, and bureau are each pictured from a different perspective. The complex interweaving of pattern and perspec-

tive is achieved with a remarkable sureness, evidenced in the thin application of paint. Rather than building up layers of pattern on top of layers of color, Matisse has achieved most of his effects here with a single paint layer. Although the dominant color of *Pianist and Checker Players* is the red of the rug, floor, and screen, Henriette's yellow dress and flecks of yellow distributed throughout suffuse the painting with a warm, golden tone as luminous as the Côte d'Azur outside his studio window.

Bibliography

Alfred H. Barr, Jr., *Matisse: His Art and His Public* (New York, 1951).

Jack Cowart and Dominique Fourcade, *Henri Matisse: The Early Years in Nice* [exh. cat., National Gallery of Art] (Washington, D.C., 1988).

Jack D. Flam, "Some Observations on Matisse's Self-Portraits," *Arts Magazine* 49 (May 1975).

Pierre Schneider, *Matisse* (New York, 1984).

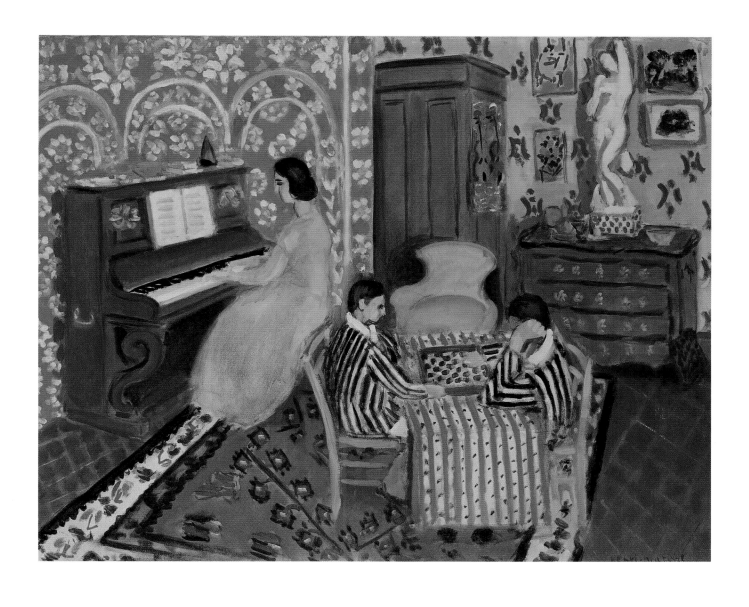

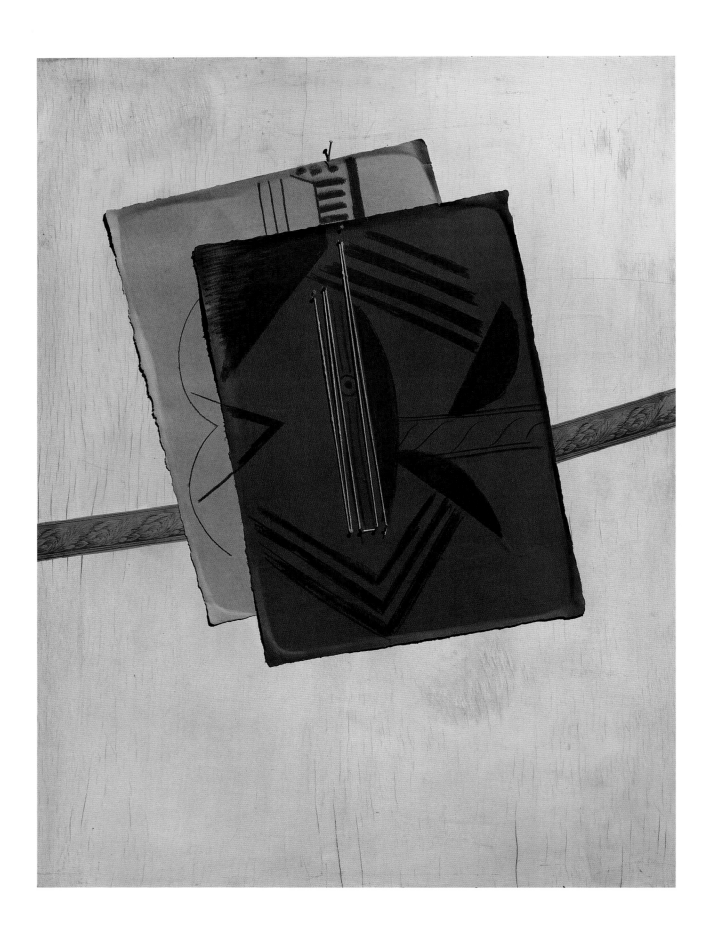

Pablo Picasso
Spanish, 1881–1973
Guitar, 1926
collage on wood, 51¼ × 38¼ (130 × 97)
Chester Dale Fund 1982.8.1

Guitar represents a revival of the collage technique that Braque invented around 1912 and that Braque and Picasso explored throughout the century's second decade. The work is unusual among Picasso's collages both for its large size and for its medium—the collage elements are mounted on wood rather than on paper or cardboard. Picasso made two other large collage guitars in 1926, both also mounted on wood, as well as nine much smaller versions mounted on cardboard. All of these he kept until his death, which suggests that they held a distinctly personal meaning for him.

In each of the three large versions the guitar is shown hanging from a nail, and the guitar strings are strung from nails. These nails are real. In the National Gallery version they have been hammered into the panel from the front. In the other two the nails were hammered in from the rear, and their sharp points project forward from the panel. The "dangerous" quality of those guitars was noted by André Breton when he named Picasso a surrealist and cited his collages as manifestations of surrealist concerns in the visual arts.

Picasso's *Guitar* evinces several characteristics meaningful to the surrealists. Of particular importance is the way Picasso calls forth a multiplicity of forms and metaphors through the image of the musical instrument. The body of the guitar can also be read as a head, or a male or female body. This kind of ambiguity had already been exploited in Picasso's earlier collages and had been taken up in different fashion by Miró.

Guitars were among Picasso's most favored subjects, and the National Gallery's *Guitar* recalls Picasso's collages of the same subject of 1912–1913. It also relates closely to his relief constructions of those same years. The monumentality and evident weight of the object, as well as its use of string and nails, lend it the quality of a sculptural relief. Picasso has left his materials whole—two full sheets of uncut paper, a long strip of wallpaper border, nails, and string. Through the placement of these few elements and drawing over them in charcoal, Picasso achieves an effect at once spare, monumental, witty, and suggestive.

Bibliography

John Golding, "Picasso and Surrealism," in *Picasso in Retrospect* (New York, 1973).

Clement Greenberg, "Collage," in *Art and Culture* (Boston, 1961).

Timothy Hilton, *Picasso* (London, 1975).

Rosalind Krauss, "Re-Presenting Picasso," *Art in America* 8 (December 1980).

William Rubin, *Picasso in the Collection of The Museum of Modern Art* (New York, 1972).

Christian Zervos, *Pablo Picasso,* vol. 7 (Paris, 1955).

Arshile Gorky

American, 1904–1948
The Artist and His Mother, c. 1926–1942
oil on canvas, 60 × 50 (152.3 × 127)
Ailsa Mellon Bruce Fund 1979.13.1

Gorky painted two versions of *The Artist and His Mother,* of which the painting in the National Gallery of Art is generally considered the earlier and that in the Whitney Museum of American Art the later. Both versions follow closely a photograph of Gorky and his mother taken when the artist was eight years old and still living in Armenia. The photograph was made to send to Gorky's father, who had emigrated to America in order to escape the Turkish draft. Gorky recovered the photograph many years later, after his mother's death, when he was reunited with his father in America. Although the photograph undoubtedly served as inspiration for the painting and provided its crucial source, the painting is much more a re-imagining than a copy. A number of additional sources have been suggested for the painting's style, ranging from an Ingres portrait to rose period and neoclassical Picasso.

The Artist and His Mother represents an effort to fix the memory of a lost moment. Gorky pictures himself with the innocence and insecurity of childhood, while his mother appears as solid and imperturbable as an icon. Gorky remembered a happy childhood brutally ended by the massacre and mass exodus of the Armenians from Turkey in 1915. His mother died of starvation in his arms in 1919. None of that is presented here, and the painting is remarkably free of any sense of tragedy or sentimentality. Nonetheless, Gorky's difficulty and mixed emotion in recovering a happier moment in his life can perhaps be inferred from the great length of time he worked on this painting, on its second version, and on a group of related drawings, one of which is in the graphic arts collection of the National Gallery. That difficulty also seems manifest in the multiple reworkings and repaintings that Gorky leaves apparent. *The Artist and His Mother* is a testament to Gorky's complex depth of memory, associations, and European culture.

Bibliography

Jim M. Jordan and Robert Goldwater, *The Paintings of Arshile Gorky: A Critical Catalogue* (New York, 1982).

Melvin P. Lader, *Arshile Gorky* (New York, 1985).

Harry Rand, *Arshile Gorky: The Implications of Symbols* (Montclair, N.J., 1981).

Diane Waldman, *Arshile Gorky 1904–1948: A Retrospective* [exh. cat., The Solomon R. Guggenheim Museum] (New York, 1981).

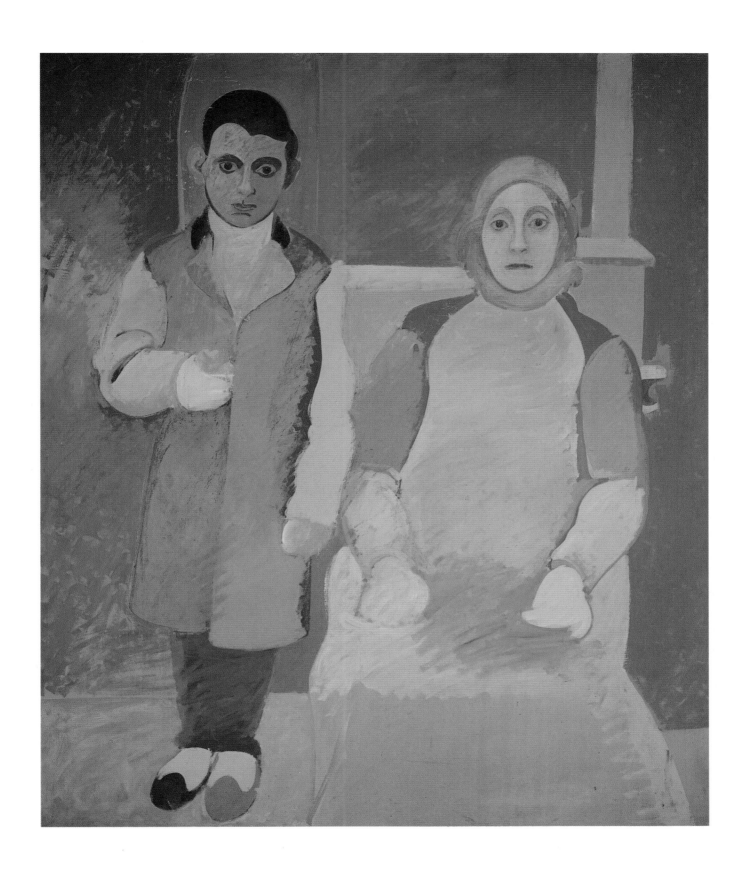

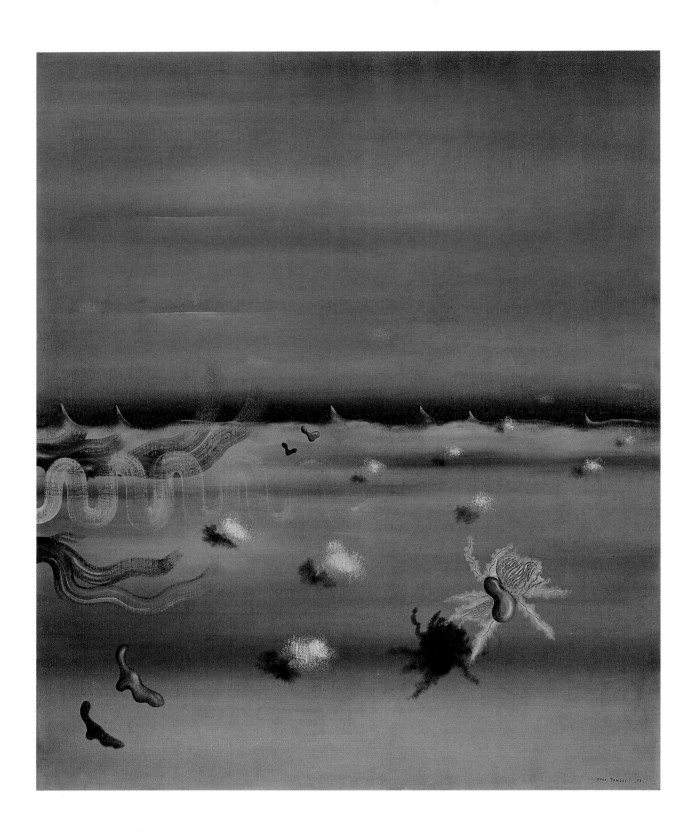

Yves Tanguy
French, 1900–1955
The Look of Amber, 1929
oil on canvas, 39⅜ × 31⅞ (100 × 81)
Chester Dale Fund 1984.75.1

Tanguy began to paint in 1923, arriving at his mature style by 1927. He remained remarkably faithful to that style for the remainder of his career. One of the major paintings of Tanguy's early maturity, *The Look of Amber* (*Le regard d'ambre*), was first owned by André Breton, author of the *Surrealist Manifesto* and founder of the surrealist movement. Neither naturalistic nor abstract, *The Look of Amber* presents a kind of dream-image in which closely depicted but unrecognizable objects float in a deep yet indeterminate and imaginary space.

Like each of the major figures of the surrealist movement, Tanguy had a distinct version of surrealism. He employed the technique of automatic drawing to trigger images, as did Miró and André Masson, but he treated the resulting biomorphic forms with a heightened degree of naturalism and illusion. Moreover, Tanguy was essentially a painter of landscapes: his forms are almost always placed in relation to a horizon that both structures the painting and provides a sense of spatial recession. The exact nature of Tanguy's landscape is never clear, however. Certain images seem like visions of the ocean floor, while others look like rock-strewn deserts. A group of paintings made in the early 1930s relates closely to the rocky formations Tanguy saw during a trip to the Sahara. *The Look of Amber,* however, most resembles a marine landscape.

Technically, *The Look of Amber* lies somewhere between the bravura illusionism of Dali and the deadpan of Magritte. Tanguy aims neither to shock nor to disarm. The muted colors, careful modeling, and use of varnish give to the painting a kind of "old master" look, a look sharply at odds with the implausible forms that cast shadows upon the sea floor. It is through such disjunctions that Tanguy achieves his most typical, and disturbing, effects.

Bibliography

John Ashbery, "Tanguy—The Geometer of Dreams," in *Yves Tanguy* [exh. cat., Acquavella Galleries, Inc.] (New York, 1974).

William S. Rubin, *Dada and Surrealist Art* (New York, 1968).

James Thrall Soby, *Yves Tanguy* (New York, 1955).

Georgia O'Keeffe
American, 1887–1986
Jack-in-the-Pulpit No. III, 1930
oil on canvas, 40 × 30 (101.6 × 76.2)
Alfred Stieglitz Collection, Bequest of Georgia
O'Keeffe 1987.58.2

Georgia O'Keeffe occupies a special place in the history of American art and in the American imagination. Her work, more than that of any other American modernist, has found a popular audience. She has become a distinctly American symbol for the purpose of art and the independence of the artist. Such renown necessarily brings as much misunderstanding as understanding, and certain aspects of O'Keeffe's work have dominated the public's perception to the exclusion of others. O'Keeffe is best known for her flowers, skulls, and Southwest landscapes. Less well known are her remarkable early abstractions, her watercolors and charcoals, her New York cityscapes, and her small, lovely still lifes. In addition, viewing O'Keeffe's work in a strictly American context has tended to obscure its complex relationship to both European and American modernism.

O'Keeffe's abstractions from 1916 to 1930 are especially close to the symbolist-derived abstractions of Kandinsky and Kupka. There is no question of direct influence; rather, the spiritual tenets of symbolism that undergirded the art of Kandinsky and Kupka were also available to O'Keeffe. These common symbolist ideas animated O'Keeffe's naturalism, most specifically the belief that the immanence of nature could be discovered in and through the refinement of form.

This belief seems especially evident in O'Keeffe's Jack-in-the-Pulpit series of 1930. In characteristically direct language, O'Keeffe described the genesis of the series during her summer visits with Alfred Stieglitz to Lake George: "In the woods near two large spring houses, wild Jack-in-the-pulpits grew—both the large dark ones and the small green ones. The year I painted them I had gone to the lake early in March. Remembering the art lessons of my high school days, I looked at the Jacks with great interest. I did a set of six paintings of them. The first painting was very realistic. The last one had only the Jack from the flower."

As the series unfolds, O'Keeffe looks deeper and deeper into the flower. The series begins with the striped and hooded bloom rendered with a botanist's care, continues with successively more abstract and tightly focused depictions, and ends with the essence of the jack-in-the-pulpit, a haloed black pistil standing alone against a black, purple, and gray field. In each step O'Keeffe moves closer to the flower's center, and in each step reaches progressively greater abstraction. Abstraction becomes here a metaphor of, and an equivalent for, knowledge—the closest view of the flower yields an abstract image; the most profound knowledge of the subject reveals its abstract form.

O'Keeffe's direct and generous involvement with the National Gallery of Art began in 1949 with her donation of 1,700 photographs by her husband, Alfred Stieglitz, followed in 1980 by a gift of Stieglitz portraits of her. O'Keeffe continued this tradition in her bequest to the Gallery of eight major paintings, the first of her paintings to enter the collection. The gift includes O'Keeffe's most important formal series of paintings, *Jack-in-the-Pulpit II–IV* (1930), as well as a subtly colored abstraction, *Line and Curve* (1927), a small still life of a spiraling snail shell, *Shell No. 1* (1928), and a large abstract painting from a series that was inspired by the view of the sky and distant horizon seen from an airplane, *Sky Above White Clouds* (1963).

Bibliography

Jack Cowart and Juan Hamilton, *Georgia O'Keeffe: Art and Letters* [exh. cat., National Gallery of Art] (Washington, D.C., 1987).

Charles C. Eldredge, "Nature Symbolized: American Painting from Ryder to Hartley," in *The Spiritual in Art: Abstract Painting 1890–1985* [exh. cat., Los Angeles County Museum of Art] (Los Angeles, 1986).

Lloyd Goodrich and Delores Bry, *Georgia O'Keeffe* [exh. cat., Whitney Museum of American Art] (New York, 1970).

Georgia O'Keeffe, *Georgia O'Keeffe* (New York, 1976).

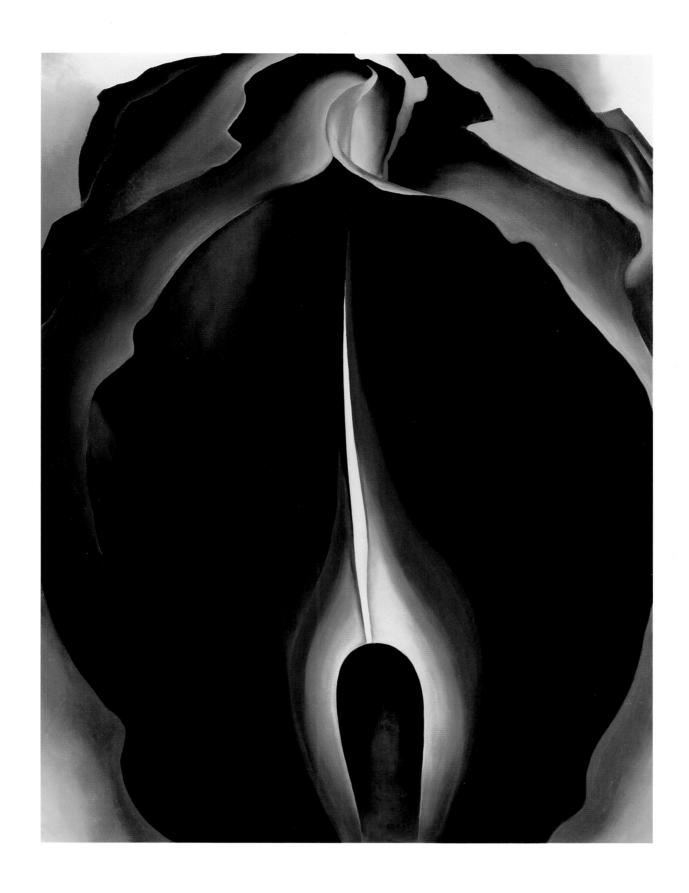

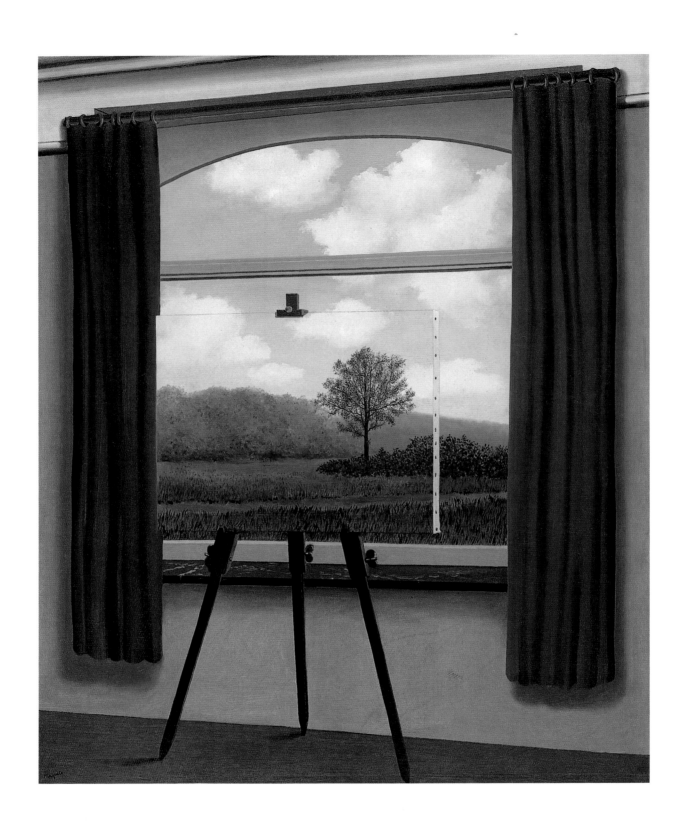

René Magritte

Belgian, 1898–1967
The Human Condition, 1933
oil on canvas, 39⅜ × 31⅞ (100 × 81)
Gift of the Collectors Committee 1987.55.1

Throughout his career Magritte returned often to a select group of themes. Two such favored themes were the "window painting" and the "painting within a painting." *The Human Condition (La condition humaine)* is one of Magritte's earliest treatments of either subject, and in it he combines the two, making what may be his most subtle and profound statement of their shared meaning.

The window has long served as a metaphor for painting, and the conventions of Renaissance perspective were predicated on the notion that one looked upon a painting in the same way one looked through a window. Even after the cubists had challenged that notion, the surrealist leader André Breton stated in a passage from his book *Surrealism and Painting,* which he published in 1928 and Magritte certainly would have read, ". . . it is impossible for me to consider a painting as other than a window, of which my first wish is to know *what it looks out on . . .* and I love nothing so much as that which stretches out before me and *out of sight.*"

In *The Human Condition* the image itself appears simple: an easel placed inside a room and in front of a window holds an unframed painting of a landscape that seems in every detail contiguous with the landscape seen outside the window. At first, one automatically assumes that the painting on the easel depicts the portion of the landscape outside the window that it hides from view. After a moment's consideration, however, one realizes that this assumption is based upon a false premise: that is, that the imagery of Magritte's painting is real, while the painting on the easel is a representation of that reality. In fact, there is no difference between them. Both are part of the same painting, the same artistic fabrication.

Even after a viewer reaches this conclusion, Magritte's painting continues to exercise a curious fascination. This results from the very illusionism that Magritte undertakes to criticize. Despite knowing that neither the painting nor the picture within it possesses a greater portion of reality, one is led, even against one's will, to repeat the initial assumption: to see the one as real, the other as representation. It is perhaps to this repeating cycle, in which the inadequacy of representation and per-ception becomes evident, that Magritte's title makes reference.

Not least of the qualities of *The Human Condition* is a sense of ironic detachment. This quality is achieved first by the simple elements out of which Magritte composes his picture, the very "homeyness" of the setting. It is also the result of Magritte's deliberately modest means. Although necessarily illusionistic, *The Human Condition* is not forcefully so: one is not swept away by trompe l'oeil detail or by plunging perspectival depth. The entire surface of the picture is even, uninflected. Magritte's aim here is not to call attention to his own skill as an illusionist, but to present an image that makes apparent the artifice of illusion.

The Human Condition was purchased directly from Magritte by Dr. Claude Spaak, a friend of the artist and a leading supporter of the Belgian surrealists. The painting was acquired from Dr. Spaak by the National Gallery through the generosity of the Collectors Committee. A keystone work in Magritte's oeuvre, *The Human Condition* was also reproduced frequently in European surrealist literature throughout the 1930s.

Bibliography

André Breton, *Surrealism and Painting,* trans. Simon Watson Taylor (London, 1972).

Richard Calvocoressi, *Magritte* (Oxford, 1984).

Michel Foucault, *This is not a Pipe,* ed. and trans. James Harkness (Berkeley, 1983).

Suzi Gablik, *Magritte* (London, 1972).

Harry Torczyner, *Magritte: Ideas and Images,* trans. Richard Miller (New York, 1977)

Arshile Gorky
American, 1904–1948
Organization, 1933–1936
oil on canvas, 49¾ × 60 (126.4 × 152.4)
Ailsa Mellon Bruce Fund 1979.13.3

Bibliography

Jim M. Jordan and Robert Goldwater, *The Paintings of Arshile Gorky: A Critical Catalogue* (New York, 1982).

Melvin P. Lader, *Arshile Gorky* (New York, 1985).

Harry Rand, *Arshile Gorky: The Implications of Symbols* (Montclair, N.J., 1981).

Diane Waldman, *Arshile Gorky 1904–1948: A Retrospective* [exh. cat., The Solomon R. Guggenheim Museum] (New York, 1981).

Gorky's portraits of the members of his family occupied an isolated place in his work. Islands of naturalism, they were produced at the same time Gorky's main efforts were directed toward mastering an abstracted form of synthetic cubism. *Organization,* painted in the same years Gorky was working on *The Artist and His Mother,* represents those primary efforts. Indeed, it is the culmination of Gorky's apprenticeship to the example of Picasso.

The formal vocabulary of *Organization* is closely related to Picasso's geometric "stick" style of 1927–1928 in which figures are reduced to straight black lines and the picture is divided into sharply outlined blocks of color. But whereas Picasso's stick paintings always presented human figures and objects in a clearly legible, albeit abstracted, fashion, in *Organization* Gorky leaves only one element of the painting recognizable: the black palette at center. Several writers have proposed Leger's purist paintings from around the 1920s as a secondary source for *Organization,* including in their argument the observation that Gorky's forms here are more mechanical than human.

Gorky's slow working method is reflected in the extraordinarily thick paint surface of *Organization.* Gorky squeezed whole tubes of oil paint onto his palettes and allowed the paint to dry for several days until it reached a thick consistency. He then spread the paint across the canvas with a palette knife. The operation was repeated a number of times as Gorky's ideas changed, and he frequently scraped off paint layers and reapplied a different color or painted a different shape. This unusual procedure lends a three-dimensionality to the painting, as one senses its actual weight. Moreover, the color scheme in *Organization,* which at first appears to be as clear as the firmly outlined forms, becomes a play of shifting tones as one notes the range of subtly mixed colors. In *Organization* Gorky has left apparent his debt to Picasso, but that debt has been repaid: having fully mastered Picasso's synthetic cubism, he has transformed that style into a powerful and personal idiom.

Max Ernst
German, 1891–1976
A Moment of Calm, 1939
oil on canvas, 66⅞ × 128 (169.8 × 325)
Gift of Dorothea Tanning Ernst 1982.34.1

Working in a variety of styles and media, Ernst was a remarkable technical innovator, inventing and refining a number of means to exploit the surrealists' cultivation of accident and the found object in painting, sculpture, and collage.

Throughout the 1930s Ernst painted many pictures of forests and birds. His forests, dense and overgrown, are usually portrayed as dangerous places where an all-devouring nature chokes off light and air. His birds too seem threatening, their talons extended, ready to grasp and tear. The creature that Ernst named Loplop, an invention half-bird and half-man, served as a kind of alter ego, a personal symbol and an ambivalent metaphor of the artist.

All of this imagery is brought together in *A Moment of Calm (Un peu de calme),* a painting Ernst began in 1939 soon after settling in the village of St. Martin d'Ardèche near Avignon. Originally the top of the painting was rounded, designed to fit into the top of an arched wall as a canvas mural in a garden room of the artist's home. When Ernst fled France for America in 1941, he left the painting in St. Martin d'Ardèche, and he did not recover it until 1953, by which time, exposed to the elements, it had begun to deteriorate. Following its recovery, Ernst restored *A Moment of Calm,* attaching a new rectangular canvas lining and adding new compositional elements, including the family of large birds, the moon, and the cloud at the left. The curved line of the original canvas can still be seen at the top.

Ernst's technique in *A Moment of Calm* is particularly fascinating. By scraping the canvas with a palette knife, a technique known as *grattage,* Ernst achieved a kaleidoscopic effect in which forms interpenetrate; they emerge from and are re-obscured by the dense foliage. The foliage here, more conspicuously painted and therefore less organic than in some of his other forest scenes, is not so threatening as in other depictions. It looms over but does not quite smother its inhabitants. According to Ernst's widow, the artist Dorothea Tanning, the changes Ernst made in the painting lightened its tonality and considerably brightened its mood, reflecting the artist's renewed optimism following the defeat of the fascist powers.

Bibliography

Werner Hofmann, "Max Ernst and Tradition," in *Max Ernst: Inside the Sight* [exh. cat., Institute for the Arts, Rice University] (Houston, 1973).

Roland Penrose, *Max Ernst* [exh. cat., Arts Council of Great Britain] (London, 1961).

Edward Quinn, *Max Ernst* (Boston, 1977).

William S. Rubin, *Dada and Surrealist Art* (New York, 1968).

John Russell, *Max Ernst: Life and Work* (New York, 1966).

Uwe M. Schneede, *The Essential Max Ernst* (London, 1972).

Werner Spies, "Max Ernst: A Succession of New Beginnings," in *The Menil Collection: A Selection from the Paleolithic to the Modern Era* [exh. cat., The Menil Collection] (New York, 1987).

Diane Waldman, *Max Ernst: A Retrospective* [exh. cat., The Solomon R. Guggenheim Museum] (New York, 1975).

Henri Matisse
French, 1869–1954
Still Life with Sleeping Woman, 1940
oil on canvas, 32½ × 39⅝ (82.5 × 100.7)
Collection of Mr. and Mrs. Paul Mellon
1985.64.26

At different points in his career Matisse favored particular subjects, motifs, and studio props. Beginning in the mid-1930s and continuing through the early 1940s, he created a number of paintings of women sleeping, often in decorative "Russian" or Romanian blouses. *Still Life with Sleeping Woman* is one of the most memorable of these. Technically, it is as close to watercolor as it is to oil painting. Matisse thinned his oil paint to transparency, and the light, painted ground and pencil underdrawing show through clearly, becoming essential parts of the color scheme and design.

Matisse contrasts the stillness of the model with the organic energy of the potted plants. As the model sleeps, the plants seem to spread their leaves across the painting. The leaf shapes in the upper right corner are closely related to cutout patterns found in Matisse's great book of 1947 entitled *Jazz*. Matisse analogizes these shapes to the hair of the sleeping woman. In turn, the model's head compares closely to one of Matisse's most important sculpture series, *Jeannette I–V* of 1910–1913.

Despite the loose, free handling of the paint and the abstracted form that characterizes *Still Life with Sleeping Woman,* most of the painting's details can be traced back to specific objects in Matisse's studio. The serpentine table top, for example, is found in many of Matisse's other paintings of this period. One might think that the back-and-forth pattern of purple brushstrokes covering its surface are a painterly expedient, but photographs of the studio reveal that the tabletop was a lush, variegated marble. Matisse's energetic brushwork thus conveys the irregular alternation of dark and light stone. The back wall of the studio is defined in the painting by the rectangle of three bright red and yellow lines that suggest a window, mirror, or picture frame. In fact, the red lines derive from the border for a study for a large tapestry entitled *Nymph in the Forest*. The tapestry was never executed, but the study was hanging in Matisse's studio during the late 1930s and early 1940s. Throughout his career Matisse represented paintings, sculpture, and mirrors within his paintings. Like the tapestry design in *Still Life with Sleeping Woman*, these self-referential images serve as symbols of Matisse's art.

Bibliography

Alfred H. Barr, Jr., *Matisse: His Art and His Public* (New York, 1951).

Pierre Schneider, *Matisse* (New York, 1984).

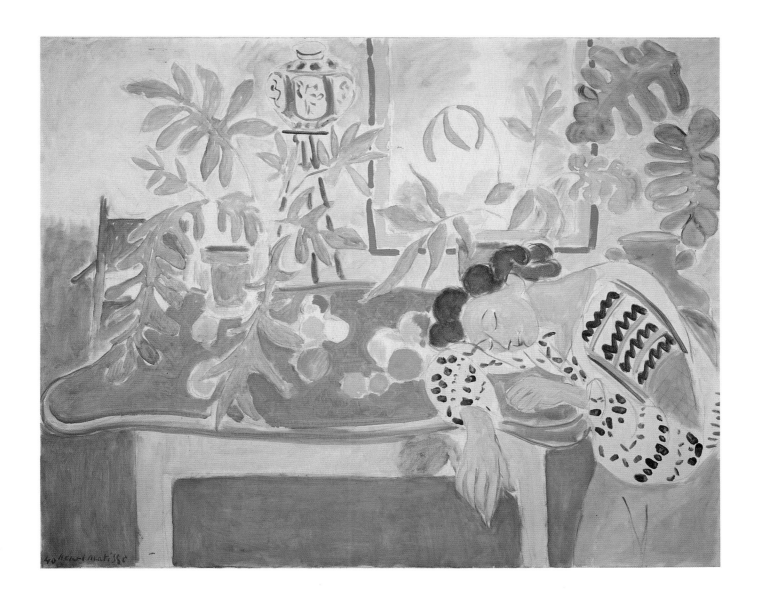

Arshile Gorky
American, 1904–1948
One Year the Milkweed, 1944
oil on canvas, 37 × 47 (94.2 × 119.3)
Ailsa Mellon Bruce Fund 1979.13.2

Writers on Gorky see 1944 as a turning point in the artist's career, the beginning of his mature period. Before that year his art was characterized by a series of deliberate apprenticeships wherein he sought to emulate the work and assimilate the theories of those artists he most admired. In each instance (as with *Organization* and Picasso, for example) Gorky produced paintings to rival his models, but, it is argued, he had not yet arrived at a distinctly personal style.

Gorky's creative breakthrough has been attributed to a number of factors, including a change of mood following his marriage in 1941 and a new and more profound interest in landscape as a subject. His friendship with André Breton also played a role. Breton, who had fled to the United States during the Nazi occupation, became a friend of Gorky's and proclaimed him an "official" surrealist. In accordance with surrealist theory, Breton urged Gorky to pursue greater automatism in his work, which had the effect of making his painting less imitative and more personal. Gorky's adoption of a more automatic procedure was in turn made possible by a change in technique. By thinning his paints, he could apply them to the canvas in transparent washes and produce much freer, more spontaneous effects than had been possible with his earlier technique of applying the paint in thick layers. This change in technique did not emerge *ex nihilo.* Miró and Matta used thin washes of color, as did Kandinsky in his early abstractions, but now Gorky would take the technique as his own and for his own ends.

The change is apparent in *One Year the Milkweed,* one of several so-called color veil paintings from 1944. Films of paint have been washed unevenly across the canvas, and evocative but indistinct forms have been brushed in (Gorky carefully reserved some areas of the white ground). Overall green and brown hues suggest a landscape, but there are no identifiable landscape forms and no spatial recession. Instead, vertical drips and the alternation of light and deep tones create a shifting, shimmering effect across the entire picture surface. There remains considerable overlapping of colors and shapes, but Gorky has made that overlapping

fully transparent. Despite the hard-won nature of his achievement, Gorky's mood here is one of lyricism and ease.

Gorky collaborated with André Breton in giving titles to a group of his paintings produced in 1944, among them *One Year the Milkweed.* Gorky's wife described the procedure as follows: "Breton came down New Year's Eve and Gorky told him something associated with or of each painting and Breton with his marvelous incision picked those of Gorky's words which made a title."

Bibliography

Jim M. Jordan and Robert Goldwater, *The Paintings of Arshile Gorky: A Critical Catalogue* (New York, 1982).

Melvin P. Lader, *Arshile Gorky* (New York, 1985).

Harry Rand, *Arshile Gorky: The Implications of Symbols* (Montclair, N.J., 1981).

Diane Waldman, *Arshile Gorky 1904-1948: A Retrospective* [exh. cat., The Solomon R. Guggenheim Museum] (New York, 1981).

Jean Dubuffet
French, 1901–1985
Lady with Pompon, 1946
mixed media and oil on canvas, 31¾ × 25½
(80.6 × 64.7)
Chester Dale Fund 1986.11.1

Lady with Pompon (La dame au pompon) figured in the second exhibition of Dubuffet's career, held at the Galerie René Drouin in Paris in 1946. That exhibition of forty-eight paintings, entitled *Mirabolus, Macadam et Cie / Hautes Pâtes,* caused something of a scandal. Dubuffet's use of rough, crude materials and coarse imagery was intended as an assault upon conventions of beauty, craftsmanship, and art in the wake of the Second World War. The assault provoked angry attacks from many critics, and some visitors slashed the paintings.

An image both dramatic and humorous, *Lady with Pompon* is typical of Dubuffet's self-proclaimed *haute pâte* (high impasto) technique. He concocted his paint from distinctly common materials that were previously foreign to art: tar, asphalt, and white lead, to which Dubuffet often added plaster debris, earth, cement, varnishes and glues, pebbles, sand and coal dust to provide color and texture. Objects could be added, too. In *Lady with Pompon* a wad of twine is used for pubic hair and the woman's pupils are made of broken pieces of colored glass. Dubuffet spread this resistant material thickly and unevenly, gouging and scratching to create or to emphasize an image almost like a low-relief sculpture.

Like many twentieth-century artists, Dubuffet admired the apparently unpremeditated forcefulness of tribal art. He had a special and active fascination for what he called *art brut,* raw art, the art of the insane and untutored children. This fascination may be reflected in the title of *Lady with Pompon* by the apparently childlike usage of the word "dame," or lady.

In contrast to the often hostile reaction he encountered in France, Dubuffet's work was well received by important American critics, collectors, and artists. Indeed, there are fascinating parallels between Dubuffet's style and subject in *Lady with Pompon* and Willem de Kooning's *Woman* series of the early 1950s, as well as between Dubuffet's mixed-media technique and Jackson Pollock's introduction of detritus, pebbles, and coins into his paintings beginning in 1947. *Lady with Pompon* was acquired in 1949 by the painter and collector Alfonso Ossorio. Ossorio's eastern Long Island home was frequented in the 1940s and 1950s by many of the New York School artists.

Bibliography

Andreas Franzke, *Dubuffet* (New York, 1981).

Mildred Glimcher, *Jean Dubuffet: Towards an Alternative Reality* (New York, 1987).

Max Loreau, *Catalogue des travaux de Jean Dubuffet,* vol. 2, *Mirabolus, Macadam et Cie (1945–1946)* (Paris, 1966).

Margit Rowell, *Jean Dubuffet: A Retrospective* [exh. cat., The Solomon R. Guggenheim Museum] (New York, 1973).

Peter Selz, *The Work of Jean Dubuffet* (New York, 1962).

William Baziotes

American, 1912–1963
Pierrot, 1947
oil on canvas, 42⅛ × 36 (107 × 91.5)
Ailsa Mellon Bruce Fund 1984.43.1

Bibliography

Lawrence Alloway, *William Baziotes: A Memorial Exhibition* [exh. cat., The Solomon R. Guggenheim Museum] (New York, 1965).

Michael Preble, *William Baziotes: A Retrospective Exhibition* [exh. cat., Newport Harbor Museum] (Newport Beach, Calif., 1978).

Although Baziotes was a central figure in the development of abstract expressionism, he worked in a manner quite different from the "action painting" of Jackson Pollock, Franz Kline, or Willem de Kooning. He painted slowly, building up images out of thin, overlapping layers of soft color. Drawn to surrealism in the early 1940s, Baziotes never abandoned figuration. His paintings always contain suggestive, biomorphic forms, which seem to float on, and through, the picture surface.

Despite the deliberated appearance and figurative nature of his paintings, Baziotes defined his technique as automatism and described it in the following terms: "There is no particular system I follow when I begin a painting. Each painting has its own way of evolving. One may start with a few color areas on the canvas; another with a myriad of lines; and perhaps another with a profusion of color. Each beginning suggests something. Once I sense the suggestion, I begin to paint intuitively. The suggestion then becomes a phantom that must be caught and made real. As I work, or when the painting is finished, the subject reveals itself."

Pierrot is one of a group of single-figure images painted by Baziotes in 1947. With several others, it refers back to the classic theme of the tragic clown, a subject treated in modernist painting most notably by Picasso and one that appealed to Baziotes much earlier in his career. In *Pierrot* the figure is painted the traditional white, and he wears a broad hat with tassles, which doubles for a head and ears. Although these features can be seen as humorous, there is also an element of the grotesque—in the armless torso, for example, or the batlike legs and the single, staring eye. The same eye is found in much darker-spirited paintings of the same year such as *Dwarf, Night Form,* and *Cyclops.* Baziotes noted that the eye in *Dwarf,* the first of these single-figure paintings, was suggested to him by the eye of a lizard (probably seen in a photograph). The eye also suggested a target.

Baziotes' early paintings of clowns were self-portraits, and he viewed the clown, whose humor traditionally masks a tragic core, as a double-sided symbol. In *Pierrot* both sides are brought forth.

Max Ernst
German, 1891–1976
Capricorn, 1948, cast 1975 (artist's proof, 1/2)
bronze, 95½ × 81½ × 59½ (242.5 × 206.9 × 151)
Gift of the Collectors Committee 1979.30.1

Although Ernst had made occasional constructions as early as 1919, his career as a sculptor was not established until 1934 when he spent a summer with Giacometti in Maloja, Switzerland. His first sculptures from that summer employed granite boulders as found objects, which he carved and painted. Soon, however, he arrived at what would be his primary sculptural technique—casting, either in plaster or in cement.

Capricorn is Ernst's most monumental sculpture. He cast the original version in cement for the home he shared with Dorothea Tanning in Sedona, Arizona, between 1946 and 1953. It was made as an assemblage of casts, and its parts derive from an assortment of found objects. The large staff, for example, was cast from milk bottles placed end to end. In 1963 he had an edition of six bronze casts made from the cement version, making several alterations along the way. Several more bronze casts were made in the mid-1970s before Ernst's death. The National Gallery version is one of two artist's proofs for the late casts.

Capricorn stands as a résumé of Ernst's sculptural themes. It contains many iconographic references, beginning with its relation to an earlier sculpture by Ernst, *The King Playing with the Queen* (1944). Its staff suggests another earlier sculpture, Ernst's destroyed *Standing Woman,* and anticipates a later Ernst sculpture, *The Genius of the Bastille* (1960). *Capricorn* has been interpreted as a surrealist family portrait, with Ernst and Tanning portrayed as the king and queen and the two small figures between them as their dogs. The two smaller figures have also been read as symbolic children, although the couple was childless. An ancient sign of the zodiac that stood for fertility and metamorphosis, Capricorn was traditionally represented by a figure whose body was half-goat and half-fish. Both aspects are present here, in the horns of the king and the flippers of the queen, as well as in the small figure held by the king and the fish in the queen's headdress.

Writers have proposed a wide range of formal influences, from Cycladic sculpture to African carvings and Hopi kachina dolls. Melding these sources and references, Ernst has made a striking sculpture full of monumental grandeur, iconographic allusion, and whimsical humor.

Bibliography

Sam Hunter, ed., *Max Ernst: Sculpture and Recent Painting* [exh. cat., The Jewish Museum] (New York, 1966).

Lucy Lippard, "The Sculpture of Max Ernst," *Arts* (March 1961).

Evan Maurer, "Dada and Surrealism," in *"Primitivism" in 20th Century Art* [exh. cat., The Museum of Modern Art] (New York, 1984).

Steven A. Nash, ed., *A Century of Modern Sculpture: The Patsy and Raymond Nasher Collection* [exh. cat., Dallas Museum of Art, National Gallery of Art] (New York, 1987).

John Russell, *Max Ernst: Life and Work* (New York, 1966).

Werner Spies, *Max Ernst: Fragments of Capricorn and Other Sculpture* [exh. cat., Arnold Herstand & Company] (New York, 1984).

Diane Waldman, *Max Ernst: A Retrospective* [exh. cat., The Solomon R. Guggenheim Museum] (New York, 1975).

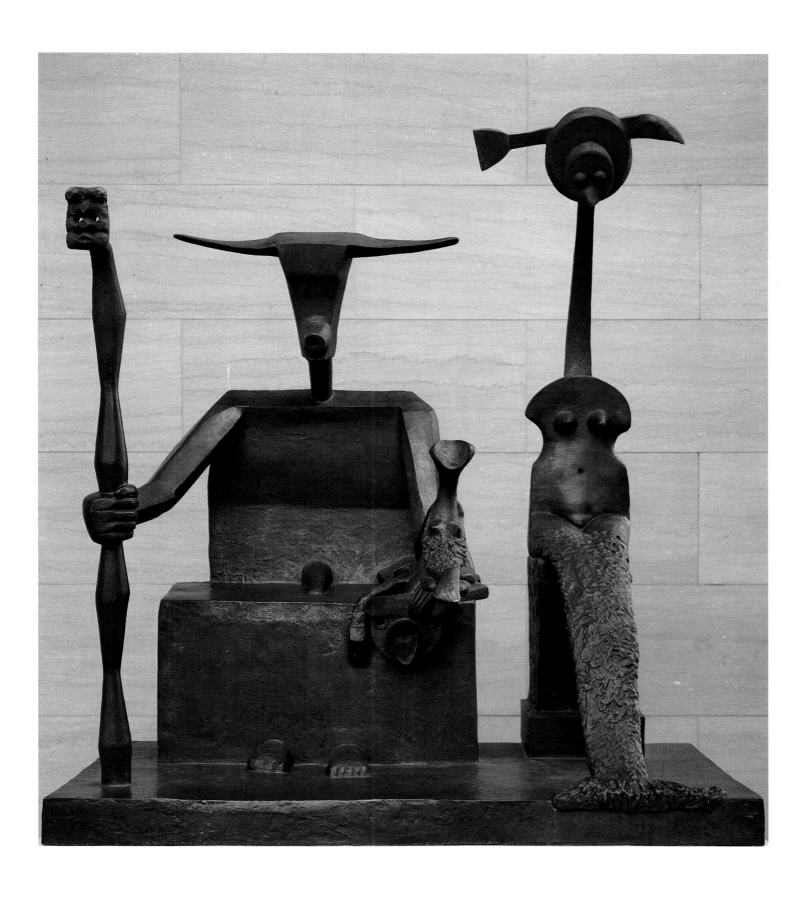

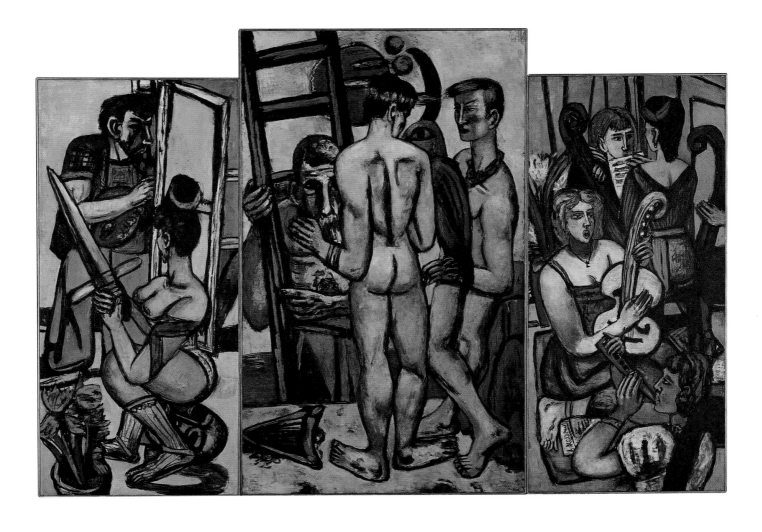

Max Beckmann

German, 1884–1950
The Argonauts, 1949–1950
oil on canvas, 72½ × 33½, 81 × 48,
73 × 33½ (184.1 × 85.1, 205.7 × 121.9,
185.4 × 85.1)
Gift of Mrs. Max Beckmann 1975.96.1 a–c

One of the signal achievements of Beckmann's career was the series of triptychs he began in 1932. The triptych format, traditionally associated with ecclesiastical art of the fifteenth and sixteenth centuries, was unusual in nineteenth- and early twentieth-century art. Beckmann found that the division of his paintings into three separate zones imbued his subjects with grandeur and a mythic air, and it allowed for complex interplays of narrative, reference, and allusion.

Beckmann's ninth and final completed triptych, *The Argonauts,* was finished only a day before the artist died (a tenth triptych, *Ballet Rehearsal,* was left unfinished). Beckmann had intended to paint a single canvas of himself as an artist with his model. That image, now the left panel of *The Argonauts,* inspired him to expand his original conception and paint a triptych that he planned to call "The Artists." The left panel thus would have represented painting, the right panel music, and the middle panel, with its central, garlanded figure, poetry.

In the course of painting the triptych, Beckmann was moved by a dream to rename it *The Argonauts.* In Greek mythology Jason and the Argonauts were heroes who traveled in search of the golden fleece. Beckmann's middle panel has at its center the poet Orpheus, at its right Jason, and at its left the sea god Glaucus, who in one ancient account foretells the future to Jason and Orpheus. The woman brandishing a sword in the left panel represents Medea, and the women in the right panel serve as a chorus.

The figure of the painter in the left panel, who stands in for Beckmann, suggests the autobiographical nature of the painting. In this context the painting's new title alludes to a group of poets and painters with whom Beckmann associated during his years in Amsterdam 1937–1947, who called themselves "the Argonauts." An important painting of Beckmann's youth, *Young Men by the Sea* (1905), is recalled by the central panel of the triptych. Multiple references have been suggested for the figures in the right panel, among them Beckmann's students, women in his family, and members of the Amsterdam underworld of cabarets and prostitution that Beckmann depicted in paintings such as *The Female Band* (1940). Out of these overlapping allusions, Beckmann creates an allegory for his own life and the life of the artist; a saga of worldly travail and eternal reward.

The Argonauts was given to the National Gallery by the artist's widow. Her gift also included two other late paintings by Beckmann, *Falling Man* (1950) and *Christ in Limbo* (1947), as well as an important group of drawings and notebooks.

Bibliography

Charles S. Kessler, *Max Beckmann's Triptychs* (Cambridge, 1970).

Carla Schultz-Hoffmann and Judith C. Weiss, ed., *Max Beckmann Retrospective* [exh. cat., The Saint Louis Art Museum] (Saint Louis, 1984).

Peter Selz, *Max Beckmann* [exh. cat., The Museum of Modern Art] (New York, 1964).

Alberto Giacometti
Swiss, 1901–1966
The Forest: Composition with Seven Figures and a Head, 1950
painted bronze, 22 × 24 × 19¼
(55.8 × 61.1 × 48.9)
Gift of Enid A. Haupt 1977.47.4

Giacometti, who in the late 1920s and early 1930s had produced some of the most complex, evocative, and disturbing sculpture of the surrealist movement, broke with the surrealist circle of André Breton in 1935. The break was occasioned by Giacometti's renewed interest in naturalistic figuration and portraiture, which resulted in a thorough revision of his artistic intentions and style. What began as a simple desire to sculpt the human figure became a ten-year struggle wherein Giacometti, working first from life and later without a model, sought to resolve the problem of how to represent figures contingent with their environment.

Giacometti came to believe traditional figurative sculpture operated from an idealistic premise. A portrait bust, for instance, represented the sitter as a closed, unitary, independent form, existing outside of time and context. Giacometti found that the longer he studied a figure, the less representable it became: he was unable to select the definitive features by which a figure should be shown and to separate what he saw from the complicated act of seeing. During the 1940s, as Giacometti pressed on with his research in sculpture, painting, and drawing, his ideas were clarified through conversations with his friend, the existential philosopher, Jean-Paul Sartre. In the late 1940s and 1950s Giacometti's sculpture and writings suggest a familiarity with the ideas of the phenomenologist Maurice Merleau-Ponty.

By 1946 Giacometti had established the essential elements of what would remain for two decades his distinctive sculptural style. Working in wet plaster (which could later be cast in bronze), he found that each mark or imprint of his fingers or a small knife recorded a separate and even contradictory instant of perception. His forms became thin, elongated, and deeply pitted. They seemed to dissolve into the air at their edges. Appearing as they did at the end of the Second World War, Giacometti's new sculptures were widely seen as expressing the ravages and atrocities of war and the fragility of human life.

Although Giacometti had broken with the official surrealist group and with many of its tenets, evidence of his earlier surrealist preoccupations remained in his postwar work. One of Giacometti's most important contributions in the early 1930s had been the tabletop tableau, sculptural elements organized on a horizontal plane in which the base served as the central object of the sculptor's concern. *The Forest* is among a group of Giacometti's postwar sculptures that modified this format. It is one of three such compositions that Giacometti executed in 1950 (the others are *The Glade* and *City Square*). At the time he was modeling several small independent figures and heads each day, and one day he entered his studio to find these works had been moved to clear space at a table and placed at random on the floor. Admiring their placement, he determined to cast two groups of sculpture (*The Forest* and *The Glade*) on common bases in the positions in which he found them.

Giacometti acknowledged the evocative power of the seven slender standing figures and the small bust in *The Forest* when he gave the work its title. In a letter to his dealer, Pierre Matisse, he explained: "The *Composition with seven figures and a head* reminded me of the corner of a forest, seen over many years during my childhood, where trees with naked slender trunks (limbless almost to their tops and behind which there were granite boulders) had always seemed to me like people stopped in their tracks and talking amongst themselves." The point, Giacometti explained, was not that his memory defined *The Forest,* but that the sculpture should incite memory and imagination.

A special aspect of this cast of *The Forest* can be seen in the delicately painted features of the heads. Giacometti occasionally painted his sculpture throughout his career, in some cases adding a general tone to a work, in others strengthening or adding features. Only visible in *The Forest* from close up, the tiny brushstrokes that barely suggest eyes or mouth give a heightened poignance to this oddly beautiful tableau.

The Forest is one of six Giacometti sculptures given to the National Gallery by Enid A. Haupt. The other five are: *Standing Woman* (c. 1947), *City Square* (1948–1949), *The Chariot* (1950), *Kneeling Woman* (1956), and *Walking Man II* (1960).

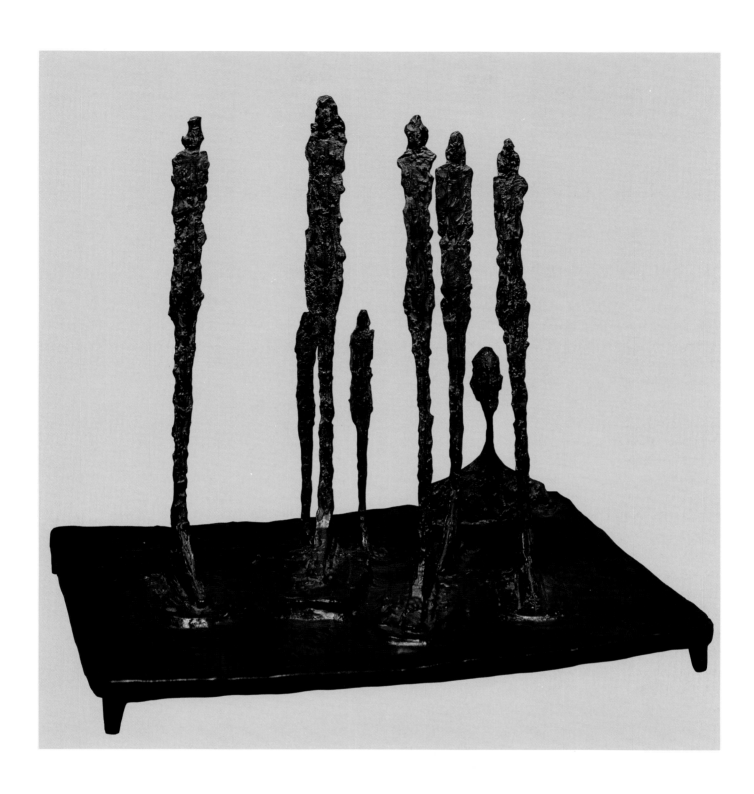

Bibliography

Valerie Fletcher, *Alberto Giacometti 1901–1966,* [exh. cat., Hirshhorn Museum and Sculpture Garden] (Washington, D.C., 1988).

Alberto Giacometti: A Retrospective Exhibition [exh. cat., The Solomon R. Guggenheim Museum] (New York, 1974).

Reinhold Hohl, *Alberto Giacometti* (New York, 1971).

Rosalind E. Krauss, *Passages in Modern Sculpture* (New York, 1977).

James Lord, *Giacometti: A Biography* (New York, 1985).

David Sylvester, "An interview with Giacometti by David Sylvester: Autumn 1964," in *Thirteen Bronzes: Alberto Giacometti* [exh. cat., Thomas Gibson Fine Art, Ltd.] (London, 1977).

Jackson Pollock
American, 1912–1956
Number 7, 1951, 1951
enamel on canvas, 56½ × 66 (143.5 × 167.6)
Gift of the Collectors Committee 1983.77.1

Bibliography

Lawrence Alloway, "Sign and Surface (Notes on Black and White Painting in New York)," *Quadrum* 9 (1960).

Elizabeth Frank, *Jackson Pollock* (New York, 1983).

Francis V. O'Connor, *Jackson Pollock: The Black Pourings* [exh. cat., Institute of Contemporary Art] (Boston, 1980).

Jackson Pollock's manner of painting changed dramatically in 1951. Turning from the abstract style of the "drip paintings" upon which his fame had recently been established, he began a series of works in thinned black enamel, returning at the same time to figuration. Considerable differences of opinion have emerged in the interpretation of this change of style and subject. Explanations range from the psychological to the formal, from Pollock's need to explore an iconography of personal imagery to his recognition that the possibilities of the drip style had been exhausted. It is probably a mistake to argue for any single explanation. In any event, as dramatic as the change appeared at the time, it was only one of a series of shifts and returns that the intensely self-critical Pollock experienced in his career.

The imagery in *Number 7, 1951*, is exceptionally legible. On the right is a striding figure whose head reads alternately as a single face seen straight-on, or two heads seen in profile. To the left stand a number of tall, reedlike forms that suggest a landscape, a suggestion heightened by the warm earth-tone of the ground. The image, like all of those in the series, is painted on unprimed or lightly primed cotton duck. Pollock purchased this industrial canvas in large sheets and, as with the drip paintings, cut them down as he painted. He found the center of the composition only in the process of painting and paring away.

Writers on Pollock's black paintings have come to call them "black pourings" because Pollock did not paint them directly with brush on canvas. According to his widow, the painter Lee Krasner, Pollock painted the black pourings using sticks and dried, hardened brushes that he used like sticks, dipping them into cans of industrial enamel and dripping the black paint onto the canvas. He also used basting syringes to draw up paint and squirt it onto the canvas in a controlled flow. Much of the paint is absorbed into the canvas, which creates a soft matte finish, but a portion at the center of each flow is not absorbed, and at these points the enamel reflects light, creating a lively, scintillating surface.

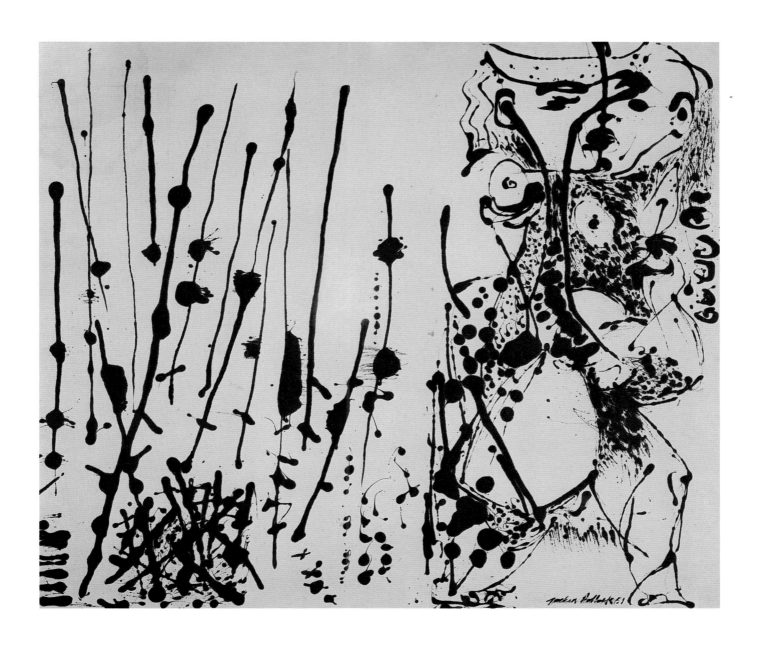

Joseph Cornell

American, 1903–1972
Untitled (Medici Prince), c. 1953
mixed media construction, 17 × 10⅝ × 4⅜
(43.2 × 27 × 11.2)
Gift of the Collectors Committee 1982.54.1

The Medici prince enclosed in Cornell's box is Piero de' Medici, son of Cosimo I, Grand Duke of Tuscany. Piero's portrait had been painted by Sofonisba Anguisciola, a sixteenth-century Italian mannerist. Cornell found the portrait reproduced in an art magazine, made a photostat print of it, and placed the photostat at the center of a box built from discarded Victorian molding. He set a sheet of blue glass with a grid pattern over but not touching the print, and at either side he fixed miniature reproductions of the portrait or fragments of it. At the prince's feet appear part of a map and two balls, one of blue cork and one of orange wood. The interior sides of the box display pieces of a Baedeker map showing the Moselle River, while several French texts are glued to the exterior.

Out of these disparate elements Cornell has constructed an object both mysterious and oddly coherent. It is one of the last in a group of works known as the Medici Slot Machine series, each of which has at its center the image of a Renaissance personnage. The series began with *Object (Medici Slot Machine)* (c. 1942), which uses the same portrait of Piero de' Medici as *Untitled (Medici Prince)*. The later object seems in many respects a reduction and refinement of the original.

Cornell's iconography is complex, and his symbols are always multivalent. Many of the objects in the boxes of the Medici Slot Machine series refer to specific places or events described in a history of the Medici family published in 1933. The imagery of *Untitled (Medici Prince)* may also reflect Cornell's fascination for the cinema. Despite the curious amalgamation of objects in this box, the overall effect is remarkably harmonious. Cornell took great care in composing and constructing his boxes, balancing vertical and horizontal elements while avoiding symmetry. Although individual elements may carry quite specific significations, Cornell is careful to keep his imagery evocative on a more general level: here a sense of distance and sadness prevails.

Bibliography

Kynaston McShine, ed., *Joseph Cornell* [exh. cat., Museum of Modern Art] (New York, 1980).

Sandra Leonard Starr, *Joseph Cornell: Art and Metaphysics* [exh. cat., Castelli, Feigen, Corcoran] (New York, 1982).

Diane Waldman, *Joseph Cornell* [exh. cat., The Solomon R. Guggenheim Museum] (New York, 1967).

Diane Waldman, *Joseph Cornell* (New York, 1977).

Mark Rothko
American, 1903–1970
Personage Two, 1946
oil on canvas, 56¹⁄₁₆ × 32¼ (142.2 × 81.9)
Gift of The Mark Rothko Foundation 1986.43.12

Untitled, 1953
oil on canvas, 76¹³⁄₁₆ × 67¹³⁄₁₆
(195.1 × 172.3)
Gift of The Mark Rothko Foundation
1986.43.135

Untitled, 1969
acrylic on canvas, 69⅝ × 62³⁄₁₆
(176.9 × 157.9)
Gift of The Mark Rothko Foundation
1986.43.163

In 1986 The Mark Rothko Foundation distributed its collection of Rothko paintings, drawings, and studies among twenty-nine American museums and six foreign institutions. The bulk of the foundation's holdings, a core collection of over nine hundred objects, was given to the National Gallery of Art. In accepting the gift, the National Gallery undertook the mission both to preserve the works and to promote the study of the collection. It also is committed, through its National Lending Service, to realizing the foundation's goal of making works by Mark Rothko available to other museums in this country and abroad.

The foundation's gift to the nation includes 195 paintings and 784 works on paper. Initially divided between 316 works intended for exhibition and a "study collection" of sketches, studies, unfinished works, and works in delicate condition, the gift will be substantially integrated as a catalogue raisonné and conservation treatments proceed. The foundation gift contains important works from all phases of Rothko's career. It includes early works of the 1930s, painted in a modified realist idiom that hints strongly at the idiosyncrasies of Rothko's later style; surrealist paintings and watercolors of the early and mid-1940s; "transitional" works of the late 1940s; "classic" abstract paintings of the 1950s; the darker abstract works of the 1960s, including paintings related to the Harvard and Seagrams mural projects; and the late series of brown-and-gray and black-and-gray paintings and works on paper.

Rothko is best known for his classic works of the 1950s and early 1960s, such as *Untitled* (1953), in which rectangular zones of color float on a colored ground. These paintings place Rothko among the foremost masters of his generation. Rothko's style was more subdued than that of Jackson Pollock, Franz Kline, or Willem de Kooning. Instead of conspicuously gestural brushwork, Rothko painted glowing clouds and fields of color in which contrasts and transitions of tone and the tension between the effects of compression and expansion control our emotional response. These classic paintings were almost always vertical and related in scale and format to the human body as well as to the traditional dimensions of the altarpiece. Although they are not explicitly religious, they seem to glow with a mysterious and ineffable light that speaks to a spirit of tragedy and transcendence.

In recent years greater attention has been paid to the American painting of the 1940s that was informed by two European vanguard movements: surrealism and geometric abstraction. Rothko's paintings and watercolors of these years, in the surrealist style, are more than preludes to his mature style. Many are considerable, fully realized works of art. A painting such as *Personage Two* (1946) reveals the community of interests that Rothko shared at this time with painters such as Adolph Gottlieb, Barnett Newman, Jackson Pollock, and William Baziotes. In various ways these artists demonstrated a concern for the issue of automatism. They were interested in ancient and native American mythology and, in most cases, in the psychoanalytic theories of Freud and Jung. Most of them saw the mission of art at this time as a quest for archetypes: hence their interest in the ancient, the primitive, the primeval. In *Personage Two* Rothko composed an anthropomorphic figure that seems more to float than to stand. Its undefined forms suggest a creature in gestation, while its multiple tendrils recall cellular life. There is little depth to the painting, but the flattened, hieratic stance of the figure and the imposing manner in which it fills the picture frame could imply a deity.

Toward the end of his life Rothko painted a series of brown-and-gray and black-and-gray paintings on paper and on canvas. In contrast to his earlier works, where color fills the entire surface of the picture, Rothko used masking tape in paintings such as *Untitled* (1969) to obtain a sharp white border around the perimeter of the image, clarifying the deliberate ambiguity of figure and ground that he had maintained in his classic paintings. Rothko's color is now considerably denser and more opaque than in his earlier work (partially a

Personage Two, 1946

result of his new use of acrylics). In his paintings of the 1950s Rothko had employed various tactics to frustrate the viewer's tendency to perceive his abstractions as landscapes. For instance, he floated areas of color in such a way that their junction could not be read as a horizon line. But now the colors do not float. Rather, they extend straight across to the edges of the composition. The black-and-gray paintings contain only these two restricted zones of color, and their meeting appears as a horizon line from which a flash of light projects.

Untitled, 1953

Untitled, 1969

Bibliography

Bonnie Clearwater, *Mark Rothko: Works on Paper* [exh. cat., American Federation of the Arts and The Mark Rothko Foundation] (New York, 1984).

Mark Rothko: Subjects [exh. cat., High Museum of Art] (Atlanta, 1983).

Eliza E. Rathbone, "Mark Rothko: The Brown and Gray Paintings," in *American Art at Mid-Century: The Subjects of the Artist* [exh. cat., National Gallery of Art] (Washington, D.C., 1978).

Robert Rosenblum, "Notes on Rothko's Surrealist Years," in *Mark Rothko: Notes on Rothko's Surrealist Years* [exh. cat., The Pace Gallery] (New York, 1981).

Diane Waldman, *Mark Rothko 1902–1970: A Retrospective* [exh. cat., The Solomon R. Guggenheim Museum] (New York, 1978).

Richard Diebenkorn
American, born 1922
Berkeley No. 52, 1955
oil on canvas, 58⅝ × 53⅞ (148.9 × 136.8)
Gift of the Collectors Committee 1986.68.1

Although Diebenkorn's style of painting has alternated over the years between figuration and abstraction, his abstraction has always retained ties to the natural world, to landscape in particular. This tie is evident in Diebenkorn's Berkeley series, painted between 1953 and 1955, of which *Berkeley No. 52* is a late and notably mature example.

Diebenkorn's early career had taken him to northern California, New Mexico, Illinois, and New York, and by the summer of 1953, which he spent in Manhattan, he was an accomplished member of the "second generation" of abstract expressionist painters. He left New York quite abruptly in the fall and settled in Berkeley, where several friends and colleagues had recently turned from abstraction to figurative painting. But for the next twenty months Diebenkorn expanded and refined his abstract style. His Berkeley paintings show the influence of Franz Kline and Willem de Kooning in their impulsive brushwork, but Diebenkorn combines rough areas of paint with smoother, more modulated passages. Brightly painted, they also show an interest in mastering complex combinations of tones and colors.

In *Berkeley No. 52* Diebenkorn controls a wide range of both colors and painterly effects by dividing the painting into discrete, interlocking zones. This "zone" approach to composition typifies much of Diebenkorn's abstract painting. Also characteristic is the relation that *Berkeley No. 52* bears to landscape. Its colors and shapes are suggestive of the San Francisco Bay and Berkeley Hills. With its complicated play of overlapping colors and variegated brushwork, *Berkeley No. 52* expands in an original fashion the abstract expressionist style developed by artists such as de Kooning and Kline.

Bibliography

Richard Diebenkorn: Paintings and Drawings, 1943–1976 [exh. cat., Albright-Knox Art Gallery] (Buffalo, 1976).

David Smith

American, 1906–1965
Sentinel I, 1956
painted steel, 89⅝ × 16⅞ × 22⅝
(227.6 × 42.9 × 57.5)
Gift of the Collectors Committee 1979.51.1

More than two decades after his death, the assessment of David Smith as the greatest American sculptor remains unchallenged. Like the American abstract expressionist painters with whom he associated, Smith transformed the achievements of European modernism into his own personal idiom. He melded aspects of the constructivist and surrealist traditions, influenced above all by Pablo Picasso, Julio Gonzalez, and Alberto Giacometti. He was an accomplished painter and draftsman as well and often painted his sculptures and addressed the use of sculpture to "draw in space." Smith explored in sculpture the genres of landscape, still life, and, above all, the human figure, making highly evocative objects that are often both figurative and abstract.

The first sculpture of the nine-part Sentinel series, which occupied Smith intermittently between 1956 and 1961, *Sentinel I* is typical of Smith's work in many aspects. It is welded together out of pieces of scrap metal and machine parts. And it has a distinctly linear quality that is enhanced by the uniform coat of black paint that covers the sculpture and makes its lines and shapes stand out as silhouettes.

As its title indicates, *Sentinel I* reads unmistakably as a human figure, but Smith's language of representation here depends far more upon syntax than resemblance. Seen independently, none of the welded pieces of *Sentinel I* would primarily suggest specific parts of the human body. Yet in placing these abstract elements together, Smith is able to articulate areas that suggest neck and head, spine, torso, legs, arms, and even hands. There is never any question of illusion: drawn as we are to read *Sentinel I* as a figure, we do not for an instant perceive the welded pieces of the sculpture as anything other than abstract shapes or metal parts.

Unlike most of Smith's sculptural series, the Sentinels are not distinguished by common material components or a shared style. All of the Sentinels, like *Sentinel I*, are vertical, organized around a central spine, and rigid in posture. E. A. Carmean has argued that *Sentinel I*, and the Sentinel series, had its genesis as a variation on a sculpture by Julio

Gonzalez entitled *Cactus Man Number 2* (1939–1940). Smith has grasped the central meaning of Gonzalez' sculpture and has transformed that into a prolonged personal meditation.

Bibliography

E. A. Carmean, Jr., *David Smith* [exh. cat., National Gallery of Art] (Washington, D.C., 1982).

Rosalind E. Krauss, *Terminal Iron Works: The Sculpture of David Smith* (Cambridge, 1971).

Karen Wilkin, *David Smith* (New York, 1984).

Pierre Soulages
French, born 1919
Painting, 1957
oil on canvas, 76¾ × 51⅛ (194.8 × 129.8)
Gift of Morton G. Neumann 1979.67.1

Soulages figured prominently among the group of artists in Paris following World War II whose art was termed *tachism* or *art informel.* Often likened to the New York School abstract expressionist painters, the *tachists* abandoned both representation and geometric abstraction to produce paintings dominated by the broad, gestural brushstroke, or *tache.* The direct *tachist* style has frequently been linked to the existentialist philosophy that emerged in Paris in those same postwar years.

Painting is typical of Soulages' work. It is composed of a grid of thick blue lines applied with a palette knife. Soulages has always denied that his painting is gestural. And indeed the execution of *Painting* speaks to the high degree of precision and control accomplished by careful movement of the hand and wrist rather than broader movements of arm and body. Compared to contemporary paintings of the New York School, *Painting* is relatively small and has a conspicuously ordered composition: three horizontal bands of color unified by a vertical spine. Moreover, while many artists of the New York School sought to unify figure and ground, Soulages maintains a clear hierarchy of distinctions. Dark, thicker strokes of blue lie atop lighter tones, and the entire blue mass seems to float upon a bluish gray ground.

Bibliography

Bernard Ceysson, *Soulages* (New York, 1980).

Sam Francis
American, born 1923
White Line, 1958–1959
oil on canvas, 108½ × 75¾ (275.6 × 192.4)
Gift of the Collectors Committee 1985.56.1

Bibliography

Sam Francis Paintings: 1947–1972 [exh. cat., Albright-Knox Art Gallery] (Buffalo, 1972).

Peter Selz, *Francis* (New York, 1975).

Living in Paris from 1950 to 1958, Francis developed a highly personal abstract expressionist style that brought together the spirituality evident in late work by Matisse and elements of oriental art and philosophy. His paintings of the early and mid-1950s contained floating clouds of highly saturated color. These paintings often began with a base of soft colors and became progressively dramatic as dark reds, blues, yellows, and blacks were added.

A turning point in Francis' style came about when he was commissioned to paint a series of huge murals for the Basel Kunsthalle, a grand commission (later dismantled) which occupied him between 1956 and 1958. Francis had always painted against a white ground, but for the Basel murals that ground became a pictorial element as active and independent as any of the colors laid against it. Following completion of the Basel murals, Francis continued to work increasingly with areas of white as discrete compositional elements. The color, which he described as a "ringing silence . . . an endless, ultimate point at the end of your life," held a special meaning for him.

In *White Line* white has commanded a place at the center of the canvas. Monumental in scale and effect, the painting is energized by the tension between the glowing color masses at either side and the open center, which seems to expand and contract at the same time, acting both as negative space and as a positive unit enlivened by a delicate tracery of thin paint drips and splatters. *White Line* is extremely fluid, the paint applied like so many of Francis' striking watercolors of the period, in a distinctive calligraphic gestural style.

The format of the white center that *White Line* so successfully explores has become a hallmark of Francis' work. The emptied, active center of the painting provides a taut compositional structure against which the artist can test jagged areas of brushed and stained color, producing arguably the most beautiful painting in the artist's White Line cycle.

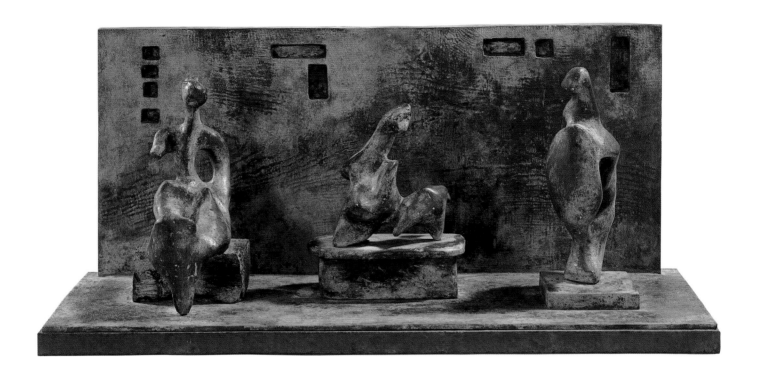

Henry Moore
British, 1898–1987
Three Motives Against Wall, Number 1,
1958/1959
bronze, 19⅞ × 42¼ × 17¼
(50.5 × 107.4 × 43.7)
Gift of Enid A. Haupt 1977.47.10

Moore once noted that sculpture, because it lacked a frame, was far more immediately tied to its environment than painting. Of course, the eventual setting for a particular work is a factor over which the sculptor often has little control once a sculpture has left the studio. Recognizing that fact, Moore began in 1956 a group of works that carry their own setting.

In *Three Motives Against Wall, Number 1,* Moore has set about creating an environment in a thoroughgoing manner. The three "motives" read as a sitting, a reclining, and a standing figure. Two of these figures are placed on benches, the third on a base. Each in turn rests on a large plinth from which a wall rises at the rear. Square and rectangular indentations in the wall suggest an irregular pattern of fenestration. In a recollection of Moore's surrealist sculpture of the 1930s, anatomical shapes can be discerned, but the rounded, organic forms seem to melt and flow in a continuing biological process.

The architectural quality of *Three Motives Against Wall, Number 1,* reflects Moore's involvement with several architectural commissions in the preceding years, including a large stone screen for the Time-Life Building in London in 1952, a brick wall-relief for the Bouwcentrum in Rotterdam in 1954, and a large reclining figure for the UNESCO headquarters in Paris, completed in 1958. Although in each instance Moore conceived the sculpture for a specific site and so could control its relation to the environment, he may still have felt some frustration at inadequacies in the sites themselves. By contrast, in *Three Motives Against Wall, Number 1,* the distinction between sculpture and architectural setting is erased. Moore here controls every aspect of the relationship.

Bibliography

Alan Bowness, ed., *Henry Moore: Sculpture and Drawings,* vol. 3, *Sculpture 1955–1964* (London, 1965).

John Russell, *Henry Moore* (New York, 1968).

David Sylvester, *Henry Moore* [exh. cat., The Tate Gallery] (London, 1968).

Barnett Newman
American, 1905–1970
The Stations of the Cross—Lema Sabachthani
and *Be II,* 1958–1966
acrylic, magna, and oil on canvas,
Stations: 78 × 60 each (198.1 × 152.4)
Be II: 80½ × 72¼ (204.5 × 183.5)
Robert and Jane Meyerhoff Collection
1985.65.1–15

Barnett Newman's fourteen *Stations of the Cross* stand as key monuments of American postwar art. Through them Newman communicates a powerful drama in the most starkly simple terms. He uses only black and white paint on unprimed canvas to evoke a full range of human experience, from suffering to exaltation. Seen as a whole, the series strikes one by its power and unity of conception. Viewed individually, each in turn, the fourteen paintings reveal considerable variety and subtlety of execution that make the overall effect of the series all the more intense.

The series had its genesis in February 1958, when Newman began two paintings on canvases of identical dimensions. Instead of the colored oils on primed canvas that he had painted before, Newman used only black magna, a quick-drying acrylic paint, on unprimed canvas. These two paintings set Newman off in a new direction, but he had not conceived them as a series. Newman kept the pictures in his studio and two years later returned to them, deciding then to make a series of four. Only when the two new paintings were completed did he determine that the four works would form the beginning of a series informed by the theme of the Stations of the Cross.

The fourteen Stations of the Cross were codified as a theme of Catholic devotion in the eighteenth century. Traditionally, images of each Station, from Christ condemned to death through the Entombment, were placed at intervals around the nave of a church so that the devout, in a kind of pilgrimage, could retrace the steps of the Passion. Newman does not focus here on specific acts of God and man but on shifts and contrasts of tone and on the marks that his brush leaves on raw canvas—that is, on acts of the artist, remnants of the artist's gesture. Instead of the specific incidents of the Passion, Newman is concerned with their thematic unity as a universal symbol of human suffering and of the question raised by that suffering—Christ's final cry "Lema Sabachthani"—Why have you forsaken me?

The coda to the series, *Be II,* may introduce a note of resolution and affirmation. It is painted on primed canvas, unlike the *Stations,* and incorporates a single line of orange paint along one side.

Bibliography

Lawrence Alloway, *Barnett Newman: The Stations of The Cross—Lema Sabachthani* [exh. cat., The Solomon R. Guggenheim Museum] (New York, 1966).

Thomas B. Hess, "Barnett Newman: The Stations of the Cross—Lema Sabachthani," in *American Art at Mid-Century: The Subjects of the Artist* [exh. cat., National Gallery of Art] (Washington, D.C., 1978).

Barnett Newman, "The 14 Stations of the Cross, 1958–1966," *Art News* 65 (May 1966).

Harold Rosenberg, *Barnett Newman* (New York, 1978).

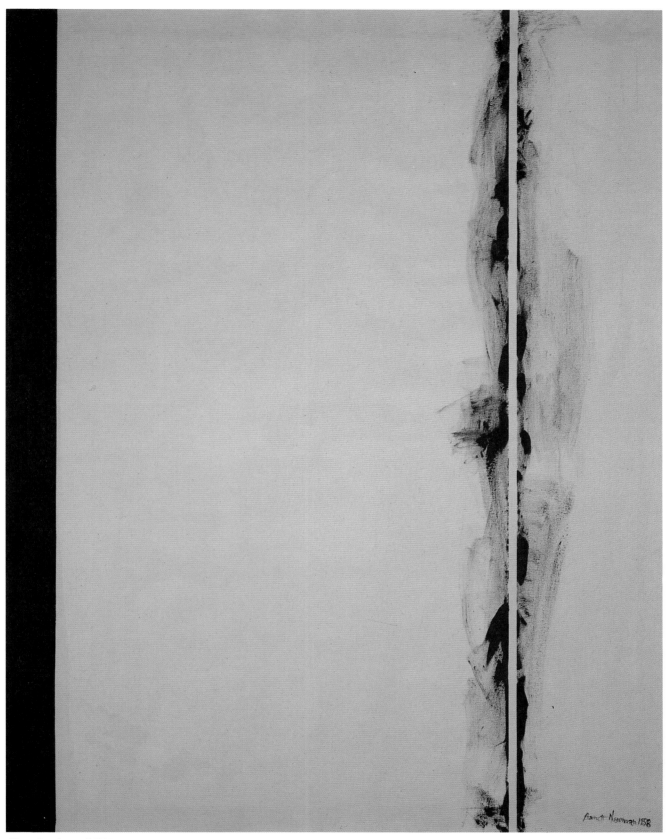

First Station, 1958

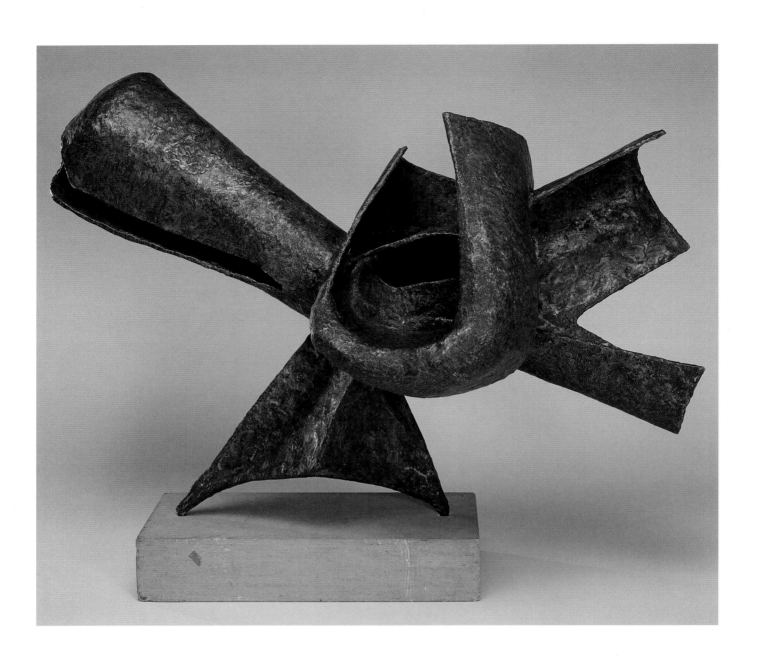

Seymour Lipton
American, 1903–1986
Sower, 1960
nickel silver on Monel metal, 26½ × 44 × 14
(67.3 × 111.8 × 35.6)
Ailsa Mellon Bruce Fund 1987.35.1

Lipton began to draw and paint at an early age, and his artistic career followed the pattern of many American abstract expressionists as he moved from figuration to surrealism to abstraction. Lipton's first profession was dentistry, but over the course of the 1930s sculpture occupied an increasing share of his energies, and he began to exhibit works in group shows. His first one-man exhibition was held in 1938.

Lipton's earliest sculpture was carved. Then in the 1940s he began to experiment with metal, and in the early 1950s he invented a technique of brazing sheet metal with bronze or nickel silver. This technique became an essential element of Lipton's style. It allowed him to create sculpture of richly modulated, almost painterly surfaces that display great formal freedom and inventiveness.

Although abstract, Lipton's sculptures are highly metaphoric in form and in relation to their evocative titles. Formally, Lipton was concerned with easily legible contrasts and oppositions, pairings and enclosures. In each of his works he stressed either horizontality or verticality. In *Sower,* one of Lipton's "horizontal" compositions, the thrust of an outstretched arm and the weight of a bag of seed are suggested, but no element of the sculpture is literally representational. A complex interplay of curves and angles, jutting forms and protected interiors, contributes to the strong horizontal effect, which is balanced by the angle of the upright and the curved forms just off center.

Bibliography

Albert Elsen, *Seymour Lipton* (New York, 1970).

Sam Hunter, "Seymour Lipton," in *Seymour Lipton: Sculpture* [exh. cat., Mint Museum of Art] (Charlotte, N.C., 1982).

Harry Rand, *Seymour Lipton: Aspects of Sculpture* (Washington, D.C., 1979).

Seymour Lipton: Sculpture [exh. cat., Hillwood Art Gallery, Long Island University, C. W. Post Campus] (Greenvale, N.Y., 1984).

Henry Moore
British, 1898–1986
Stone Memorial, 1961–1969
travertine marble, 59¾ × 68⅞
(151.7 × 174.9)
Collection of Mr. and Mrs. Paul Mellon
1983.1.71

Moore's sculpture can evoke many simultaneous associations. He favored certain forms—weathered bones and wood, landscapes of hills and valleys, pebbles, the human figure—but while one form may seem dominant in a particular sculpture, the essence of other forms is usually contained within.

To this art of multiple associations, Moore added a special sensitivity to the innate character of his materials. He believed that a sculpture should reveal something about the material from which it was made. That quality might have to do with a physical property, but it could also pertain to its historical associations, which, for Roman travertine marble, ran particularly strong. Travertine is associated with many of the great monuments of ancient and Renaissance architecture. In its emphasis upon weight and mass *Stone Memorial* is typical of Moore's response to travertine. Moore keeps surface detail to a minimum, emphasizing the pitted whiteness and the natural striations of the marble. The relatively smooth, simple treatment of the marble balances a complex arrangement of the two blocks.

Stone Memorial differs from much of Moore's work in one important respect: there is no principal viewpoint. Generally Moore's freestanding sculpture reveals itself most fully from one side, although the viewer's experience is enriched by seeing the work from several sides. Because the two blocks of *Stone Memorial* form a square, each side of which is different, no viewpoint has primacy. One must walk around the sculpture to appreciate its architectonic quality and evident weight as well as its contrasting organic aspect of swelling individual forms.

Bibliography

Alan Bowness, *Henry Moore: Sculpture and Drawings,* vol. 4, *Sculpture 1964–1973* (London, 1977).

David Mitchinson, ed., *Henry Moore: Sculpture* (New York, 1981).

John Russell, *Henry Moore* (New York, 1968).

David Sylvester, *Henry Moore* [exh. cat., The Tate Gallery] (London, 1968).

94

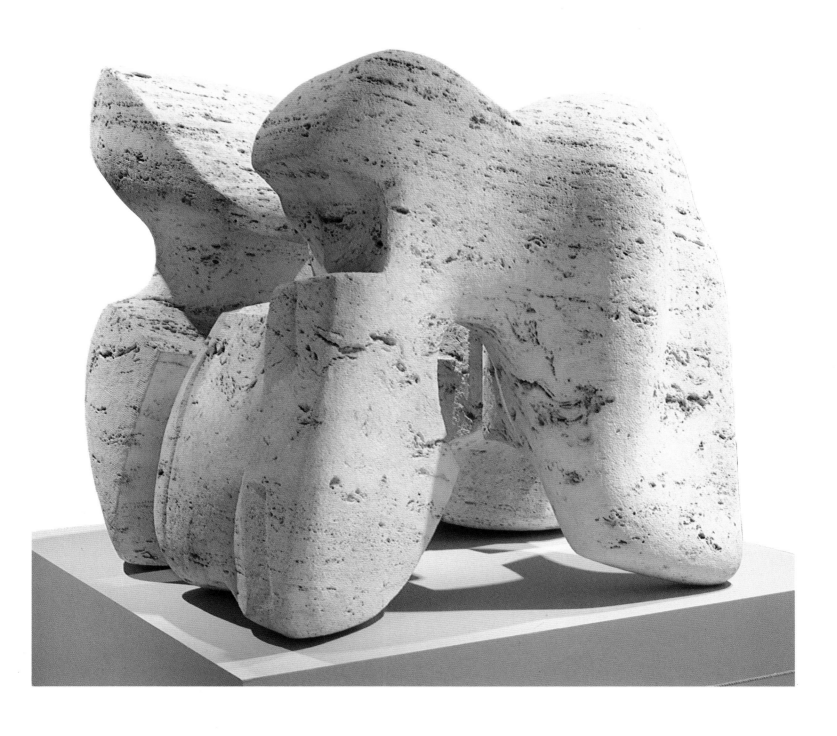

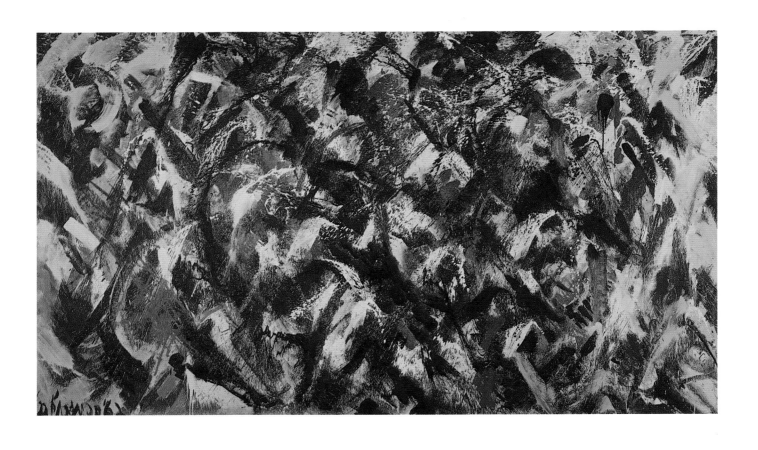

Lee Krasner
American, 1908–1984
Cobalt Night, 1962
oil on canvas, 93½ × 161⅜ (237.5 × 409.9)
Gift of Lila Acheson Wallace 1984.40.1

The early stages of Krasner's career were characteristic of the first generation of New York School abstract expressionists. After studying at Cooper Union and the National Academy of Design in the late 1920s and early 1930s, Krasner joined the Federal Art Project of the Works Progress Administration in the mid-1930s. From 1937 to 1940 she studied with Hans Hofmann, and in 1940 she exhibited with the American Abstract Artists group in New York.

Krasner's style of gestural abstraction developed concurrently with that of other abstract expressionists. She painted in an allover manner exceptionally early, but throughout the 1940s and for much of the 1950s she avoided working on the large scale favored by painters such as Jackson Pollock, Clyfford Still, and Franz Kline. That changed in 1957, and the vastly increased size of her new paintings also generated a change in style. The gestures by which Krasner painted her earlier, smaller pictures had involved movements of the hand and wrist. Now the brushstrokes reflected sweeping movements of her arm and body. Krasner's paintings of the late 1950s and early 1960s are distinguished by large fanlike brushstrokes that curve back and forth across the canvas.

Cobalt Night is one of the last of a group of large paintings known as the Umber series, named for their nearly monochrome, brown and off-white tonality. Krasner began the Umber paintings in 1959, and their limited color scheme has been attributed to the fact that she painted most of them at night under artificial light. *Cobalt Night* was painted in daylight toward the end of the series; it retains a strong umber cast but displays a range of rich colors. The essential pictorial element here is provided by the fanlike brushstrokes, which are evenly distributed across the canvas. The brushstrokes create a dense pattern of color and texture, as needled flecks and skeins of color shoot outward. Although not literally representational, *Cobalt Night* has been compared to a tumultuous landscape or a storm at sea. The enormous size of the painting encourages the viewer to be caught up by its rhythms of cascading color.

Bibliography

Richard Howard, "A Conversation with Lee Krasner," in *Lee Krasner: Paintings 1959–1962* [exh. cat., The Pace Gallery] (New York, 1979).

Barbara Rose, *Lee Krasner: A Retrospective* [exh. cat., The Museum of Fine Arts, Houston, and The Museum of Modern Art, New York] (Houston and New York, 1983).

Marcia Tucker, *Lee Krasner: Large Paintings* [exh. cat., Whitney Museum of American Art] (New York, 1973).

Andy Warhol
American, 1928–1987
Let Us Now Praise Famous Men
(Rauschenberg Family), 1963
silkscreen on canvas, 82 × 82 (208.2 × 208.2)
Gift of Mr. and Mrs. William Howard Adams
1982.96.1

In 1962, when Warhol turned to the subject of celebrity, he had already used as subject matter the imagery of our consumer culture: notably Coca Cola bottles and dollar bills. The celebrity series that he began in 1962 included images of Troy Donahue, Elvis Presley, Elizabeth Taylor, and Marilyn Monroe. Warhol adapted publicity shots of the screen idols, using a technique he and Robert Rauschenberg invented of painting with silkscreen on canvas and employing the colors of mass mechanical reproduction to give the paintings a commercial poster look.

Let Us Now Praise Famous Men (Rauschenberg Family) might be said to belong to Warhol's celebrity series, but it differs from the other paintings in several important respects. Unlike Marilyn Monroe or Elvis Presley, Rauschenberg was not quite internationally famous when this painting was made. He was a friend of Warhol's and an artist whose work was known in the New York art world to have set crucial precedents for pop art. Moreover, instead of a publicity photograph, Warhol used a family snapshot lent to him by Rauschenberg. The photograph was taken in about 1926, when Rauschenberg was an infant.

The painting's title refers to a book of the same name, published at the end of the Depression, in which James Agee recounted the lives of three families of Alabama sharecroppers photographed by Walker Evans. The book sold few copies when it first appeared in 1941, but when it was republished in 1960, at a time when an awareness of rural poverty in America was reawakening, it was acclaimed as an important document of American social commentary and photography. Warhol was drawn to the visual parallel between Rauschenberg's family snapshot and Evans' Depression-era photographs. He emphasized the old-fashioned look of the snapshot by employing an overall sepia tone that serves in commercial illustration and advertising design as a conventional sign for age and times past.

While not the boldest or brightest painting of the celebrity series, *Let Us Now Praise Famous Men* may be among the deepest and most suggestive.

Literary and personal allusions are made through the language of commercial mechanical reproduction, producing a complex and ironic layering of meanings. The central concerns and devices of the painting continued to characterize Warhol's work: notably the interest in photography and the grid composition. Most important, *Let Us Now Praise Famous Men* is a subtle early example of Warhol's abiding interest in fame (expressed clearly in the painting's title). *Let Us Now Praise Famous Men* treats both celebrity and obscurity, and the in-between state of fame not yet arrived.

Bibliography

John Coplans, *Andy Warhol* (Boston, 1970).

Rainer Crone, *Andy Warhol* (New York, 1976).

Stephen Koch, *Stargazer: Andy Warhol's World and His Films* (New York, 1974).

Carter Ratcliff, *Andy Warhol* (New York, 1983).

Patrick S. Smith, *Warhol: Conversations About the Artist* (Ann Arbor, 1988).

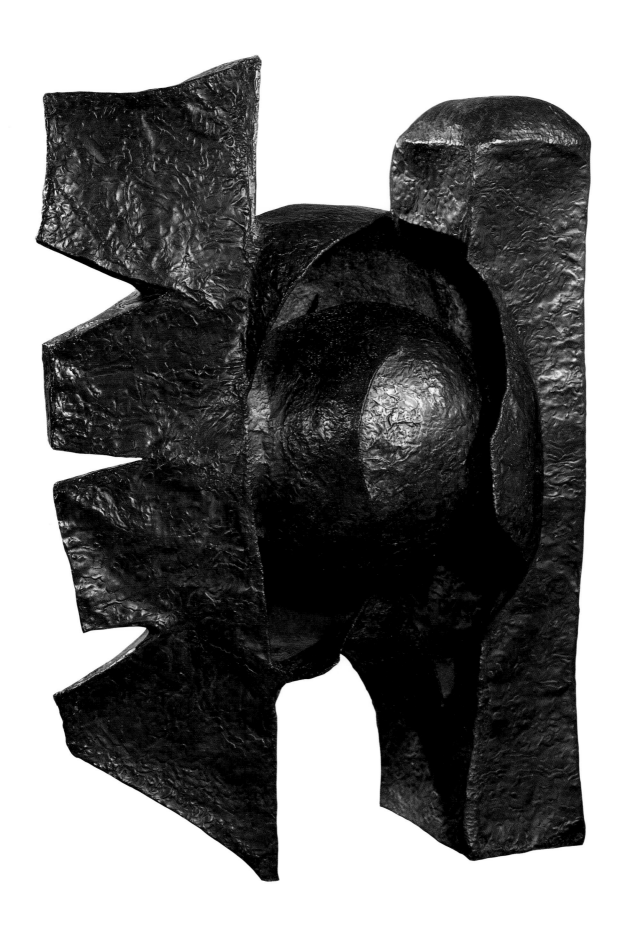

Seymour Lipton
American, 1903–1986
Gateway, 1964
nickel silver on Monel metal, 76 × 59 × 35
(193 × 149.8 × 88.9)
Gift of Seymour Lipton 1986.75.43

Monumental and imposing, *Gateway* represents the theme of "verticality" in Lipton's sculpture and makes a striking contrast to his earlier *Sower* (1960), also in the National Gallery's collection. In *Gateway* Lipton is especially concerned with the appearance of weight and volume. The large, rounded forms and textured surface provide a sense of mass, and this effect is not undercut by the realization that the sculpture is hollow and made of light sheet metal.

Lipton opposes the jagged, open edge of the left side of *Gateway* with the smooth, rounded, closed form of the right side. He also opposes movement and stasis, interior and exterior. The nestled globe at the center suggests a seed that has just burst its pod. At rest now and still protected by the metal lip or baffle that curves around it, the seed seems to guard all the energy of its imminent expansion. The viewer is drawn to explore the space behind and within the globe, but this space remains dark and partially hidden. The forms of *Gateway* seem to unfold from this obscured and mysterious core.

Bibliography

Albert Elsen, *Seymour Lipton* (New York, 1970).

Sam Hunter, "Seymour Lipton," in *Seymour Lipton: Sculpture* [exh. cat., Mint Museum of Art] (Charlotte, N.C., 1982).

Harry Rand, *Seymour Lipton: Aspects of Sculpture* (Washington, D.C., 1979).

Seymour Lipton: Sculpture [exh. cat., Hillwood Art Gallery, Long Island University, C. W. Post Campus] (Greenvale, N.Y., 1984).

René Magritte
Belgian, 1898–1967
The Blank Signature, c. 1965
oil on canvas, 32 × 25⅝ (81.3 × 65.1)
Collection of Mr. and Mrs. Paul Mellon
1985.64.24

The essential elements of Magritte's artistic vision and style were formed by the late 1920s, and Magritte was remarkably faithful to that vision for the remainder of his career. From the 1920s on, he was one of the leading representatives of those surrealists known as *imagiers*—painters who favored the realistic depiction of dreams or fantasies over abstraction or images derived from the process of automatic drawing. But whereas the other *imagiers* used the tools of illusionist representation to make their fantastical inventions as convincing as possible, Magritte frequently used those same tools to call illusionism into question.

The Blank Signature (*Le blanc seing*) presents a visual impossibility. Normally, a horse and rider walking through a woods might be partly obscured from view by trees in front of them. Here, the horse is partly hidden by the space *between* two trees, as well as by a tree that stands behind a tree in front of which the horse and rider walk. It is as if the normal rules of physics have been reversed, even while the scene itself appears largely unremarkable. Indeed, it is Magritte's achievement here that as much as we know the image to be impossible, we are nevertheless led to perceive it as rational and coherent.

Bibliography

Richard Calvocoressi, *Magritte* (Oxford, 1984).

Suzi Gablik, *Magritte* (London, 1972).

William S. Rubin, *Dada and Surrealist Art* (New York, 1968).

Harry Torczyner, *Magritte: Ideas and Images,* trans. Richard Miller (New York, 1977).

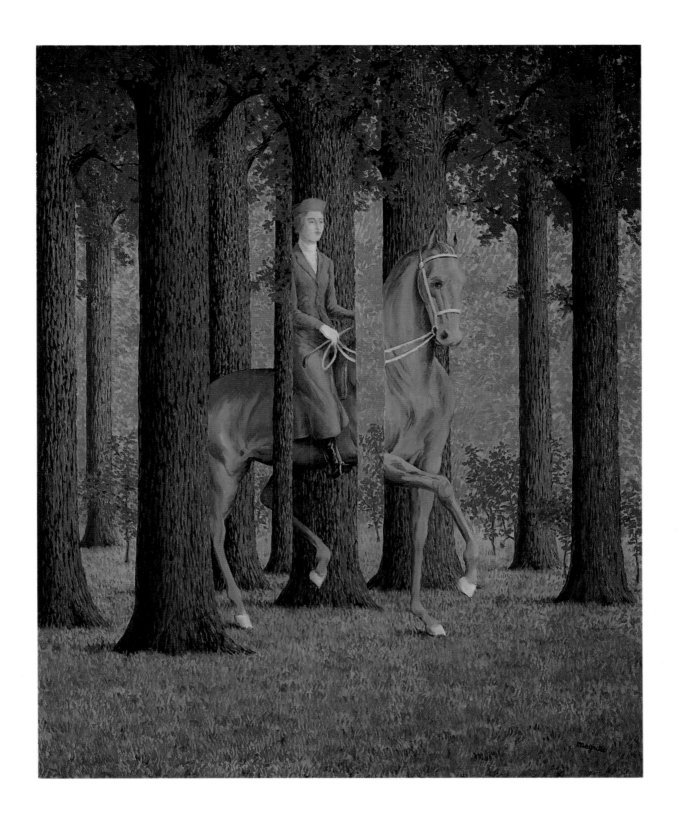

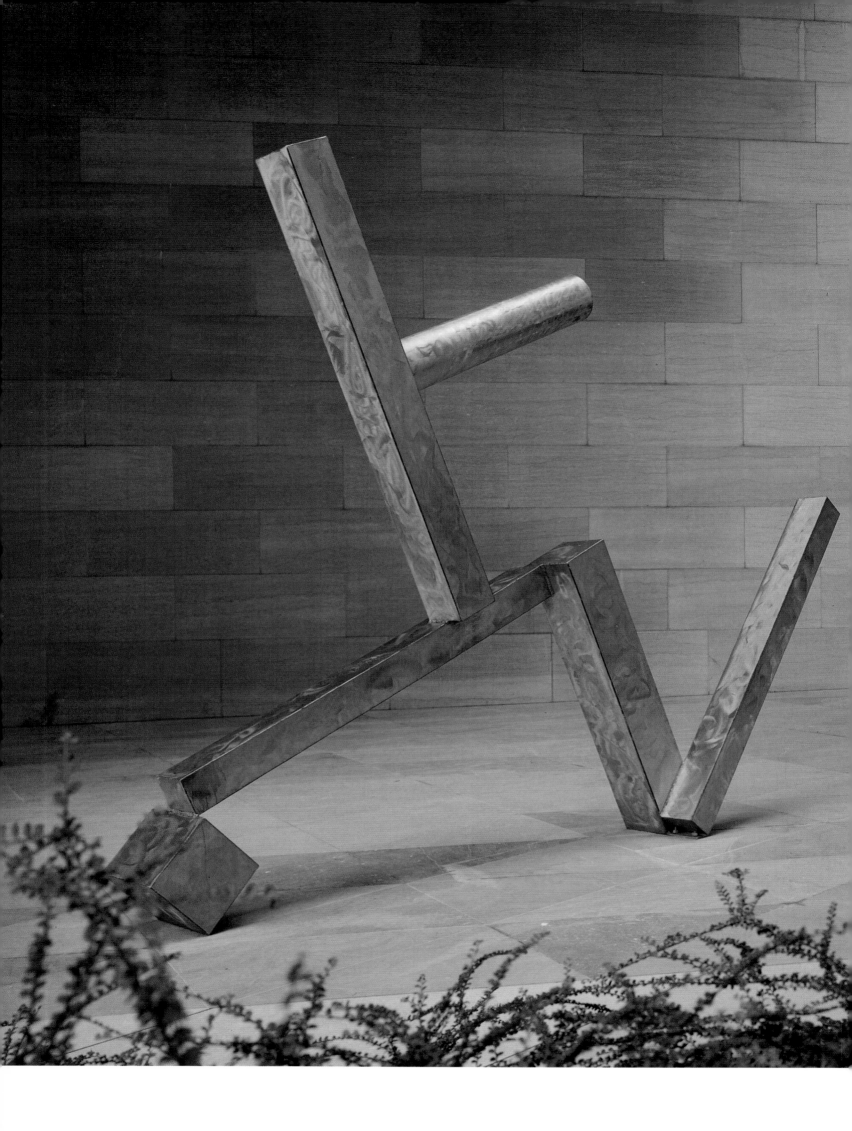

David Smith
American, 1906–1965
Cubi XXVI, 1965
stainless steel, 119½ × 151 × 25⅞
(303.4 × 383.4 × 65.6)
Ailsa Mellon Bruce Fund 1978.14.1

The Cubi series on which Smith was working at the time of his death both culminates the sculptor's earlier efforts and marks a radical new departure. Each sculpture in the twenty-eight work series, which Smith began in 1961, is made up of stainless steel cubes, rectangles, and cylinders. Their surfaces are burnished with a disk grinder in an irregular, abstract pattern that makes them especially reflective of light.

In a significant departure from his earlier practice of employing found objects, especially pieces of scrap metal and abandoned tools or machine parts, Smith either made the pieces of the Cubis himself or had them made by his assistant, Leon Pratt. Smith might use these pieces as he did the found objects of his earlier works, composing with them directly on his studio floor. But he also worked with preparatory drawings, paintings, and even cardboard maquettes. The use of manufactured pieces had the effect of limiting the Cubi series to a distinct set of geometric forms, which were considerably more bulky and three-dimensional than those of his earlier work. It also allowed Smith to conceive works that were no longer limited in imagination or execution by the scale of found objects he had chosen.

Cubi XXVI is among the last of the Cubi series, finished in January 1965. *Cubi XXVII* and *Cubi XXVIII* were completed later, in March of that year, but before Smith died, he returned *Cubi XXVI* to his studio. It has been argued that *Cubi XXVI* represented the newest direction in his work.

Instead of occupying or enclosing space, *Cubi XXVI* seems to extend through space both laterally and vertically. As in many of the Cubis, the apparent weight of its geometric blocks is counteracted by their reflective surfaces, which lend the sculpture an airy lightness. This is especially true when the sculpture is seen in direct sunlight. The multiple reflections of the burnished steel act to dematerialize the blocky forms. *Cubi XXVI* is particularly light in feeling, for its long steel blocks appear as sparkling, gravity-defying lines drawn through space. In fact, the sculpture barely touches the ground, its entire weight borne by only two small points.

Despite their vocabulary of pure geometric form, many of the Cubis, among them *Cubi XXVI,* refer metaphorically to the human figure. The springing diagonal lines of *Cubi XXVI* suggest a figure running and jumping, and the sculpture has been compared to works that Smith named after his children, such as *Running Daughter* and *Bec-Dida Day.* Asked in an interview whether any of his abstract sculptures were, in fact, personages, Smith responded: "They don't start that way. But how can a man live off of his planet? How on earth can he know anything that he hasn't seen or doesn't exist in his own world? Even his visions have to be made up of what he knows, of the forms and the world that he knows. . . . And he naturally uses his proportion and his sort of objectivity. He can't get away from it. There is no such thing as *truly* abstract. Man always has to work from his life."

Bibliography

E. A. Carmean, Jr., *David Smith* [exh. cat., National Gallery of Art] (Washington, D.C., 1982).

Edward F. Fry and Miranda McClintic, *David Smith: Painter, Sculptor, Draftsman* (New York, 1982).

Rosalind E. Krauss, *Terminal Iron Works: The Sculpture of David Smith* (Cambridge, 1971).

Garnett McCoy, ed., *David Smith* (New York, 1973).

Stanley E. Marcus, *David Smith: The Sculptor and His Work* (Ithaca, 1983).

Karen Wilkin, *David Smith* (New York, 1984).

Helen Frankenthaler
American, born 1928
Wales, 1966
acrylic on canvas, 113¼ × 45 (287.5 × 114.4)
Anonymous gift 1981.86.1

Bibliography

E. C. Goosen, *Helen Frankenthaler* [exh. cat., Whitney Museum of American Art] (New York, 1969).

Barbara Rose, *Frankenthaler* (New York, 1972).

A number of artists, including Arshile Gorky, Mark Rothko, and Jackson Pollock, had played off areas of flat, stained color against layers of built-up paint. But it was Frankenthaler who seized upon the multiple implications of their work, developing with a remarkable freedom and range of expressive invention the technique of making pictures entirely through the soaking and staining of thinned paint into raw, unprimed canvas.

Frankenthaler works with her canvas laid out on the floor, as did Pollock. She pours colors onto raw cotton duck and then blots them, or she manipulates a flow of liquid with her hand or a sponge, mop, rag, or brush. Work proceeds from all four sides of the canvas until the painting is completed. In 1962 Frankenthaler switched from oil paint to acrylics, which dry faster and are absorbed into the fibers of the canvas somewhat less quickly than oil paint. Acrylics tend to flood and form pools, which read as sharp edges when the paint has dried. Frankenthaler was able to exploit these effects in addition to creating atmospheric fields of softly expanding color. As their titles often suggest, Frankenthaler's paintings can be considered abstract landscapes. Places are not depicted literally, but the effects of light, atmosphere, distance, and the rise and fall of sea and land are constantly evoked.

Wales is typical of a number of Frankenthaler's paintings of the mid-1960s in which expanses of light color are opened up at the center of the picture. Channels of reserved white canvas separate areas of color, and darker colors are pushed out to the edge of the painting. The feeling of outward expansion in *Wales* also reflects Frankenthaler's technique of cropping. Frankenthaler does not draw or plan out her paintings in advance; rather she finds her image as she pours paint onto canvas. Once the image is found, she composes by cutting away unwanted canvas. In *Wales,* a painting of sharply accentuated verticality, the edges of the painting are clearly part of larger pools of color, the presence of which one continues to feel. Although colors are sharply delineated and abut the canvas edge, *Wales,* stretching upward, lyrically suggests the infinite.

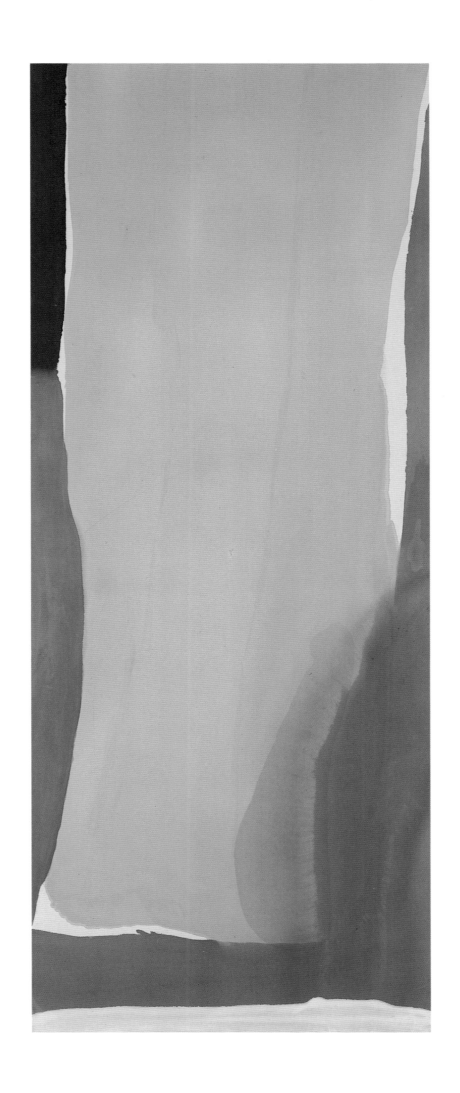

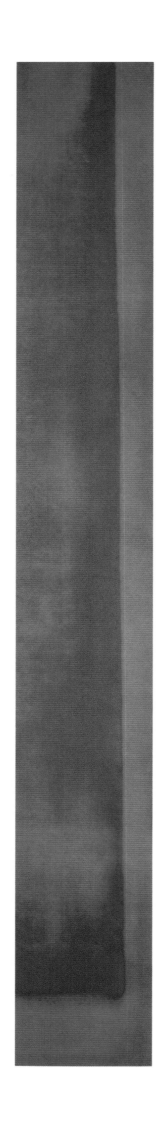

Jules Olitski
American, born 1922
Unlocked, 1966
water-miscible acrylic on canvas, 140½ × 19
(356.8 × 48.2)
Gift of Mr. and Mrs. Robert Eichholz 1978.39.1

One of the leading figures of the "color-field" movement of the 1960s and early 1970s, Olitski based his art on the common theoretical premise that painting should contend only with those elements that specifically define its existence: color, surface, and edge. In the early 1960s Olitski employed the stain-painting technique also used by painters such as Helen Frankenthaler, Morris Louis, and Kenneth Noland. In the mid-1960s he developed a technique of his own, namely, spray painting.

Working with unprimed, unsized canvas laid out flat on the floor, Olitski used several electric spray guns to put down grainy films of color on top of color. Spray painting allowed Olitski to achieve subtle effects of tone without muddy areas of mixed color. Although resolutely flat, his spray paintings nevertheless possess an illusion of depth as they offer the sensation of looking through the shimmering, grainy layers of paint.

In *Unlocked* the issues of color and surface are addressed by the spray painting technique, while the issue of edge is addressed by the tall, thin proportions of the canvas. Olitski was concerned that on canvases of traditional proportions the spray painted surface would look like a shapeless, indeterminate field. By restricting *Unlocked* to a narrow vertical strip, Olitski makes the canvas edge an element of equal importance to the painting's evanescent color and surface. The importance of the edge is reinforced by the division of *Unlocked* into two interlocking areas of color whose line of meeting echoes the edge of the canvas.

Bibliography

Michael Fried, *Three American Painters* [exh. cat., Fogg Art Museum, Harvard University] (Cambridge, 1965).

Michael Fried, "Jules Olitski," in *Jules Olitski: Paintings 1963–1967* [exh. cat., The Corcoran Gallery of Art] (Washington, D.C., 1967).

Kenworth Moffett, *Jules Olitski* (New York, 1981).

Tony Smith
American, 1912–1980
Wandering Rocks, 1967
stainless steel, five elements
Gift of the Collectors Committee 1981.53.1

Tony Smith had three careers: architect, painter, and sculptor. He came to the last of these only in 1960, at the age of forty-eight. Not surprisingly perhaps, his sculptures of pure geometric solids and modular forms bear a clear relation to architectural theory and practice.

Wandering Rocks is a sculpture of five sharply faceted geometric elements. The title alludes to a chapter of James Joyce's *Ulysses,* but part of Smith's inspiration came from his interest in Japanese gardens. He did not design the pieces of *Wandering Rocks* to be placed on the ground in any particular order but preferred that they be placed at random. Although geometric, the individual elements are of Smith's invention and do not correspond to regular geometric solids. Because of the sharply angled facets of the blocks, one or more planes of each remain hidden when viewed from any one angle. The irregularity of the blocks means that a viewer who walks around and through the sculpture is constantly surprised by the presence of a facet or the unexpected truncation of a form.

Smith's interests in *Wandering Rocks* are close in some respects to those of minimalist sculptors such as Donald Judd and Carle Andre, but Smith is more concerned with the syntax of composition, the relation of parts to the whole and of one element to the other. Like the minimalists, Smith is concerned with exploring and exploiting the phenomenology of perception: with contrasting vision, knowledge, and expectations.

Bibliography

Lucy Lippard, *Tony Smith* (New York, 1972).

Tony Smith: Ten Elements and Throwback [exh. cat., The Pace Gallery] (New York, 1979).

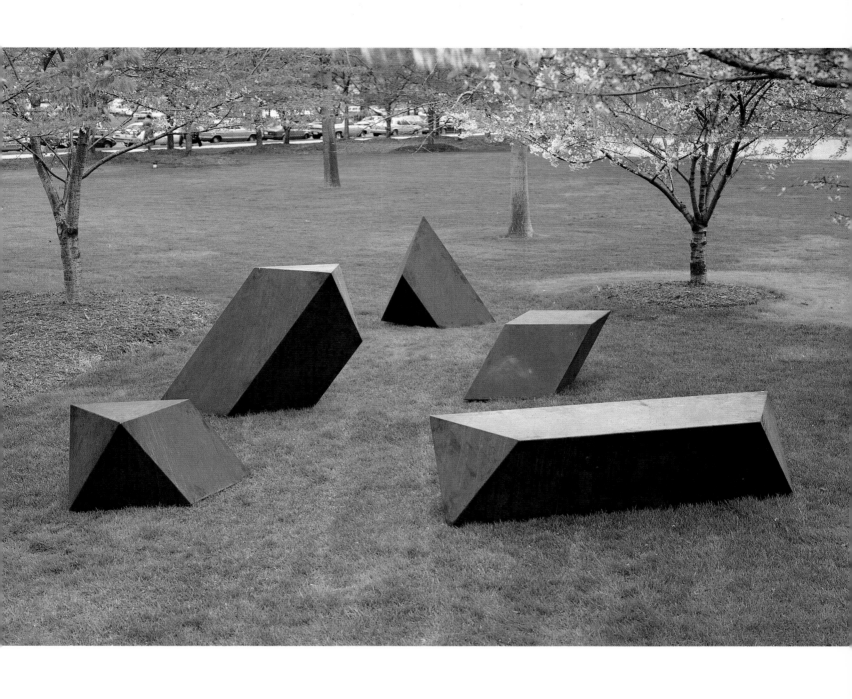

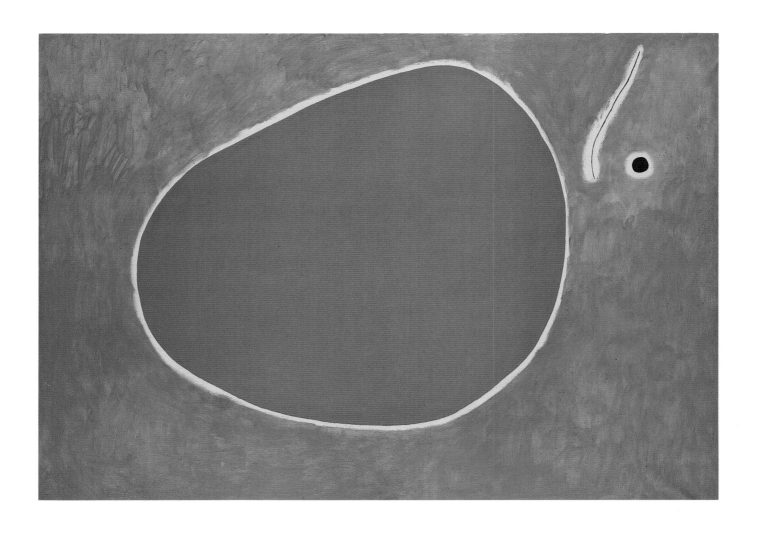

Joan Miró
Spanish, 1893–1983
The Flight of the Dragonfly before the Sun, 1968
oil on canvas, 68½ × 96 (173.9 × 243.8)
Collection of Mr. and Mrs. Paul Mellon
1983.1.23

In the early 1960s Miró began to paint mural-sized canvases that reflected the influence of American abstract expressionist painting (particularly the grand scale and free execution of Jackson Pollock and the "color field" painting of artists like Mark Rothko) while also recalling his own style of the mid-1920s in such paintings as *Head of a Catalan Peasant* (1924). Like that earlier painting, *Flight of the Dragonfly before the Sun* offers a unified field of loosely brushed color. Within this field float three forms: a large blue mass, a thin black line, and a small black circle.

In the 1960s Miró determined the titles of his paintings near the time of their completion, in accordance with the theory of automatism that had come to interest him again in those years. Miró's choice of title here suggests a familiarity with haiku poetry. In fact, his interest in Japanese culture can be traced back as far as his early years in Barcelona, and Miró traveled to Japan in 1966. The painting *The Flight of the Dragonfly before the Sun* should not be understood as an illustration of its title. Rather, painting and title function as poetic equivalents, each enriching the other.

Bibliography

Rosalind E. Krauss and Margit Rowell, *Joan Miró: Magnetic Fields* [exh. cat., The Solomon R. Guggenheim Museum] (New York, 1972).

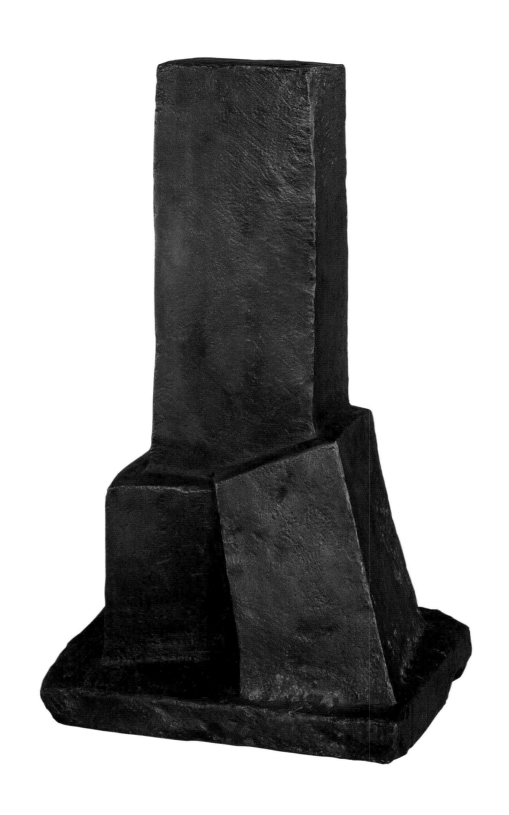

Fritz Wotruba
Austrian, 1907–1975
Torso, 1968/1969
bronze, 24^{15}/$_{16}$ × 15^{3}/$_{8}$ × 10
(63.4 × 39 × 25.4)
Gift of Z-Bank of Vienna 1984.54.1

Coming to artistic maturity in Vienna in the years before the Second World War, Wotruba was driven by the deeply humanistic impulse and tradition of that culture. After training as an engraver, he began to study sculpture in the late 1920s. In the 1930s he met and became a close friend of the architect Josef Hoffmann as well as many of the leading Viennese writers and musicians of the time. In 1938, following the Anschluss, Wotruba left Austria and settled in Switzerland where he remained until 1945. Returning to Vienna at the end of the war, Wotruba accepted a teaching post at the Akademie der Bildenden Kunste, from which he influenced several generations of Austrian sculptors. From the late 1940s Wotruba also contributed set and costume designs for theater and opera.

Wotruba sculpted only the human figure. His early sculpture of the 1930s was naturalistic, following the model of Aristide Maillol. By the end of his career, however, he had achieved a personal fusion of human and architectural form, of which *Torso* is a characteristic example. Despite its blocky, abstract form, the human referent in *Torso* is easily apparent. The opposed angles of the blocks recall the contrapposto of classical sculpture. As for his architectural referents, Wotruba was quite specific: "My desire to work is not stimulated by the classical proportions of Greek architecture, but by functional silos and hangars. . . . The confusion of places cluttered with art and culture chokes my inspiration. What stimulates and interests me is the natural noise of a busy city, and the practical lay-out of a harbor or factory which has come into being without consideration of any aesthetic principles."

Bibliography

Friedrich Heer, *Fritz Wotruba: Humanity out of Stone* (Neuchâtel, Switzerland, 1961).

The Human Form: Sculpture, Prints, and Drawings/ Fritz Wotruba [exh. cat., The Smithsonian Institution Traveling Exhibition Service] (Washington, D.C., 1977).

Jack Beal

American, born 1931
Portrait of the Doyles, 1970
oil on canvas, 76¼ × 58⅛ (193.7 × 147.6)
Gift of Evelyn and Leonard Lauder 1984.43.1

After a period of painting in an abstract expression-ist manner in the 1950s, Beal turned decisively to realism in the early 1960s. Over the course of that next decade his style alternated between thick, colorful impastoes and more restrained, subdued treatments. *Portrait of the Doyles* represented a second major turning point in his career, one that he has described in clear terms: "In 1970 we made a trip west, drove to the West Coast, drove through Utah and New Mexico and Arizona and saw all that great natural color that exists out there, as opposed to the natural color in the east: green. And I came back to New York and made the painting with [friends and fellow artists] Jane and Tom Doyle, which was again another big turning point in my life because I was able finally to merge my love of color with the kind of realism that I had wanted to paint. Since 1970 I think that the marriage between my love of color and my love of nature has been a better marriage."

As is evident in *Portrait of the Doyles,* Beal's realism firmly situates his subjects in a temporal and social context: details of dress and place are closely observed, as are mood and expression. The paint surface is matte and even, as Beal avoids the painterly description or replication of texture. The painting is enlivened, on the other hand, by a dynamic composition involving a sharply tilted ground plane and a series of strong diagonal lines that energize this depiction of a moment of stillness.

Bibliography

Gerrit Henry, "Jack Beal: A Commitment to Realism," *Art News* 83 (December 1984).

Mark Strand, ed., *Art of the Real: Nine American Figurative Painters* (New York, 1983).

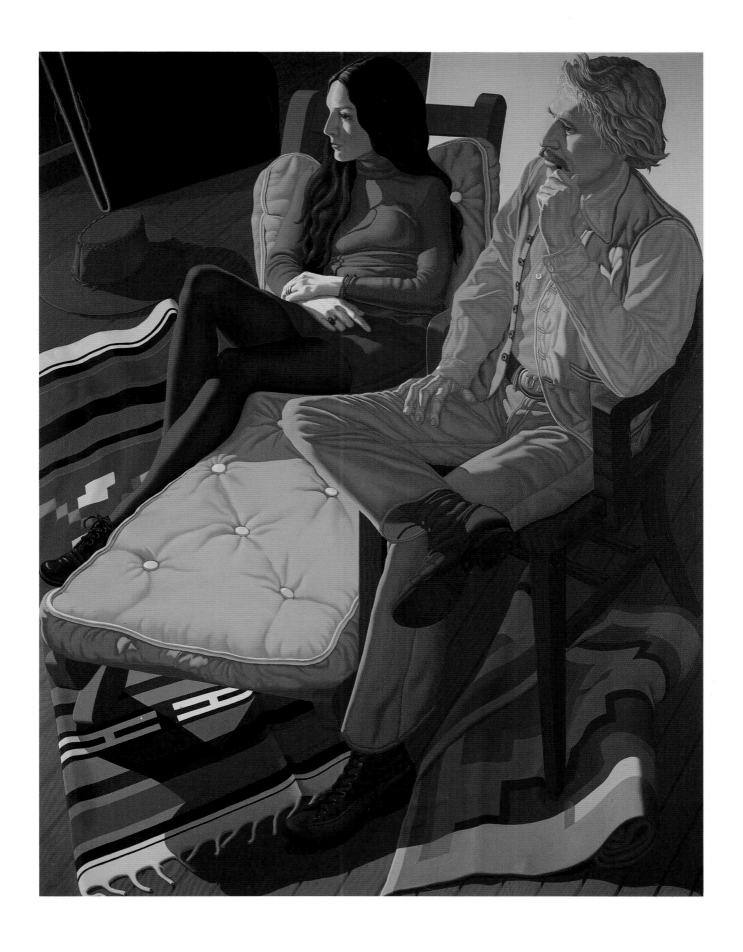

George Segal
American, born 1924
The Dancers, 1971, cast 1982 (2/5)
bronze with white patina, 70½ × 151 × 71
(179 × 269.2 × 180.3)
Gift of the Collectors Committee 1983.78.1

Having trained and exhibited initially as a painter, Segal began to make figurative sculpture out of burlap, plaster, and chicken wire in 1958. He developed his distinctive sculptural technique in 1961, adapting the materials and methods of orthopedic surgeons to make life casts. Segal wraps his models with surgical gauze bandages dipped in plaster, and when the casts have hardened, he cuts away the bandages, eerily freezing the poses of his models and unevenly obscuring their features with layers of covering. Segal often places his life casts in environments constructed from real or found materials—they may sit on chairs or at tables, in rooms or in fabricated subway cars—and Segal devotes as much care to the setting as he does to the figure or figures within it. On occasion, and as is the case with *The Dancers,* the plaster casts are cast in bronze.

Because his sculpture often treats contemporary life and contemporary settings, Segal has been categorized with the pop artists who emerged with him in the late 1950s and early 1960s. He shared the interest of artists like Claes Oldenburg in creating whole environments rather than discrete objects, and of artists like Allan Kaprow in developing that characteristic artistic event of the 1960s, the "happening." Unlike Oldenburg or painters such as Warhol and Lichtenstein, however, Segal rarely makes irony predominate in his work. His art also differs from that of contemporary sculptors such as Duane Hanson who likewise works directly from live models. Hanson aims to make the viewer mistake, if only for an instant, his sculpture for an actual person. This is never Segal's aim. The force of Segal's work resides first in a tenuous separation of art and life, a separation made metaphorically visible in the plaster-encrusted layers out of which his figures are formed. His figures also call up associations with the tragic remnant forms of Herculaneum and Pompeii, while their unidealized bodies make a striking contrast to the idealistic tradition of white marble sculpture.

The range of Segal's subject matter is wide, although he frequently returns to subjects of contemporary social concern. Another consistent theme is art *about* art. In the 1970s Segal became interested in adapting in three dimensions the works of the great modernist painters. *The Dancers* had its origins in Matisse's *The Dance* and *The Dance II,* which Segal saw side by side at the great Matisse retrospective in Paris in 1970. Segal took from Matisse the motif of dancers in a circle, and even the posture of the dancer leaning to the left. The spirit of exaltation evident in Matisse's paintings is undercut in Segal's work by an awareness of the intense concentration evidenced by his dancers. Instead of Matisse's idealized vision of release in his five dancers, Segal presents us with four contemporary, more human dancers calmly and methodically at work.

Bibliography
William C. Seitz, *Segal* (New York, 1972).

Phyllis Tuchman, *George Segal* (New York, 1983).

Jan van der Marck, *Segal* (New York, 1975).

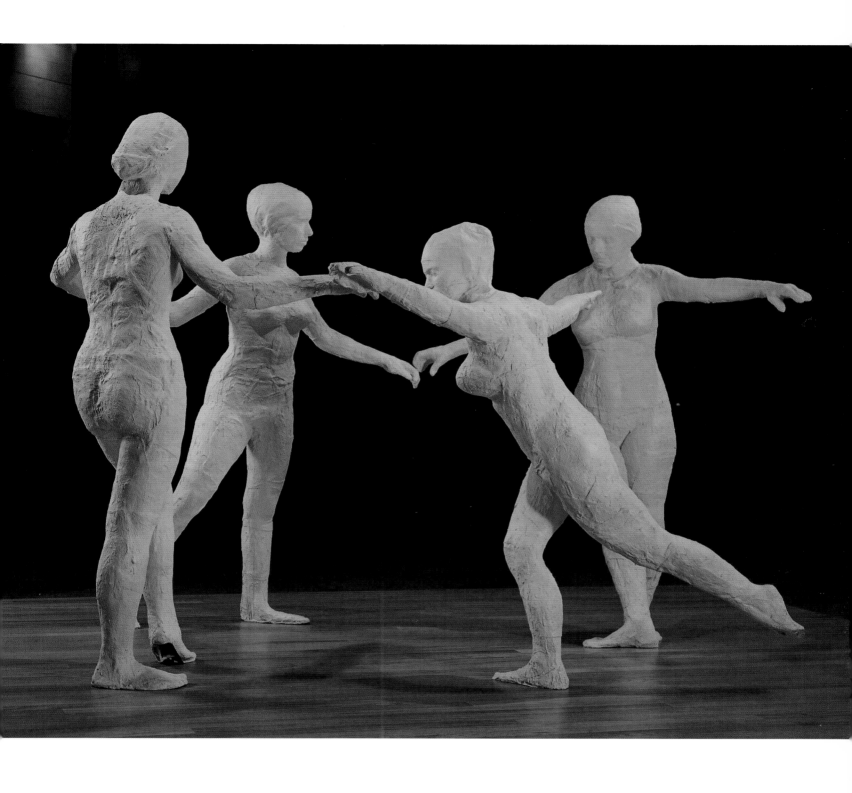

Alexander Calder
American, 1898–1976
Obus, 1972
painted steel, 142½ × 152 × 89⅝
(361.8 × 385.9 × 227.6)
Collection of Mr. and Mrs. Paul Mellon
1983.1.49

Calder first achieved fame as the inventor of the mobile—constructed sculpture in which pieces of metal suspended from wire slowly twirl or bob. In the mid-1930s he developed a second sculptural format, which he called the "stabile." Stabiles were composed of intersecting sheets of metal, usually cut in whimsical patterns suggestive of organic or animal forms and painted a uniform red or black. Like the mobiles, Calder's stabiles represent a highly personal amalgamation of constructivism and surrealism. Pieced together and without mass, they define areas of space. Their biomorphic shapes suggest fantastical creatures of the imagination. The stabile proved a particularly successful vehicle for public sculpture in the 1960s and 1970s when a number of giant stabiles were commissioned for public spaces in Europe and America.

Obus is an intermediate size among Calder's stabiles, between the small, handmade works and the giant commissions. Like the large commissions, *Obus* was manufactured at a metal factory on the basis of a small maquette that Calder cut from sheet aluminum. Calder instructed the factory as to the size of the enlargement, and once the large pieces of metal were cut, he worked out details of ribbing and brackets. Calder provides a surprise in *Obus* by painting the stabile red, black, and blue. From one side only the red is visible, and when walking around the sculpture, one comes unexpectedly upon the black and blue planes.

Bibliography

David Bourdon, *Calder: Mobilist/Ringmaster/Inventor* (New York, 1980).

Alexander Calder, *An Autobiography with Pictures* (New York, 1966).

Jean Lipman, *Calder's Universe* (New York, 1976).

Robert Osborn, "Calder's International Monuments," *Art in America* 57 (March–April 1969).

Frank Stella

American, born 1936
Chyrow II, 1972
mixed media, 112 × 100 (284.5 × 254)
Gift of the Collectors Committee 1979.29.1

Between 1970 and 1973 Stella made more than 130 reliefs, most of them painted and collectively named the Polish Village series. Each work in the series takes its title from a Polish synagogue destroyed by the Nazis during the Second World War. The reliefs derive from a group of forty-two drawings the artist made in 1970. From each of these drawings Stella constructed between one and three reliefs. First, second, and third versions were indicated by roman numerals following the title.

In a number of respects the Polish Village series marked a major departure in Stella's work, and the artist has spoken of them as opening a "second career." Much of the thrust of his earlier work had been to create "nonrelational" paintings in which parts related only to a whole that could be grasped immediately. The Polish Village paintings were "relational"; they set up complex interrelationships of parts, parallels and oppositions, balances and imbalances. Elaborately engineered and constructed, these are works that reveal themselves through prolonged visual contemplation. Furthermore, although Stella had for years worked with shaped canvases, he had never before worked in relief. Stella considered these objects paintings insofar as they were essentially concerned with pictorial problems of line, color, and the relation of shapes in a plane. But all of these concerns were addressed in the medium of relief and collage. The surfaces of the Polish Village pictures incorporate canvas, paper, felt, plywood, pressboard, and masonite.

Chyrow II is typical of the Polish Village series in its shifting planes and play of interlocking shapes, colors, and textures. Irregular in outline, it is still relatively closed in form, with parts jutting out from the central mass at top and bottom. Especially in the upper portion, there is a complex interweaving and suggested repetition of positive and negative shapes. Although there is greater mass at the bottom than at the top, weight appears evenly distributed. Throughout, the use of matte colors and felt softens the effect of hard edges and sharp angles.

The National Gallery has also acquired the collage study for this painting.

Bibliography

Philip Leider, *Stella Since 1970* [exh. cat., The Fort Worth Art Museum] (Fort Worth, 1978).

William Rubin, *Frank Stella 1970–1987* [exh. cat., The Museum of Modern Art] (New York, 1987).

Christopher Wilmarth
American, 1943–1987
Clearing, 1972
etched plate glass and steel with cable,
53¼ × 60 × 46½ (135.3 × 152.4 × 118.1)
Gift of Rose and Charles F. Gibbs 1985.66.1

Wilmarth's central artistic preoccupation was always with light and mass. It is therefore not surprising that he determined almost at the outset of his career to work with glass. His early works were directly indebted to Brancusi, whose highly polished, light reflective, and absorbing surfaces Wilmarth admired. When Wilmarth finished art school at Cooper Union in 1965, he began to juxtapose thick sheets of plate glass with wooden spools that recalled Brancusi's sculpture. It was not evident at that time which element, wood or glass, would come to predominate.

By 1970 wood had been abandoned and glass was the dominant element. Wilmarth painted heavy sheets of glass with acid, etching the surface to produce a clouded, atmospheric effect. Wire cable was woven over and behind the sheets, creating lines either definite or partially obscured.

Clearing marks another important step in Wilmarth's career: the wedding of etched glass and wire cable to steel plate. A sheet of glass leans against a long steel plate that has been bent and cut to hold the glass securely. Seen from the side or rear, the strong, firmly outlined metal contrasts with the brittle glass. From the front, one looks through the smoky, blue green glass to the metal plate, which appears as a hazy shadow. The steel is visible only where it touches the glass. Two lines of cable drawn across the outer surface of the glass echo the shape of the metal shadow.

Wilmarth created sculptures that respected physical and mathematical rules and proportions, and *Clearing* is informed by a rigorous geometry, but its overall aim is the melding and transformation of opposites: steel seems effortlessly malleable and glass dangerously rigid, and it is opaque metal that adds depth to translucent glass. Each element has been formed by great pressures, heat and action. Wilmarth sensed these forces and aimed to make them physically present in a sculpture that deals equally with the intangible.

Bibliography

Dore Ashton, *Christopher Wilmarth: Layers* [exh. cat., Hirschl & Adler Modern] (New York, 1984).

Joseph Masheck, "Wilmarth's New Reliefs," in *Christopher Wilmarth: Nine Clearings for a Standing Man* [exh. cat., Wadsworth Atheneum] (Hartford, 1974).

Robert Pincus-Witten, "Christopher Wilmarth: A Note on Pictorial Sculpture," *Artforum* 9 (May 1971).

Kenneth Noland
American, born 1924
Another Time, 1973
acrylic on canvas, 72 × 72 (182.9 × 182.9)
Gift of the Collectors Committee 1979.28.1

Few other modern painters have so explicitly linked formalist art theory and artistic practice as has Kenneth Noland. From the mid-1950s Noland's work has demonstrated a steady and conscious progression wherein issues of figure and ground, shape and support, line and color have been systematically explored and merged.

Another Time belongs to a distinct stage of this exploration. It is one of Noland's so-called plaid pictures, a group of works begun in 1971. These paintings are defined by thin lines that crisscross at right angles. The thin lines of the plaid pictures represent a break from the broad parallel bands of color that had previously structured Noland's compositions. Noland's first plaid pictures were vertical in format, long narrow rectangles in which thin stripes clung to the edges of the painting. In 1973 Noland shifted format and began to work with circular and diamond-shaped canvases. The thin lines of these paintings now met around the center of the canvas.

The crisscrossing of horizontal and vertical lines within a diamond-shaped canvas in *Another Time* cannot but remind one of Mondrian's diamond compositions. Like Mondrian, Noland keeps his lines from crossing at the center of the painting. But *Another Time* is far more centered and symmetrical than any painting by Mondrian. Noland is also concerned here with controlling the illusion of space that the overlapping of lines of different color necessarily create. He interweaves his lines so that no coherent illusion can be established and the picture remains a flat, colored surface.

Bibliography

Michael Fried, *Three American Painters* [exh. cat., Fogg Art Museum, Harvard University] (Cambridge, 1965).

Kenworth Moffett, *Kenneth Noland* (New York, 1977).

Diane Waldman, *Kenneth Noland: A Retrospective* [exh. cat., The Solomon R. Guggenheim Museum] (New York, 1977).

Roy Lichtenstein
American, born 1923
Cubist Still Life, 1974
oil and magna on canvas, 90 × 68¹/₁₆
(228.6 × 173.2)
Lila Acheson Wallace Fund 1983.50.1

Bibliography

Lawrence Alloway, *Roy Lichtenstein* (New York, 1983).

Jack Cowart, *Roy Lichtenstein: 1970–1980* (New York, 1981).

Bernice Rose, *The Drawings of Roy Lichtenstein* [exh. cat., The Museum of Modern Art] (New York, 1986).

Lichtenstein's pop art of the early 1960s explored the premise that the impersonal style and exaggerated subjects of comics and commercial art could provide appropriate material for contemporary fine art. In the mid-1960s Lichtenstein's premise shifted. He recognized that his highly personal adaptation of commercial art could be used to re-represent the styles and subjects of fine art: more specifically, various great moments of the modern movement, the "isms" of twentieth-century art history. Lichtenstein has since made free adaptations in his characteristic manner after the works of Picasso, Matisse, and Mondrian, among others, and has explored cubism, futurism, German expressionism, surrealism, and abstract expressionism.

Cubist Still Life is not a copy of any specific cubist painting but rather draws upon the cubist style as a whole. It bears its closest relation to the broad, flat patterns and clear delineations of shapes found in the cubist still-life paintings and collages of Juan Gris, while alluding to the work of Picasso and Braque as well. Lichtenstein's *Cubist Still Life* is cubist in both subject and style. Guitar, fruits, and a bottle placed on an oval table were characteristic elements of cubist still life, as were the patterns of woodgraining, molding, and harlequin diamonds that Lichtenstein sets off one against the other. But here the similarities end. The bright, unmodulated colors, the grand scale, and the curious sense that the painting is an enlarged reproduction from an art book, all twist and reverse the sense of Lichtenstein's models.

In its careful reconstruction of the essential elements of cubist still life, Lichtenstein's painting represents a considered tribute to the cubist masters. But as is characteristic of American pop art, the tribute is rendered in the form of a send-up. As closely as Lichtenstein hews to the conventions of cubism, he treats those conventions in a manner quite foreign to their original nature. In its distinctive style, scale, and wit, *Cubist Still Life* remains unmistakably Lichtenstein's own.

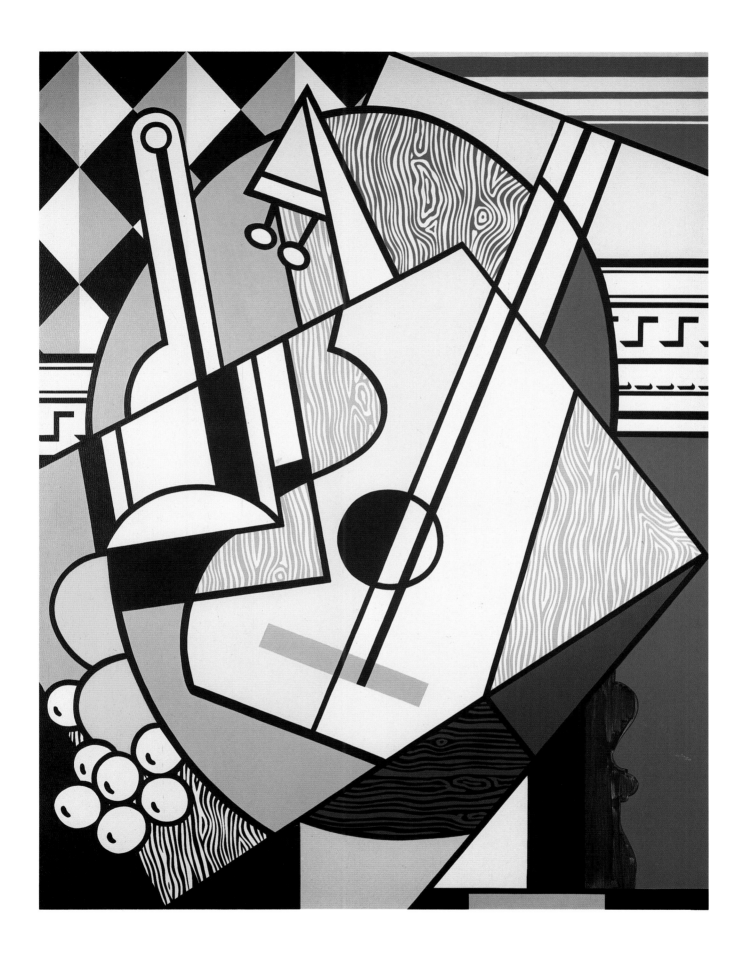

Gene Davis
American, 1920–1985
Narcissus III, 1975
acrylic on canvas, 96⅛ × 114¼
(244.2 × 289.9)
Anonymous gift 1980.6.1

Davis is best known as "the painter of the stripe." Certainly the stripe was his primary mode of expression, but his oeuvre nevertheless encompasses a far broader range of possibilities. Davis did not pursue these in a logical and ordered progression but rather alternated throughout his career, at times working in two or more styles simultaneously. Even Davis' stripe paintings can be divided into subgroups, between which he alternated throughout the 1960s and 1970s.

Although grouped with Kenneth Noland and Morris Louis as a member of the Washington color school, Davis always asserted his independence from the other Washington painters. He traced his interest in the stripe to the influence of Paul Klee and Barnett Newman. Davis disclaimed any concern for color theory. His primary interest, he stated, was in intervals of color. He never painted according to a predetermined program of color progressions or relationships, choosing instead the color and placement of his stripes as his painting proceeded.

Narcissus III is close to a number of light-toned canvases that Davis painted in the 1970s. Here Davis' stripes are irregularly spaced but nevertheless form a compositional order. Thin and broadly spaced at the center of the painting, the stripes thicken and form clusters at the sides. Like the classical device of the *repoussoir,* the denser sides of the painting emphasize its airy openness at center.

Bibliography

Steven Naifeh, *Gene Davis* (New York, 1982).

Jacquelyn Days Serwer, *Gene Davis: A Memorial Exhibition* [exh. cat., National Museum of American Art] (Washington, D.C., 1987).

Donald Wall, ed., *Gene Davis* (New York, 1975).

Ellsworth Kelly
American, born 1923
White Curve VIII, 1976
oil on canvas, 96$\frac{1}{16}$ × 76$\frac{15}{16}$ (244 × 194.5)
Gift of Mr. and Mrs. Joseph Helman 1984.105.1

As its title implies, *White Curve VIII* is one of a series of paintings defined by a curving white line, paintings that relate closely to a number of Kelly's curved wall relief sculptures. The White Curve paintings of 1972–1976 are in turn closely related to Kelly's Third Curve series of lithographs, produced between 1973 and 1976 (three of these lithographs are based upon *White Curve VIII: Tavant, Conques,* and *Thoronet*). Both paintings and lithographs present images divided between black and white areas that intersect in a curved line.

As always in Kelly's work, the magic of *White Curve VIII* resides in the artist's ability to produce an image of clarity, simplicity, and directness that at the same time retains extraordinary subtlety and visual interest. His concern in the White Curve paintings and prints was to marry blocks of black and white, to unify the field of the painting with an image divided into opposites. Normally, since black recedes and white advances, it is difficult to hold the two together in a single plane. Kelly had approached the problem in a number of two-paneled paintings made in the 1960s. In those the division of black and white into two contingent panels gave each area of color an independence and equality. Part of Kelly's solution in the single-panel White Curve series resides in his approach to black. Like Matisse, Kelly regards black as a positive color rather than as the absence of color. In *White Curve VIII* his black has a rich, matte complexity that keeps it in balance with the white.

The gentle curve of the line provides the second part of Kelly's solution in *White Curve VIII*. The first full-sized vertical format painting in the White Curve series, *White Curve VIII* is also the first in which the total area of the painting has an apparently equal division, arrived at intuitively, between black and white. That division is not evenly made. As the horizontal line of intersection curves across the canvas, black seems to invade the area of white, and white that of black. The two colors are held together in a relation of tense interaction.

Kelly has always maintained that his art is not abstract. All of his apparently abstract shapes and forms are derived from something seen, whether an object, a shadow, or a space between objects. For Kelly it is the relation to the seen world that gives his work energy and inspiration. In turn, he does not see his paintings as limited by the edges of the canvas. An accomplished sculptor as well as a painter, Kelly's paintings function as shaped wall-reliefs, defining the space around them and setting up distinct relationships to their environment. The black and white shapes of *White Curve VIII* seem to expand outward even while each holds the other in check.

Bibliography

Richard H. Axsom, *The Prints of Ellsworth Kelly: A Catalogue Raisonné 1949–1985* (New York, 1987).

Elizabeth C. Baker, *Ellsworth Kelly: Recent Paintings and Sculpture* [exh. cat., The Metropolitan Museum of Art] (New York, 1979).

Ellsworth Kelly: Paintings and Sculpture 1963–1979 [exh. cat., Stedelijk Museum] (Amsterdam, 1980).

E. C. Goosen, *Ellsworth Kelly* (New York, 1973).

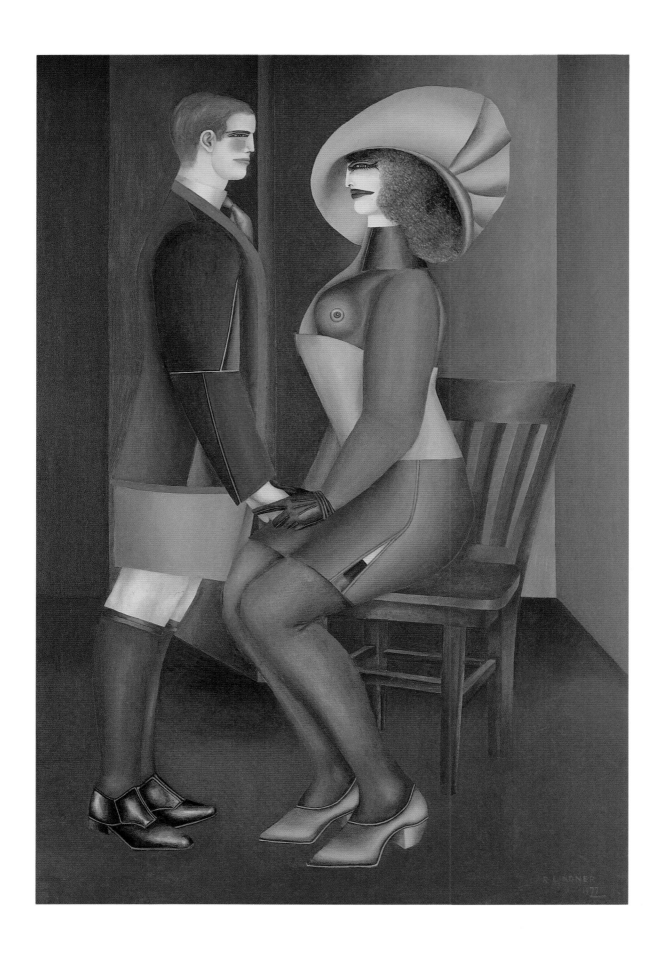

Richard Lindner

German/American, 1901–1978
Contact, 1977
oil on canvas, 80 × 54⅛ (203.2 × 137.5)
Gift of Denise Lindner 1986.73.1

Lindner trained in Germany as a painter and worked in Berlin as a commercial artist. He left Germany for Paris in 1933 the day after Hitler assumed power, then emigrated to the United States in 1941. Settling in New York, Lindner worked initially as a commercial artist before deciding in 1950 to paint full time. His first one-man show was held in 1954, but Lindner's art did not receive much attention until 1963 when it was included in an exhibition at the Museum of Modern Art in New York.

The year 1963 marked a high point for pop art, and Lindner's figurative paintings were associated with the international pop movement. That association was not wholly inaccurate, for Lindner's paintings resembled in certain respects those of Martial Raysse, Allen Jones, and Peter Blake. Lindner was fascinated and inspired by the vitality of New York and by the energy and the imagery of mass culture. Nevertheless, the psychic source for his art was the culture of Weimar, Germany. This accounts for a curiously displaced air evident in many of Lindner's paintings: it is as if the drama of one culture is being acted out in the costume of another.

Contact, one of Lindner's last paintings, sums up many of the artist's concerns. "Subject matter," Lindner once said, "for me is always a man, a woman, a child and a dog." Out of a few repeated elements, presented singly or as a narrative group, Lindner obsessively constructed images both brutally vivid and strangely enigmatic. Most frequently, he returned to images of older women with young men or boys. Always the woman is physically larger and dominating. In *Contact* she may be a prostitute with a young client, but the painting also suggests a solemn breaking of taboo, as if the protagonists were mother and son. Lindner monumentalizes his figures, filling the picture space with their forms. His treatment of the figures as combinations of smoothly colored, simplified geometric forms has a close parallel in the purist painting of Leger. But his imagery resonates most strongly with the disabused realism and disturbed sexuality of Weimar period *Neue Sachlichkeit* painters such as Georg Grosz, Otto Dix, and Friedrich Schroeder-Sonnenstein. Typically of Lindner, the title of *Contact* is ironic. The figures certainly touch, but their only contact is physical. Each is psychologically separate, removed, and still.

Bibliography

Rolf-Gunter Dienst, *Lindner* (New York, 1970).

John Gruen, "Richard Lindner 1901–1978," *Art News* 77 (summer 1978).

Hilton Kramer, *Richard Lindner* (Boston, 1975).

Frank Stella
American, born 1936
Sacramento Mall Proposal #4, 1978
acrylic on canvas, 103⅜ × 103¼
(262.5 × 262.1)
Gift of the Collectors Committee 1982.53.1

In the early 1960s Stella developed a format of concentric squares to which he has returned several times in his career. These paintings were highly organized both in composition and color. In the early Concentric Square paintings Stella abstracted a numbered sequence of hues from the color wheel and transferred the sequence to canvas. The simplicity and correctness of this system appealed to him. Stella later said of the format: "It's just a powerful pictorial image. It's so good that you can use it, abuse it, and even work against it to the point of ignoring it. It has a strength that's almost indestructible—at least for me. It's one of those givens, and it's very hard for me not to paint it. It is a successful picture before you start, and it's pretty hard to blow it."

Stella returned to the concentric square format in the late 1960s, and again in 1974 in the Diderot series of paintings that followed completion of the Polish Village series. The Diderot pictures, named after works by the French encyclopedist, differed from the earlier Concentric Squares in one important respect: size. While the earlier paintings were relatively modest in scale, the Diderot pictures were enormous, measuring over eleven feet square. Despite the increased size of these paintings, Stella did not enlarge the width of their concentric bands, meaning that the number of bands in a painting was vastly increased. Since Stella kept to the system of graded hues, the greater number of bands made for more conspicuous gradations. This in turn created effects of recession not present in the Concentric Squares of the 1960s.

Sacramento Mall Proposal #4 represents Stella's fourth campaign in the concentric square format. Although quite large, *Sacramento Mall Proposal #4* is not so big as the paintings of the Diderot series. In the new series Stella left a ring of unpainted canvas between each color band (a common feature of his work since the late 1950s) and filled the center of each unpainted band with a contrasting red tone. This created a vibrating rhythm across the surface of the canvas, which tends to cancel any sense of recession.

The Sacramento Mall Proposal series was named after a commission for a mall in Sacramento, California, for which Stella was asked to submit a group of paintings. Ultimately, the six paintings he completed did not go to the projected mall and were sold separately.

Bibliography

Philip Leider, *Stella Since 1970* [exh. cat., The Fort Worth Art Museum] (Fort Worth, 1978).

William Rubin, *Frank Stella 1970–1987* [exh. cat., The Museum of Modern Art] (New York, 1987).

Robert Rauschenberg

American, born 1925
Doric Circus, 1979
mixed media, 96 × 136½ × 26
(243.8 × 346.7 × 66)
Gift of Lila Acheson Wallace 1985.28.1

Rauschenberg is one of the most imaginative and prolific of contemporary artists. For the last five years he has literally traveled the world, finding, conceiving, and producing images. He confirms in the variety of his work and subjects his statement that "There is no reason not to consider the world as a gigantic painting."

If Rauschenberg's aim is to encompass in his art an extraordinary variety and disparity of forms, objects, and subjects, his method, evident in *Doric Circus,* has remained strikingly consistent. In an important sense Rauschenberg reinvented collage. His work operates by the masterful placement and juxtaposition in a common field of a variety of found elements. But whereas for the earlier practitioners of collage, notably Georges Braque and Kurt Schwitters, the addition of quotidien materials to the picture surface always served a common and in some way unitary end, for Rauschenberg collage has meant the dissolution of unitary meaning. Art, for Rauschenberg, can be about anything and can include anything, and there are no limits on the number of meanings a work of art can contain. Moreover, he does not mean for his works to exist as distant objects of contemplation. He has extended the collage method to three dimensions, and his works intrude aggressively into the space of the viewer.

Doric Circus makes its strongest connection with the viewer's world through the triangular element that defines the right edge of the work and juts out into our space. That element glows from within by means of colored electric lights, while in its reflective surface the viewer's image is mirrored. Although Rauschenberg's method is inclusive, it is not haphazard. The elements of *Doric Circus* are laid out according to a grid system that is one of the defining formal characteristics of the artist's work. That grid system is a late inheritance from cubism, which Rauschenberg gained most directly through his teacher, Joseph Albers. It allows Rauschenberg to unify the most disparate forms and objects in a general, syncopated rhythm across the picture field. Despite the heterogeneity of Rauschenberg's work, certain elements of his characteristic iconography can be discerned in *Doric Circus:* birds and airplanes, images of flight; automobiles, flowers, and bits of the natural world. Atop, he has placed a *memento mori,* a skull.

Bibliography

John Cage, *Silence: Lectures and Writings* (Middletown, Conn., 1961).

Andrew Forge, *Robert Rauschenberg* (New York, 1969).

Rosalind Krauss, "Rauschenberg and the Materialized Image," in *Artforum* 13 (December 1974).

Robert Rauschenberg [exh. cat., National Collection of Fine Arts, Smithsonian Institution] (Washington, D.C., 1976).

Robert Rauschenberg [exh. cat., The Tate Gallery] (London, 1981).

Calvin Tomkins, *Off the Wall* (New York, 1980).

140

Frank Stella
American, born 1936
Jarama II, 1982
mixed media on etched magnesium,
126 × 100 × 24¾ (319.9 × 253.9 × 62.8)
Gift of Lila Acheson Wallace 1982.53.1

In 1974, while he was still painting the Diderot series (the flat Concentric Square canvases that followed the Polish Village reliefs), Stella began drawings and maquettes for the Brazilian series. This was the first series of the painted metal reliefs that have become his principal means of expression for most of the last thirteen years. The Brazilian series was completed in 1975 and was followed in turn by the Exotic Birds series and the Indian Birds series. In 1980 Stella began the Circuit series, which includes *Jarama II.*

Each of the Circuit paintings is named after an automobile racetrack (Stella is a racing aficionado), hence the title of the series. *Jarama II* is named after a Spanish racetrack outside Madrid. Stella has noted that "circuit" also refers to the interweaving of parts that characterizes these reliefs. The series is enormously varied, but throughout Stella employs thin, sinuous strips of metal whose movement around and through the reliefs recalls, among other references, the Hiberno-Saxon tradition of interlace pattern that Stella studied as an undergraduate at Princeton. Stella consistently cuts through what remained of the picture plane in his earlier series, emphasizing voids as well as solids and creating multileveled compositions.

For each work in the Circuit series Stella first made drawings and studies, then a maquette out of foamcore. He drew the designs of the individual pieces with the aid of, and occasionally in the shape of, mechanical drafting tools such as ships' curves. After he had begun the Circuit series, Stella discovered the flexicurve, a tool that can change the direction of a curve as it is being drawn. The flexicurve gave many of the works in the Circuit series their characteristically sinuous lines, analogous to the switchbacks and chicanes of grand prix racecourses. Once Stella had cut pieces of foamcore to construct the maquette, he might also find a use for the remnants, creating interplays of positive and negative shapes. The completed maquette was then sent to a factory where pieces of etched metal were cut in the shape of the various foamcore parts. Stella would paint each part separately before finally assembling a relief.

Jarama II is extraordinarily agitated and forceful, and it gains energy from the opposition of rigid and swerving forms. Straight vertical pieces of metal on either side act as constraining elements, from which snakelike lines break free. The complex overlapping structure of *Jarama II* is clarified to a degree by the bright patterns and colors of its individual parts. Characteristically of all Stella's work, from the Black Paintings of 1959 on, *Jarama II* has no principal focus. Stella distributes visual interest evenly across the work and through its surfaces. The evident weight of the metal relief is effectively negated by the exuberance of its forms and colors, and paradoxically, the entire object seems almost cloudlike in its lightness.

Bibliography

William Rubin, *Frank Stella 1970–1987* [exh. cat., The Museum of Modern Art] (New York, 1987).

Chuck Close
American, born 1940
Fanny/Fingerpainting, 1985
oil on canvas, 102 × 84 (259.1 × 213.4)
Gift of Lila Acheson Wallace 1987.2.1

Although Close's paintings are realistic, intensely so, their roots lie in the same critique of abstract expressionism that helped produce minimalist and conceptualist art. Close did not believe that expressive, gestural painting could provide a unique and instantaneous recording of the artist's inner psyche. He wanted to create an art powerful in effect and impersonal in treatment, yet deeply personal in subject. In his paintings of 1968 through 1970 he worked from black-and-white photographs of his own face or the faces of friends, dividing the photographs into grids of hundreds or even thousands of units, transposing the grid onto a much larger canvas, and then reproducing each unit of the grid with an airbrush. The resultant paintings displayed hardly any evidence of human facture, and they contained no overtly expressive element, but their looming, visceral presence was unforgettable.

Close adapted his airbrush technique to working in color in 1970, while still maintaining the invisible grid system. In 1973 he determined to make the grid visible in a series of so-called dot drawings. For these drawings, still executed with an airbrush, Close worked from broader grids. Instead of blending colors within each square, as in his earlier work, Close painted small, equally sized dots, one next to the other. As Lisa Lyons has observed: "If Close's large-scale paintings are about the upper limits of perception—the point at which a face almost drowns in a welter of visual data—then the dot drawings are about the lower limits. How little information do you need to recognize a face? How generalized can it be before the specific relationship of features falls apart? And which features are the first to disappear?"

In the mid-1980s Close began to experiment, first in drawings and prints and later in paintings, with a technique that provided simultaneously the extreme detail of the earlier airbrush paintings and the sense of visible dissolution of the dot drawings. That technique, which Close called fingerpainting, could also be called fingerprinting, for it entailed the direct application of pigment to a paper or canvas surface with the artist's fingertips. The application of these fingerprints was determined by the system of photographs and grids that underpinned the airbrush paintings and the dot drawings. Returning to black and white, Close could achieve a wide range of tonal effects by varying the amount of ink or paint and adjusting the pressure of his finger on the paper or canvas. The fingerpaintings present a paradoxical and ironic combination of the personal and the impersonal. They give a more conspicuous record of the artist's irreducibly personal touch than the most animated abstract expressionist brushwork could provide. At the same time, those touches are dictated by an abstract, distinctly impersonal system.

Fanny/Fingerpainting, a portrait of Close's mother-in-law, represents one of the largest and most masterly executions of this new technique. Seen from a distance, the painting looks like a giant, silvery-toned photograph that unrelentingly reveals every crack and crevice of the sitter's face. Closer up, the paint surface dissolves into whorls and swirls that have an abstract beauty even as they metaphorically suggest the wearing away of the sitter's flesh with age. The viewer's experience repeats that of the artist at work. Awareness of the whole is diminished, and the fingerprints lose their specific mimetic significance. One is confronted instead with a sea of fingerprints, some knotted and clustered, others floating free.

The monumental, close-up view in *Fanny/ Fingerpainting* forces an uncomfortable, even embarrassing intimacy upon the viewer. There is an element of aggression here, found as well in Close's earlier monumental paintings. It is an aggression directed both toward the viewer and toward the sitter, whose features are depicted in the most unforgiving detail. Close, diagnosed with dyslexia as an adult, found that he had always worked in giant portraits partly to memorize the faces of friends and family. Thus he found a way to represent them that relied on direct, physical touch rather than on words or other codes. *Fanny/Fingerpainting* indelibly imprints itself on our memories as well.

Bibliography

Lisa Lyons and Martin Friedman, *Close Portraits* [exh. cat., Walker Art Center] (Minneapolis, 1980).

Lisa Lyons and Robert Storr, *Chuck Close* (New York, 1987).

Louis K. Meisel, *Photo-Realism* (New York, 1980).

Nancy Graves
American, born 1940
Spinner, 1985
cast bronze with polychrome patina and glass
enamel, 53 × 35 × 11¾
(134.6 × 88.9 × 29.8)
Gift of Lila Acheson Wallace 1986.19.1

With a career that spans both painting and sculpture, and with interests that include anthropology, tribal art, botany, and zoology, Graves creates objects that are marvels of bronze casting and energetic combination. Her most extraordinary effects are achieved by the technique of direct casting and by use of a wide array of patinas. Through both direct and lost-wax casting she reproduces a profusion of varied and surprising objects, and from her inventory of hundreds of these cast forms she then assembles her sculptures, welding them together piece by piece. Direct casting allows Graves to reproduce in bronze objects as delicate as leaves. Her technique is so precise that when she casts pretzels, the salt crystals appear, and when she casts sardines, one can see the fine lines of their scales preserved in bronze.

Rejecting the centuries-old tradition of bronze sculpture with a monochrome patina of dark brown or green, Graves brightly polychromes her sculpture. Each separate piece may have a different color or may be multicolored. To broaden the range of chromatic effects, Graves may also enamel or paint parts of her sculptures. Color plays such an essential role in her work that traditional distinctions between painting and sculpture begin to break down.

For all her formal and technical innovation, Graves makes explicit reference in her art to the major movements and masters of twentieth-century sculpture. Like the constructivists, she makes sculpture that defines space and volume, not mass. Following the surrealist tradition of Ernst and Miró, her sculptures are assemblages of cast found objects. Her work has a particularly close relation to that of David Smith who, like Graves, combined the constructivist and surrealist traditions.

The influence of another American sculptor is felt in *Spinner.* The suggestion of animal form and the object's rotating head and neck, which give the work its title, recall Alexander Calder's mobiles. *Spinner* is one of several sculptures by Graves from the early 1980s that include moving parts, and often these sculptures have titles that describe a single part or element. Here, with a wittiness that is characteristic of Graves' sculpture, "spinner" alludes not only to the animal's head but also to a weathervane. The relative spareness of *Spinner* highlights the peculiar humor of its various cast parts, from the bunch of bananas at the creature's tail, to the pretzels and sardines along the rotors, to the crayfish that hangs on triumphantly at the top.

Bibliography

Debra Bricker Balken, *Nancy Graves: Painting, Sculpture, Drawing, 1980–1985* [exh. cat., Vassar College Art Gallery] (Poughkeepsie, N.Y., 1986).

E. A. Carmean, et. al., *The Sculpture of Nancy Graves: A Catalogue Raisonné* (New York, 1987).

Elizabeth Frank, "Her Own Way: The Daring and Inventive Sculptures of Nancy Graves," *Connoisseur* (February 1986).

AFTERWORD

This exhibition and new installation celebrates both the tenth anniversary of the East Building and the dramatic growth in the National Gallery's collection of twentieth-century art. Following the preeminent bequest of the Chester Dale Collection in 1963, the Gallery has continued to receive important donations of art (paintings, sculpture, and works on paper) as well as purchase monies from many generous patrons. These notable works of art have been chosen and accepted with the precise, disciplined goal of establishing at the National Gallery the highest quality concentrations of major works by our century's most important and influential European and American artists. Held in trust for the nation, the critical mass of this collection is now in place. Names of all contributors of twentieth-century paintings and sculpture to the Gallery since its founding in 1941 are given following the installation checklist.

We gratefully acknowledge as well the continued support and select loans from generous collectors and artists. The installation, comprising over two hundred objects (of which 60 percent are in the Gallery's collection), will remain on view at least through 1990. Works are displayed in twenty-five completely redesigned galleries extending over 30,000 square feet. The East Building itself comprises visually exciting and flexible gallery spaces. These will serve our expanding collection and exhibition program well as we continue to move in active response to the best art of our time.

This exhibition and installation has been realized only with the full support of every department and office at the National Gallery. J. Carter Brown, our director, with the former deputy director, John Wilmerding, and former chief curator, Sydney Freedberg, have encouraged this department at every juncture. Roger Mandle, the new deputy director, has expanded this active executive support. Among those departments central to the exhibition process has been that of design and installation, led by Gaillard Ravenel and Mark Leithauser. Gill's and Mark's early ideas and enthusiasm helped initiate the tenth-anniversary installation concept. They have designed and built extremely handsome and functional spaces that display the art to its best advantage. Additional design coordination was provided by Gordon Anson, Bill Bowser, John Olson, Barbara Keyes, Gloria Randolph, and James Spicknall.

We would also like to thank D. Dodge Thompson and his department of exhibition programs as well as registrar Anne Halpern, Stephanie Belt of the department of records and loans, and the art handlers managed by John Poliszuk. The office of external affairs has been resourceful and energetic in their support. In particular, Genevra Higginson, Ruth Kaplan, Elizabeth C. Weil, and their respective departments have overseen the special events, public information, and communications with the generous corporate sponsor, American Express Company.

In the department of twentieth-century art assistant curator Jeremy Strick has coordinated myriad details and changes while patiently helping us shape the fundamental artistic and historical layout and program of the installation. He is the primary author of this catalogue of selected acquisitions, 1978–1988, and we are pleased to acknowledge his dedication to these many tasks and his intelligent and most useful text. In addition, exhibition assistant Laura Coyle has provided constant curatorial support. Museum interns Rachel Gerstenhaber and Cahssey Groos and volunteer Vanessa Green ably compiled essential documentation. We acknowledge the tireless clerical and office support given by the departmental secretaries Cara Taussig and Amy Heilman.

Jack Cowart
Curator of twentieth-century art

Nan Rosenthal
Curator of twentieth-century art

INSTALLATION CHECKLIST

Jean Arp, French, 1887–1966
Shirt Front and Fork, 1922
painted wood, 23 × 27½ × 2⅜ (58.4 × 70 × 6.1)
Ailsa Mellon Bruce Fund 1983.3.1

Mirr, 1936/1960
marble, 6⅞ × 8⅝ × 6 (17.5 × 22 × 15.2)
Gift of Mr. and Mrs. Burton Tremaine 1977.75.6

Hurlou, 1957
marble, 38¼ × 15 (97.2 × 38.1)
Boris and Sophie Leavitt

Grande Sculpture Classique, 1963–1964
bronze, 93⅞ × 14⁹⁄₁₆ × 14½ (238.5 × 37 × 36.8)
Ailsa Mellon Bruce Fund 1971.66.11

After Jean Arp
Variation sur "Aubette," c. 1975
wool, 118½ × 236 (300.9 × 599.2)
Gift of the Collectors Committee 1976.31.1

Oriforme, 1977
stainless steel, 89¾ × 84½ × 23⅝ (227.9 × 214.6 × 60)
To the American People in Gratitude—Leon Chalette, Arthur
Lejwa, and Madeleine Chalette Lejwa 1978.22.1

William Baziotes, American, 1912–1963
Pierrot, 1947
oil on canvas, 42⅛ × 36 (107 × 91.5)
Ailsa Mellon Bruce Fund 1984.43.1

Tropical, 1959
oil on canvas, 50¼ × 40 (127.6 × 101.6)
Boris and Sophie Leavitt

Max Beckmann, German, 1884–1950
The Argonauts, 1949–1950
oil on canvas, left to right panels: 72½ × 33½ (184.1 ×
85.1); 81 × 48 (205.7 × 121.9); 73 × 33½ (185.4 × 85.1)
Gift of Mrs. Max Beckmann 1975.96.1a–c

Harry Bertoia, American, 1915–1978
Tonal Sculpture, 1977
beryllium copper with bronze weights, 228 (579.1) high
Gift of Bernard and Audrey Berman 1984.103.1

Constantin Brancusi, Romanian, 1876–1957
Maiastra (Bird Before It Flew), cast c. 1911
polished bronze, 22 × 7½ × 7⅜ (55.9 × 18.9 × 18.7)
Gift of Katharine Graham 1980.75.1

Bird in Space, 1925
marble, stone, and wood, 136½ (344.6) high
Gift of Eugene and Agnes E. Meyer 1967.13.3

Agnes E. Meyer, 1929
marble, 90⅝ (230.1) high
Gift of Eugene and Agnes E. Meyer 1967.13.4

Georges Braque, French, 1882–1963
Bottles and Glasses, 1911–1912
oil on canvas, 31⅛ × 23¼ (79.1 × 59.1)
Mrs. Robert B. Eichholz

Aria de Bach, 1913
collage with black paper, imitation wood, charcoal, and white
chalk on white paper, 24½ × 18½ (62.2 × 47)
Collection of Mr. and Mrs. Paul Mellon 1982.55.2

Still Life: The Table, 1928
oil on canvas, 32 × 51½ (81.3 × 130.8)
Chester Dale Collection 1963.10.92

Still Life: Le Jour, 1929
oil on canvas, 45¼ × 57¾ (115 × 146.7)
Chester Dale Collection 1963.10.91

Alberto Burri, Italian, born 1915
Red Accent, 1954
oil on canvas, 39 × 34 (99.1 × 86.4)
Morton G. Neumann Family Collection

Alexander Calder, American, 1898–1976
Obus, 1972
painted steel, 142½ × 152 × 89⅝ (361.8 × 385.9 × 227.6)
Collection of Mr. and Mrs. Paul Mellon 1983.1.49

Untitled, 1976
aluminum and steel, 358½ × 912 (910.3 × 2315.5)
Gift of the Collectors Committee 1977.76.1

Anthony Caro, British, born 1924
Scheherazade, 1974
steel, 102½ × 156 × 108 (260.4 × 396.2 × 273.3)
Guido Goldman Sprinkling Trust

National Gallery Ledge Piece, 1978
welded steel, 171⅛ × 243¼ × 106
(434.5 × 617.6 × 273.3)
Gift of the Collectors Committee 1978.21.1

Chuck Close, American, born 1940
Fanny/Fingerpainting, 1985
oil on canvas, 102 × 84 (259.1 × 213.4)
Gift of Lila Acheson Wallace 1987.2.1

Willem de Kooning, American, born 1904
Woman, c. 1949
oil on canvas, 60½ × 47⅞ (153.7 × 121.6)
Boris and Sophie Leavitt

Robert Delaunay, French, 1885–1941
The Windows, 1912
oil on canvas, 35⅞ × 33⅜ (91.1 × 84.8)
Morton G. Neumann Family Collection

André Derain, French, 1880–1954
Mountains at Collioure, 1905
oil on canvas, 32 × 39½ (81.3 × 100.3)
John Hay Whitney Collection 1982.76.4

Charing Cross Bridge, London, 1906
oil on canvas, 31⅝ × 39½ (80.3 × 100.3)
John Hay Whitney Collection 1982.76.3

View of the Thames, 1906
oil on canvas, 28⅞ × 36⁵⁄₁₆ (73.3 × 92.2)
Collection of Mr. and Mrs. Paul Mellon 1985.64.12

Richard Diebenkorn, American, born 1922
Berkeley No. 52, 1955
oil on canvas, 58⅝ × 53⅞ (148.9 × 136.8)
Gift of the Collectors Committee 1986.68.1

Ocean Park, No. 50, 1972
oil on canvas, 93 × 81 (236.2 × 205.7)
Lent by Mr. and Mrs. Paul Mellon

Ocean Park, No. 61, 1973
oil on canvas, 93 × 81 (236.2 × 205.7)
Lent by Mr. and Mrs. Paul Mellon

Ocean Park, No. 87, 1975
oil on canvas, 100 × 81 (254 × 205.7)
Lent by Mr. and Mrs. Paul Mellon

Ocean Park, No. 89, 1975
oil on canvas, 81 × 81 (205.7 × 205.7)
Lent by Mr. and Mrs. Paul Mellon

Jean Dubuffet, French, 1901–1985
Leader in a Parade Uniform (Chef en tenue de parade), 1945
oil on canvas, 36⅜ × 25⅞ (92.4 × 65.7)
Morton G. Neumann Family Collection

Lady with Pompon (La dame au pompon), 1946
mixed media and oil on canvas, 31¾ × 25½ (80.6 × 64.7)
Chester Dale Fund 1986.11.1

Antonin Artaud with Tufts (Antonin Artaud aux Houppes),
1947
oil on canvas, 50¾ × 37¼ (128.9 × 94.6)
Morton G. Neumann Family Collection

The Ceremonious One (Le cérémonieux), 1954
oil on canvas, 51 × 34⅝ (129.5 × 88)
Morton G. Neumann Family Collection

Max Ernst, German, 1891–1976
A Moment of Calm (Un peu de calme), 1939
oil on canvas, 66⅞ × 128 (169.8 × 325)
Gift of Dorothea Tanning Ernst 1982.34.1

Capricorn, 1948, cast 1975 (artist's proof, 1/2)
bronze, 95½ × 81½ × 59½ (242.5 × 206.9 × 151)
Gift of the Collectors Committee 1979.30.1

Lyonel Feininger, American, 1871–1956
The Bicycle Race, 1912
oil on canvas, 31⅝ × 39½ (80.3 × 100.3)
Collection of Mr. and Mrs. Paul Mellon 1985.64.17

Lucio Fontana, Italian, 1899–1968
Spatial Concepts, Expectations (Concetto Spaziale Attese),
c. 1957
oil on canvas, 28 × 36 (71.1 × 91.4)
Morton G. Neumann Family Collection

Sam Francis, American, born 1923
White Line, 1958–1959
oil on canvas, 108½ × 75¾ (275.6 × 192.4)
Gift of the Collectors Committee 1985.56.1

Helen Frankenthaler, American, born 1928
Mountains and Sea, 1952
oil on canvas, 86⅞ × 117¼ (220.7 × 297.8)
Collection of Helen Frankenthaler

Alberto Giacometti, Swiss, 1901–1966
Observing Head, 1927–1928
bronze, 15¼ × 14 × 2½ (38.7 × 35.6 × 6.4)
Morton G. Neumann Family Collection

No More Play (On ne joue plus), 1931–1932
marble, wood, and bronze, 1⅝ × 22⅞ × 17¾
(4.1 × 58 × 45.2)
Patsy and Raymond Nasher Collection

The Invisible Object (Hands Holding the Void), 1935
bronze, blond patina, 60¼ × 12⅞ × 11¾
(153 × 32.6 × 29.9)
Ailsa Mellon Bruce Fund, 1973.27.1

Standing Woman, c. 1947
bronze, 46½ × 8¼ × 11⅛ (181.1 × 21 × 28.3)
Gift of Enid A. Haupt 1977.47.6

The City Square, 1948–1949
bronze, 9½ × 25½ × 17⅛ (24 × 64.7 × 43.4)
Gift of Enid A. Haupt 1977.47.3

Seated Woman, 1949
oil on canvas, 34⅝ × 23⅜ (88 × 59.4)
Morton G. Neumann Family Collection

The Chariot, 1950
bronze, wood base, 64⅝ × 27 × 26⅜ (164.1 × 68.6 × 67)
Gift of Enid A. Haupt 1977.47.2

The Forest: Composition with Seven Figures and a Head, 1950
painted bronze, 22 × 24 × 19¼ (55.8 × 61.1 × 48.9)
Gift of Enid A. Haupt 1977.47.4

Kneeling Woman, 1956
bronze, 19¾ × 6 × 9½ (50.1 × 15.2 × 24.3)
Gift of Enid A. Haupt 1977.47.5

Walking Man II, 1960
bronze, 74¼ × 11 × 43⅝ (188.5 × 27.9 × 110.7)
Gift of Enid A. Haupt 1977.47.7

Arshile Gorky, American, 1904–1948
The Artist and His Mother, c. 1926–1942
oil on canvas, 60 × 50 (152.3 × 127)
Ailsa Mellon Bruce Fund 1979.13.1

Organization, 1933–1936
oil on canvas, 49¾ × 60 (126.4 × 152.4)
Ailsa Mellon Bruce Fund 1979.13.3

Still Life on Table, c. 1936–1937
oil on canvas, 54 × 64 (137.2 × 162.6)
private collection

N.T. Head, c. 1937
oil on canvas, 21 × 21 (53.3 × 53.3)
private collection

Portrait of Akho, c. 1937
oil on canvas, 19½ × 15 (49.5 × 38.1)
private collection

Portrait of Master Bill, c. 1937
oil on canvas, 52⅛ × 40⅛ (132.4 × 101.9)
private collection

Self-Portrait, c. 1937
oil on canvas, 55½ × 34 (141 × 86.4)
private collection

Composition, c. 1937–1938
oil on canvas, 29 × 40 (73.7 × 101.6)
private collection

Gray Painting, 1938
oil on canvas, 29¼ × 40⅛ (74.3 × 101.9)
private collection

Khorkom, c. 1938
oil on canvas, 40 × 52 (101.6 × 132.1)
private collection

One Year the Milkweed, 1944
oil on canvas, 37 × 47 (94.2 × 119.3)
Ailsa Mellon Bruce Fund 1979.13.2

The Limit, 1947
oil on paper on canvas, 50¾ × 62½ (128.9 × 158.8)
private collection

Adolf Gottlieb, American, 1903–1974
Coalesence, 1961
oil on canvas, 90 × 72 (228.6 × 182.9)
Boris and Sophie Leavitt

Nancy Graves, American, born 1940
Spinner, 1985
cast bronze with polychrome patina and glass enamel,
53 × 35 × 11¾ (134.6 × 88.9 × 29.8)
Gift of Lila Acheson Wallace 1986.19.1

Juan Gris, Spanish, 1887–1927
Banjo with Glasses, 1912
oil on canvas, 11½ × 22½ (29.2 × 57.2)
Morton G. Neumann Family Collection

Fantômas, 1915
oil on canvas, 23½ × 28⅞ (59.8 × 73.3)
Chester Dale Fund 1976.59.1

Philip Guston, American, 1913–1980
Beggar's Joy, 1954–1955
oil on canvas, 71⅛ × 68 (180.7 × 172.7)
Boris and Sophie Leavitt

Marsden Hartley, American, 1877–1943
The Aero, 1914
oil on canvas, 39½ × 32 (100.3 × 81.2)
Andrew W. Mellon Fund 1970.31.1

Jasper Johns, American, born 1930
Flag on Orange Field, II, 1958
encaustic on canvas, 54 × 36¼ (137.2 × 92.1)
private collection, New York

Target, 1958
oil and collage on canvas, 36 × 36 (91.4 × 91.4)
Collection the artist

No, 1961
encaustic, collage, and sculp-metal on canvas with objects,
68 × 40 (172.7 × 101.6)
Collection the artist

Fool's House, 1962
oil on canvas with objects, 72 × 36 (182.9 × 91.4)
Jean-Christophe Castelli

Field Painting, 1963–1964
oil on canvas with objects, 72 × 36¾ (182.9 × 93.4)
Collection the artist

Harlem Light, 1967
oil and collage on canvas, 79⅛ × 172⅛ (201 × 437.2)
Collection David Whitney

Untitled (A Dream), 1985
oil on canvas, 75 × 50 (190.5 × 127)
Robert and Jane Meyerhoff

Untitled (M. T. Portrait), 1986
oil on canvas, 75 × 50 (190.5 × 127)
Robert and Jane Meyerhoff

Wassily Kandinsky, Russian, 1866–1944
Improvisation 31 (Sea Battle), 1913
oil on linen, 55⅜ × 47⅛ (145.1 × 119.7)
Ailsa Mellon Bruce Fund 1978.48.1

Ellsworth Kelly, American, born 1923
Relief with Blue, 1950
oil on wood, 45 × 17½ × 1¼ (114.3 × 44.5 × 3.2)
private collection

White Relief, 1950
oil on wood, 39¼ × 27¼ × 1¾ (99.7 × 69.2 × 4.5)
private collection

White Square, 1953
oil on wood, 43¼ × 43¼ (109.9 × 109.9)
private collection

Black Square with Blue, 1970
oil on canvas, two joined panels, 120 × 120 (304.8 × 304.8)
private collection

White Curve VIII, 1976
oil on canvas, 96 1/16 × 76 15/16 (244 × 195.4)
Gift of Mr. and Mrs. Joseph Helman 1984.105.1

Red Curve VI, 1982
oil on canvas, 74¼ × 140½ (188.6 × 356.9)
private collection

Untitled, 1988
bronze, 120 × 24½ × 1 (304.8 × 62.2 × 2.5)
private collection

Yves Klein, French, 1928–1962
The Blue Night, 1959
oil on canvas, 35¾ × 28⅝ (90.8 × 72.7)
Morton G. Neumann Family Collection

Gustav Klimt, Austrian, 1862–1918
Baby (Cradle), 1917–1918
oil on canvas, 43⅝ × 43½ (110.9 × 110.4)
Gift of Otto and Franziska Kallir with the help of the Carol and
Edwin Gaines Fullinwider Fund 1978.41.1

Franz Kline, American, 1910–1962
Four Square, 1956
oil on canvas, 78⅜ × 50¾ (199 × 128.9)
Gift of Mr. and Mrs. Burton Tremaine 1971.87.12

C & O, 1958
oil on canvas, 77 × 110 (195.6 × 279.4)
Gift of Mr. and Mrs. Burton Tremaine 1971.87.4

František Kupka, Czechoslovakian, 1871–1957
Organization of Graphic Motifs II, 1912–1913
oil on canvas, 78¾ × 76⅜ (200 × 194)
Ailsa Mellon Bruce Fund and Gift of Jan and Meda Mladek
1984.51.1

Fernand Léger, French, 1881–1955
Man with a Dog, 1920
oil on canvas, 36 × 25⅜ (91.4 × 64.5)
Morton G. Neumann Family Collection

Two Women, 1922
oil on canvas, 35¾ × 23 (90.8 × 58.4)
Richard S. Zeisler Collection, New York

Still Life, 1927
oil on canvas, 51 × 37¾ (129.5 × 95.9)
Morton G. Neumann Family Collection

Roy Lichtenstein, American, born 1923
Look Mickey, 1961
oil on canvas, 48 × 69 (121.9 × 175.3)
private collection

Live Ammo, 1962
oil on canvas, left to right panels: 68½ × 56⅝
(174 × 143.8); 68½ × 36½ (174 × 92.7)
Morton G. Neumann Family Collection

Girl with Hair Ribbon, 1965
oil and magna on canvas, 48 × 48 (121.9 × 121.9)
private collection

Yellow Brushstroke II, 1965
oil and magna on canvas, 36 × 108 (91.4 × 274.3)
private collection

Rouen Cathedral, Set III, 1969
oil and magna on canvas, five paintings, each 63 × 42
(160 × 106.7)
private collection

Cubist Still Life, 1974
oil and magna on canvas, 90 × 68¹/₁₆ (228.6 × 173.2)
Gift of Lila Acheson Wallace 1983.50.1

Cosmology, 1977
oil and magna on canvas, 108 × 168 (274.3 × 426.7)
private collection

Brushstroke Chair, Bronze, 1987
bronze, 72 × 24 × 36 (182.9 × 61 × 91.4)
Boris and Sophie Leavitt

Brushstroke Ottoman, Bronze, 1987
bronze, 24 × 24 × 36 (61 × 61 × 91.4)
Boris and Sophie Leavitt

Seymour Lipton, American, 1903–1986
Gateway, 1964
nickel silver on Monel metal, 76 × 59 × 35
(193 × 149.8 × 88.9)
Gift of Seymour Lipton 1986.75.43

Morris Louis, American, 1912–1962
Verdigris, 1958
acrylic on canvas, 87½ × 128¾ (222.3 × 327)
Collection Lois and Georges de Menil

Beta Kappa, 1961
acrylic resin on canvas, 103¼ × 173 (262.3 × 439.4)
Gift of Marcella Louis Brenner 1970.21.1

René Magritte, Belgian, 1898–1967
Underground Fire (Le feu souterrain), c. 1928
oil on canvas, 21 × 28⅜ (53.3 × 72.1)
Morton G. Neumann Family Collection

The Human Condition (La condition humaine), 1933
oil on canvas, 39⅜ × 31⅞ (100 × 81)
Gift of the Collectors Committee 1987.55.1

The Blank Signature (Le blanc seing), c. 1965
oil on canvas, 32 × 25⅝ (81.3 × 65.1)
Collection of Mr. and Mrs. Paul Mellon 1985.64.24

Henri Matisse, French, 1869–1954
The Coiffure, 1901
oil on canvas, 37½ × 31½ (95.2 × 80.1)
Chester Dale Collection 1963.10.165

Palm Leaf, Tangier, 1912
oil on canvas, 46¼ × 32¼ (117.5 × 81.9)
Chester Dale Fund 1978.73.1

Lorette with Turban, Yellow Jacket, 1917
oil on wood, 24⅛ × 19½ (61.3 × 49.4)
Chester Dale Collection 1963.10.39

The Plumed Hat, 1919
oil on canvas, 18¾ × 15 (47.7 × 38.1)
Chester Dale Collection 1963.10.168

Odalisque, Half-Length—The Tatoo, 1923
oil on canvas, 14 × 9⅝ (35.6 × 24.4)
Chester Dale Collection 1963.10.40

Odalisque Seated with Arms Raised, Green Striped Chair, 1923
oil on canvas, 25⅝ × 19¾ (65.1 × 50.2)
Chester Dale Collection 1963.10.167

Pianist and Checker Players, 1924
oil on canvas, 29 × 36⅜ (73.7 × 92.4)
Collection of Mr. and Mrs. Paul Mellon 1985.64.25

Still Life with Apples on Pink Tablecloth, 1924
oil on canvas, 23¾ × 28¾ (60.4 × 73)
Chester Dale Collection 1963.10.169

Still Life with Sleeping Woman, 1940
oil on canvas, 32½ × 39⅝ (82.5 × 100.7)
Collection of Mr. and Mrs. Paul Mellon 1985.64.26

Beasts of the Sea, 1950
painted, cut, and pasted paper, 116⅜ × 60⅝ (295.5 × 154)
Ailsa Mellon Bruce Fund 1973.18.1

La Négresse, 1952
painted, cut, and pasted paper, 178¾ × 245½
(453.9 × 623.3)
Ailsa Mellon Bruce Fund 1973.6.1

Venus, 1952
painted, cut, and pasted paper, 39⅞ × 30⅛ (101.2 × 76.5)
Ailsa Mellon Bruce Fund 1973.18.2

Large Composition with Masks, 1953
painted, cut, and pasted paper, 139¼ × 392½
(353.6 × 996.4)
Ailsa Mellon Bruce Fund 1973.17.1

Woman with Amphora and Pomegranates, 1953
painted, cut, and pasted paper, 96 × 37⅞ (243.6 × 96.3)
Ailsa Mellon Bruce Fund 1973.18.3

Joan Miró, Spanish, 1893–1983
The Farm, 1921–1922
oil on canvas, 48¾ × 55⅝ (123.8 × 141.3)
Gift of Mary Hemingway 1987.18.1

Head of a Catalan Peasant, 1924
oil on canvas, 57½ × 45 (146 × 114.2)
Gift of the Collectors Committee 1981.9.1

Mural Painting for a Temple I, 1962
oil on canvas, 106¼ × 139¾ (269.9 × 355)
private collection

Mural Painting for a Temple II, 1962
oil on canvas, 106¼ × 139¾ (269.9 × 355)
private collection

Mural Painting for a Temple III, 1962
oil on canvas, 106¼ × 139¾ (269.9 × 355)
private collection

After Joan Miró
Woman, 1977
wool, 415 × 238 (1053.7 × 604.3)
Gift of the Collectors Committee and George L. Erion
1978.23.1

Amedeo Modigliani, Italian, 1884–1920
Head of a Woman, 1910–1911
limestone, 25¾ × 7½ × 9¾ (65.2 × 19 × 24.8)
Chester Dale Collection 1963.10.241

Chaim Soutine, 1917
oil on canvas, 36⅛ · × 23½ (91.7 × 59.7)
Chester Dale Collection 1963.10.47

Léon Bakst, 1917
oil on canvas, 21¾ × 13 (55.3 × 33)
Chester Dale Collection 1963.10.173

Madame Kisling, c. 1917
oil on canvas, 18¼ × 13⅛ (46.2 × 33.2)
Chester Dale Collection 1963.10.175

Nude on a Blue Cushion, 1917
oil on linen, 25¾ × 39¾ (65.4 × 100.9)
Chester Dale Collection 1963.10.46

Woman with Red Hair, 1917
oil on canvas, 36¼ × 23⅞ (92.1 × 60.7)
Chester Dale Collection 1963.10.176

Madame Amédée (Woman with Cigarette), 1918
oil on canvas, 39½ × 25½ (100.3 × 64.8)
Chester Dale Collection 1963.10.172

Nude on a Divan, 1918
oil on canvas, 23⅝ × 36⅛ (60.2 × 91.7)
Chester Dale Collection 1963.10.77

Gypsy Woman with Baby, 1919
oil on canvas, 45⅝ × 28¾ (115.9 × 73)
Chester Dale Collection 1963.10.174

Piet Mondrian, Dutch, 1872–1944
Diamond Painting in Red, Yellow, and Blue, c. 1921–1925
oil on canvas on hardboard, 56¼ × 56 (142.8 × 142.3)
Gift of Herbert and Nannette Rothschild 1971.51.1

Henry Moore, British, 1898–1986
Stone Memorial, 1961–1969
travertine marble, 59¾ × 68⅞ (151.7 × 174.9)
Collection of Mr. and Mrs. Paul Mellon 1983.1.71

Knife Edge Mirror Two Piece, 1977, cast 1978
bronze, 210½ × 284 × 143 (534.5 × 721.1 × 363.1)
Gift of The Morris and Gwendolyn Cafritz Foundation
1978.43.1

Robert Motherwell, American, born 1915
Two Figures with Cerulean Blue, 1960
oil on canvas, 84½ × 109½ (214.6 × 278.1)
Boris and Sophie Leavitt

Reconciliation Elegy, 1978
acrylic on canvas, 120 × 364 (304.8 × 924.2)
Gift of the Collectors Committee 1978.20.1

Barnett Newman, American, 1903–1970
Pagan Void, 1946
oil on canvas, 33 × 38 (83.8 × 96.5)
Gift of Annalee Newman 1988.57.1

Dionysius, 1949
oil on canvas, 69 × 48 (175.3 × 121.9)
Gift of Annalee Newman 1988.57.2

Yellow Painting, 1949
oil on canvas, 67 × 52 (170.2 × 132.1)
Gift of Annalee Newman 1988.57.3

The Name II, 1950
oil on canvas, 108 × 96 (274.3 × 243.8)
Gift of Annalee Newman 1988.57.4

Achilles, 1952
oil on canvas, 96 × 79 (243.8 × 200.7)
Gift of Annalee Newman 1988.57.5

The Stations of the Cross—Lema Sabachthani
Robert and Jane Meyerhoff Collection 1986.65.1–14

 First Station, 1958
 magna on canvas, 77⅞ × 60½ (197.8 × 153.7)

 Second Station, 1958
 magna on canvas, 78⅛ × 60½ (198.4 × 153.7)

 Third Station, 1960
 oil on canvas, 78⅛ × 59⅞ (198.4 × 152.1)

 Fourth Station, 1960
 oil on canvas, 78 × 60¼ (198.1 × 153)

 Fifth Station, 1962
 oil on canvas, 78¼ × 60¼ (198.7 × 153)

 Sixth Station, 1962
 oil on canvas, 78⅛ × 59⅞ (198.4 × 152.1)

 Seventh Station, 1964
 oil on canvas, 78 × 60 (198.1 × 152.4)

 Eighth Station, 1964
 oil on canvas, 78⅛ × 60 (198.4 × 152.4)

 Ninth Station, 1964
 acrylic on canvas, 78 × 60⅛ (198.1 × 152.7)

 Tenth Station, 1965
 magna on canvas, 78 × 60¹⁄₁₆ (198.1 × 152.5)

 Eleventh Station, 1965
 acrylic on canvas, 78 × 60 (198.1 × 152.4)

 Twelfth Station, 1965
 acrylic on canvas, 78 × 60 (198.1 × 152.4)

 Thirteenth Station, 1965–1966
 acrylic on canvas, 78¹⁄₁₆ × 60¹⁄₁₆ (198.2 × 152.5)

 Fourteenth Station, 1965–1966
 acrylic and duco on canvas, 78 × 59¹⁵⁄₁₆ (198.1 × 152.2)

Be II, 1961–1964
acrylic and oil on canvas, 80½ × 72¼ (204.5 × 183.5)
Robert and Jane Meyerhoff Collection 1986.65.15

Isamu Noguchi, American, born 1904
Great Rock of Inner Seeking, 1974
basalt, 127⅞ × 62⅜ × 35 (324.8 × 158.4 × 88.9)
Gift of Arthur M. Sackler, M.D., and Mortimer D.
Sackler, M.D. 1976.58.1

Francis Picabia, French, 1879–1953
Amorous Parade, 1917
oil on board, 37⅝ × 28⅝ (95.6 × 72.7)
Morton G. Neumann Family Collection

Pablo Picasso, Spanish, 1881–1973
The Gourmet, 1901
oil on canvas, 36½ × 26⅞ (92.8 × 68.3)
Chester Dale Collection 1963.10.52

Pedro Mañach, 1901
oil on linen, 41½ × 27½ (105.5 × 67)
Chester Dale Collection 1963.10.53

The Tragedy, 1903
oil on wood, 41½ × 27⅛ (105.4 × 69)
Chester Dale Collection 1963.10.196

Lady with a Fan, 1905
oil on linen, 39½ × 32 (100.3 × 81.2)
Gift of the W. Averell Harriman Foundation in memory of
Marie N. Harriman, 1972.9.19

Family of Saltimbanques, 1905
oil on canvas, 83¾ × 90⅜ (212.8 × 229.6)
Chester Dale Collection 1963.10.190

Two Youths, 1905
oil on canvas, 59⅝ × 36⅞ (151.5 × 93.7)
Chester Dale Collection 1963.10.197

Nude, 1909
oil on canvas, 35¼ × 28 (89.5 × 71.1)
Morton G. Neumann Family Collection

Nude Woman, 1910
oil on linen, 73¾ × 24 (187.3 × 61)
Ailsa Mellon Bruce Fund 1972.46.1

Young Girl with Left Arm Raised, 1910
oil on canvas, 21 × 17½ (53.3 × 44.5)
Morton G. Neumann Family Collection

The Cup of Coffee, 1912
collage with paper, wallpaper, charcoal, and gouache,
23¾ × 13¾ (60.3 × 34.9)
Collection of Mr. and Mrs. Paul Mellon 1985.64.105

Compote, Dish, Glass Bottle and Pipe, 1919
oil on canvas, 18¾ × 24¾ (47.6 × 62.9)
Morton G. Neumann Family Collection

The Lovers, 1923
oil on linen, 51¼ × 38¼ (130.2 × 97.2)
Chester Dale Collection 1963.10.192

Madame Picasso, 1923
oil on linen, 37⅞ × 32¼ (100.3 × 82)
Chester Dale Collection 1963.10.194

Guitar, 1926
collage with wallpaper, carpet tacks, nail, paper, string, and
charcoal on wood, 51¼ × 38¼ (130 × 97)
Chester Dale Fund, 1982.8.1

Jackson Pollock, American, 1912–1956
No. 1, 1950 (Lavender Mist), 1950
oil, enamel, and aluminum on canvas, 87 × 118 (221 ×
299.7)
Ailsa Mellon Bruce Fund 1976.37.1

Number 7, 1951, 1951
enamel on canvas, 56½ × 66 (143.5 × 167.6)
Gift of the Collectors Committee 1983.77.1

Ivan Pougny, Russian/French, 1894–1956
Suprematist Construction Montage, 1915–1916
painted wood, metal, and cardboard, 27½ × 19⅛ × 2¾
(69.8 × 48.7 × 7)
Andrew W. Mellon Fund 1976.70.1

Robert Rauschenberg, American, born 1925
Female Figure (Blueprint), c. 1949
monoprint: blueprint paper, 105 × 36 (266.7 × 91.4)
private collection

Automobile Tire Print, 1951
monoprint: ink on paper mounted on canvas, fully extended,
16½ × 264½ (41.9 × 671.2)
private collection

White Painting, 1951
oil on canvas, seven panels, total dimensions, 72 × 126
(182.9 × 320)
private collection

Black Painting, 1951–1952
oil and newsprint on canvas, four panels, total dimensions,
99 × 171⅝ (251.5 × 435.9)
private collection

Minutiae, 1954
mixed media, 84¾ × 81 × 30½ (215.3 × 205.7 × 77.5)
private collection

Blue Eagle, 1961
mixed media, 84 × 60 (213.4 × 152.4)
private collection

Selected works by Robert Rauschenberg from the
Rauschenberg Overseas Culture Interchange Collection

Ad Reinhardt, American, 1913–1967
Untitled, 1947
oil on canvas, 40 × 32 (101.6 × 81.3)
Ailsa Mellon Bruce Fund and Gift of The Circle of the National
Gallery of Art 1988.60.1

Black Painting No. 34, 1964
oil on canvas, 60¼ × 60⅛ (153 × 152.6)
Gift of Mr. and Mrs. Burton Tremaine 1970.37.1

Aleksandr Rodchenko, Russian, 1891–1956
Untitled, 1919
oil on wood, 15⅜ × 8⁵⁄₁₆ (39 × 21.1)
Gift of the Collectors Committee 1987.60.1

James Rosati, American, 1912–1988
Untitled, 1971–1977
painted aluminum, 113½ × 249½ × 106¾
(288.2 × 633.5 × 271.1)
Gift of the Collectors Committee based on model given by the
artist in memory of William C. Seitz 1978.24.1

Mark Rothko, American, 1903–1970
Archaic Phantasy, 1945
oil on canvas, 48⁷⁄₁₆ × 24⅛ (123.1 × 61.4)
Gift of The Mark Rothko Foundation 1986.43.11

Personage Two, 1946
oil on canvas, 56¹⁄₁₆ × 32¼ (142.2 × 81.9)
Gift of The Mark Rothko Foundation 1986.43.12

Untitled, 1949
oil on canvas, 81⅜ × 66⅜ (206.7 × 168.6)
Gift of The Mark Rothko Foundation 1986.43.138

Blue, Green and Brown, 1951
oil on canvas, 103 × 83 (261.6 × 210.8)
Lent by Mr. and Mrs. Paul Mellon

Untitled, 1953
oil on canvas, 76¹³⁄₁₆ × 67¹³⁄₁₆ (195.1 × 172.3)
Gift of The Mark Rothko Foundation 1986.43.135

Orange and Tan, 1954
oil on canvas, 81¼ × 63¼ (206.4 × 160.6)
Gift of Enid A. Haupt 1977.47.13

Yellow and Blue, 1954
oil on canvas, 96 × 73½ (243.8 × 186.7)
Lent by Mr. and Mrs. Paul Mellon

Red, Black, White on Yellow, 1955
oil on canvas, 105 × 93 (266.7 × 236.2)
Lent by Mr. and Mrs. Paul Mellon

White and Greens in Blue, 1957
oil on canvas, 102 × 82 (259.1 × 208.3)
Lent by Mr. and Mrs. Paul Mellon

Untitled, 1969
acrylic on canvas, 69⅝ × 62³⁄₁₆ (176.9 × 157.9)
Gift of The Mark Rothko Foundation 1986.43.163

Robert Ryman, American, born 1930
Register, 1978
oil on linen with metal, 62½ ×60 (158.8 × 152.4)
Morton G. Neumann Family Collection

David Salle, American, born 1952
Aerialist, 1988
acrylic, oil, and mixed media on canvas, 72 × 192
(182.9 × 487.7)
Boris and Sophie Leavitt

George Segal, American, born 1924
The Dancers, 1971, cast 1982
bronze with white patina, 70½ × 106 × 71
(179 × 269.2 × 180.3)
Gift of the Collectors Committee 1983.78.1

Gino Severini, Italian, 1883–1966
The Argentine Tango, 1913
oil on canvas, 38⅞ × 31 (98.7 × 78.7)
Morton G. Neumann Family Collection

David Smith, American, 1906–1965
Blue Construction, 1938
fabricated steel, enameled blue, black, 36¼ × 28½ × 30
(92.1 × 72.4 × 76.2)
The Collection of Candida and Rebecca Smith

Personage from Stove City, 1946
painted carbon steel, 34⅛ × 41⅛ × 15⅛
(86.7 × 104.5 × 38.4)
The Collection of Candida and Rebecca Smith

Aggressive Character, 1947
stainless steel, wrought iron, 32½ × 4 × 7½
(82.6 × 10.2 × 19.1)
The Collection of Candida and Rebecca Smith

Untitled (December 12), 1953
steel on steel base, 80⅜ × 9¼ × 8⅝ (204.2 × 23.5 × 22)
The Collection of Candida and Rebecca Smith

Portrait of a Painter, 1954
bronze, 96¼ × 24½ × 11⅞ (244.5 × 62.2 × 30.2)
The Collection of Candida and Rebecca Smith

Construction with Forged Neck, 1955
rusted steel, 76¼ × 13 × 8⅝ (193.7 × 33 × 22)
The Collection of Candida and Rebecca Smith

Personage of August, 1956
steel, 74⅞ × 15⅞ × 16⅜ (190.2 × 40.3 × 41.6)
The Collection of Candida and Rebecca Smith

Sentinel I, 1956
steel, 89⅝ × 16⅞ × 22⅝ (227.6 × 42.9 × 57.5)
Gift of the Collectors Committee 1979.51.1

The Woman Bandit, 1956–1958
steel, cast iron, bronze, 68¼ × 12⅛ × 12½
(173.4 × 30.8 × 31.8)
The Collection of Candida and Rebecca Smith

Lunar Arcs on 1 Leg, 1956–1960
painted steel, 106⅛ × 19 × 14⅜ (269.6 × 48.3 × 36.5)
The Collection of Candida and Rebecca Smith

Tanktotem VI, 1957
painted steel, 103⅞ (263.8) high
The Collection of Candida and Rebecca Smith

Sentinel V, 1959
stainless steel, 147 × 48 × 16 (373.4 × 121.9 × 40.6)
The Collection of Candida and Rebecca Smith

Tanktotem IX, 1960
painted steel, 88¼ × 48 × 38 (224 × 122 × 96.5)
The Collection of Candida and Rebecca Smith

Black White Forward, 1961
painted steel, 88¼ × 48 × 38 (224 × 122 × 96.5)
The Collection of Candida and Rebecca Smith

Ninety Father, 1961
painted steel, 90 × 26 × 12 (228.6 × 66 × 30.5)
The Collection of Candida and Rebecca Smith

Ninety Son, 1961
painted steel, 74⅛ × 20 × 13 (188.3 × 50.8 × 33)
The Collection of Candida and Rebecca Smith

Sentinel, 1961
stainless steel, 106 × 23 × 16½ (269.2 × 58.4 × 41.9)
The Collection of Candida and Rebecca Smith

Zig V, 1961
painted steel, 111¼ × 84¼ × 27¼ (282.6 × 214 × 69.2)
The Collection of Candida and Rebecca Smith

Circle I, 1962
painted steel, 79 × 107¾ × 18 (200.6 × 273.6 × 45.7)
Ailsa Mellon Bruce Fund 1977.60.1

Circle II, 1962
painted steel, 105½ × 110¾ × 23⅝ (267.9 × 81.2 × 60)
Ailsa Mellon Bruce Fund 1977.60.2

Circle III, 1962
painted steel, 95½ × 72 × 18 (242.5 × 182.8 × 45.7)
Ailsa Mellon Bruce Fund 1977.60.3

Voltri VII, 1962
iron, 85 × 122 × 43½ (215.8 × 311.6 × 110.5)
Ailsa Mellon Bruce Fund 1977.60.4

Voltri XVI, 1962
steel, 44 × 40 × 38 (111.8 × 101.6 × 96.5)
The Collection of Candida and Rebecca Smith

Untitled (Zig VI?) 1964
painted steel I-beams, 78¾ × 44¼ × 29
(200 × 112.5 × 73.5)
The Collection of Candida and Rebecca Smith

Construction December II, 1964
steel, 82⅝ × 66⅞ × 29½ (210 × 170 × 75)
The Collection Candida and Rebecca Smith

Gondola II, 1964
painted steel, 70⅝ × 69⅜ × 18 (179.4 × 176.2 × 45.7)
The Collection of Candida and Rebecca Smith

Wagon II, 1964
steel, 107½ × 111½ × 44 (273 × 282.5 × 112)
The Collection of Candida and Rebecca Smith

Cubi XXVI, 1965
stainless steel, 119½ × 151 × 25⅞ (303.4 × 383.4 × 65.6)
Ailsa Mellon Bruce Fund 1978.14.1

Tony Smith, American, 1912–1980
Wandering Rocks, 1967
stainless steel, five elements
Gift of the Collectors Committee 1981.53.1

Pierre Soulages, French, born 1919
Painting, 1957
oil on canvas, 76¾ × 51⅛ (194.8 × 129.8)
Gift of Morton G. Neumann 1979.67.1

Chaim Soutine, Russian, 1893–1943
Portrait of a Boy, 1928
oil on canvas, 36¼ × 25⅝ (92.1 × 65.1)
Chester Dale Collection 1963.10.216

Frank Stella, American, born 1936
Chyrow II, 1972
mixed media, 112 × 100 (284.5 × 254)
Gift of the Collectors Committee 1979.29.1

Sacramento Mall Proposal #4, 1978
acrylic on canvas, 103⅜ × 103¼ (262.5 × 262.1)
Gift of the Collectors Committee 1982.53.1

Jarama II, 1982
mixed media on etched magnesium, 126 × 100 × 24¾
(319.9 × 253.9 × 62.8)
Gift of Lila Acheson Wallace 1982.35.1

Yves Tanguy, French, 1900–1955
The Look of Amber (Le regard d'ambre), 1929
oil on canvas, 39⅜ × 31⅞ (100 × 81)
Chester Dale Fund 1984.75.1

Cy Twombly, American, born 1928
Nike, 1981
flat paint, crayon, and graphite on paper, 39½ × 27½
(100.3 × 69.9)
Gift of Lila Acheson Wallace 1986.12.3

Sylvae, 1981
paint stick, flat paint, crayon, and graphite on paper,
39¼ × 27¾ (100.3 × 69.9)
Gift of Lila Acheson Wallace 1986.12.1

Sylvae, 1981
paint stick, flat paint, crayon, and graphite on paper,
39¼ × 27¾ (100.3 × 69.9)
Gift of Lila Acheson Wallace 1986.12.2

Theo van Doesburg, Dutch, 1883–1931
Contra-Composition, 1924
oil on canvas, 25 × 25⅛ (63.5 × 63.8)
Morton G. Neumann Family Collection

Andy Warhol, American, 1928–1987
A Boy for Meg, 1961
oil on canvas, 72 × 52 (182.9 × 132.1)
Gift of Mr. and Mrs. Burton Tremaine 1971.87.11

Thirty-Two Soup Cans, 1962
acrylic on canvas, thirty-two panels, each 20 × 16
(50.8 × 40.6)
Mr. Irving Blum

Let Us Now Praise Famous Men (Rauschenberg Family), 1963
silkscreen on canvas, 82 × 82 (208.2 × 208.2)
Gift of Mr. and Mrs. William Howard Adams 1982.96.1

Max Weber, American, 1881–1961
Rush Hour, New York, 1915
oil on canvas, 36¼ × 30¼ (92 × 76.9)
Gift of the Avalon Foundation 1970.6.1

Christopher Wilmarth, American, 1943–1987
Clearing, 1972
etched plate glass and steel with cable, 53¼ × 60 × 46½
(135.3 × 152.4 × 118.1)
Gift of Rose and Charles F. Gibbs 1985.66.1

Due to the length of the exhibition, loan commitments, and
new acquisitions, particular objects on view may vary from
time to time. In addition, three of the galleries are designed to
present changing installations: the first for European works on
paper, the second for selections from The Mark Rothko Foun-
dation gift to the National Gallery and related works by artists
of the New York School, and the third for acquisitions and
loans of recent art.

Dimensions are given in inches (centimeters); height precedes
width precedes depth.

Donors of Twentieth-Century Painting and Sculpture, 1941–1988

Mr. and Mrs. William Howard Adams
Avalon Foundation
Mrs. Mathilde Q. Beckmann
Bernard and Audrey Berman
Leslie Bokor
Marcella Louis Brenner
Ailsa Mellon Bruce
Mrs. Mellon Byers
Lewis Cabot
The Morris and Gwendolyn Cafritz Foundation
Mrs. Charles S. Carstairs
Leon Chalette
Marian Corbett Chamberlain
Mrs. Gilbert W. Chapman
The Circle of the National Gallery of Art
Mr. and Mrs. Ralph F. Colin
Collectors Committee
Mrs. Edward Corbett
Chester Dale
Leslie Dame
Mrs. Carley Dawson
Mr. and Mrs. Ernest du Pont, Jr.
Mr. and Mrs. Robert Eichholz
Epstein Estate
George L. Erion
Dorothea Tanning Ernst
Julia Feininger
Lorser Feitelson
Mr. and Mrs. Sidney M. Feldman
John George Fischer
Friends of Anne Truitt
Carol and Edwin Gaines Fullinwider
Rose and Charles F. Gibbs
Katharine Graham
W. Averell Harriman
W. Averell Harriman Foundation
Jane Haslem Gallery
Enid A. Haupt
Joseph H. Hazen
Joseph H. Hazen Foundation, Inc.
Mr. and Mrs. Joseph Helman
Mary Hemingway
Mr. and Mrs. Philip Gibson Hodge
Dahlov Ipcar
Billy Morrow Jackson
Rupert L. Joseph
Harry and Margery Kahn
Otto and Franziska Kallir
Mr. and Mrs. Stephen M. Kellen
Robert P. and Arlene R. Kogod
Mr. and Mrs. Earl M. Latterman
Evelyn and Leonard Lauder
Arthur Lejwa
Madeleine Chalette Lejwa
Denise Lindner

Seymour Lipton
Mrs. Alexander H. McLanahan
Andrew W. Mellon Fund
Paul Mellon
Vincent Melzac
Mrs. Houghton P. Metcalf
Eugene and Agnes E. Meyer
Robert and Jane Meyerhoff
Adolph Caspar Miller Fund
Jan and Meda Mladek
John W. Mowinckel
Mr. and Mrs. John U. Nef
Mr. and Mrs. Morton G. Neumann
Annalee Newman
Mrs. Seymour Obermer
Frederick C. Oechsner
Georgia O'Keeffe
Gustave Pimienta
Curt H. Reisinger
Mrs. Charles Edward Rhetts and Children
The Roberts Foundation
James Rosati
The Mark Rothko Foundation
Herbert and Nannette Rothschild
Lawrence Rubin
William S. Rubin
Arthur M. Sackler, M.D.
Mortimer D. Sackler, M.D.
John H. Safer
Lili-Charlotte Sarnoff
Virginia Steele Scott
Mrs. William C. Seitz
Regina Slatkin
Mrs. McFadden Staempfli
Lauson H. Stone
Marshall H. Stone
Michael Straight
Horton and Chiyo Telford
Mr. and Mrs. E.W.R. Templeton
Mr. and Mrs. Burton Tremaine
James Twitty
Lila Acheson Wallace
Eleanor Ward
Mr. and Mrs. Hans W. Weigert
Dr. and Mrs. Robert Wetmore
John Hay Whitney Charitable Trust
William C. Whitney Foundation
Joseph E. Widener
Howard Wise
Mr. and Mrs. William Wood Prince
Eric M. Wunsch
Z-Bank of Vienna
Tessim Zorach
Donors who wish to remain anonymous